Essays on Mexican Art

Some other books by Octavio Paz

The Labyrinth of Solitude
The Other Mexico
Alternating Current
The Bow and the Lyre
Children of the Mire
Conjunctions and Disjunctions
Selected Poems
One Earth, Four or Five Worlds
Convergences
The Other Voice

OCTAVIO PAZ

Essays on Mexican Art

Translated from the Spanish by Helen Lane

Harcourt Brace & Company

New York San Diego London

D.R. © 1987, Fondo de Cultura Económica, S.A. de C.V.

English translation copyright © 1993

by Harcourt Brace & Company

Library of Congress Cataloging-in-Publication Data

Paz, Octavio, 1914–

[Essays. English. Selections]

Essays on Mexican art / Octavio Paz ; translated
from the Spanish by Helen Lane. —1st ed.

p. cm.

ISBN: 0-15-129063-6

1. Art, Mexican. I. Title.

N6550.P26 1993

709'.72—dc20 92-27692

Designed by Camilla Filancia

Printed in the United States of America

First edition A B C D E

Following is a list of first editions of the works by Octavio Paz referred to at the end of a number of the essays in this volume. The books below contain the original essays as published or variant versions.

—Trans.

In/Mediaciones. Barcelona: Seix Barral, 1979

Puertas al Campo. Mexico City: Universidad Nacional Autónoma, 1966

Pintado en Mexico. Madrid: Fundación Banco Exterior de España, 1983

El Signo y el Garabato. Mexico City: Editorial Joaquín Mortiz, 1973

Sombras de Obras. Barcelona: Seix Barral, 1983

. . . confirming through seeing once again

all the privileges of seeing

Luis de Góngora

Contents

Mural Painting

Loners and Independents

Contemporary Art

Essays on Mexican Art

Review in the Form of a Preamble

The relations between modern poetry and the other arts have been intimate, constant. Baudelaire's reflections on painting are no less widely read than are his poems; nor is it easy to forget that we are indebted to him for several memorable essays on Wagner and music. This twofold fascination appears in Mallarmé as well. The attitude of the two poets is not exceptional: we have all felt the attraction, on occasion simultaneous, to color and to the musical note. At the same time it is evident that in certain eras poetry is closer to music and in others to painting. Symbolism, for instance, had deep-seated affinities with music; painting itself was regarded, in this period, as music for the eyes. (I am thinking of Monet.) In the following period, with the appearance of Cubism, the relationship is reversed, and painting takes the place of music. Not entirely,

however, as is shown by Stravinsky and Schönberg, among others. The representative poet of the time, Apollinaire, is the author of a book that was the manifesto of the new artists: *Les peintres cubistes* (1913). A little later the Surrealists, as always, overdo the note. Or better put: the color. They were deaf, not blind: Breton wrote *Le surréalisme et la peinture*, but he did not say a word about music. Since the Second World War the ties between the arts of the ear, the eyes, and the word have grown slack even though, here and there, attempts have been made to reconstruct Baudelaire's triangle. A triangle that is a mystery resembling that of the Trinity: poetry, music, and painting are three different arts and yet one and the same true one.

The community of aesthetic ideas and ambitions of artists and poets was the spontaneous result of a historical situation that is not likely to be repeated. Between 1830 and 1930 artists formed a society within society or, more exactly, in confrontation with it. The rebellion of artistic communities against the taste of the Academy and the bourgeoisie manifested itself, brilliantly and consistently, in the critical works of a number of poets: Baudelaire, Apollinaire, Breton. I have mentioned only French poets because the phenomenon occurred most strikingly and most decisively in Paris, which was the center of modern art during those hundred years. These poets were not only the voice but the conscience of artists. After the Second World War the focal point of world art shifted to New York. It would be useless to delve into the Anglo-American tradition in search of a relationship similar to the one that conjoined poets and musicians, painters and sculptors in the great cities of the European continent. No great poet writing in English has been, as Baudelaire was, a great art critic as well. The most serious consequence was the change in the social situation of artists: in New York the art galleries, closely connected to the great economic network, direct and promote artistic movements (and at

times invent them), dominate museums, and have appropriated the functions that once belonged to critics. Poets have ceased to be the conscience of modern art. (But does modern art still have a conscience?) The great rebellion of art and poetry began with Romanticism; a century and a half later artists had been assimilated and integrated into the circular process of the market. They are just another part meshing with the rest of the financial train of gear wheels as it goes round and round.

In Mexico the French phenomenon was repeated, though on a reduced scale and with certain differences, one of them considerable. Our first really modern poet was José Juan Tablada. It is not surprising that he was also a sharp-witted and lively art critic. Not a professional critic but one in the sense of the tradition initiated by Baudelaire, of seeing painting from the perspective of poetry. Apart from having written, in 1914, the first book in Spanish on Hiroshige, an early and highly esteemed discovery, he was the author of an *Historia del arte de México* that is still well worth reading today. Another of his credits, and far from a minor one: he was one of the first to defend, and extend lofty praise to, Orozco and Rivera and, later, to Tamayo and Covarrubias. Several of the poets of the following generation—Gorostiza, Villaurrutia, Cuesta—began writing about the poets of their time with intelligence and discrimination. The only one who went on doing so was Villaurrutia; he was the most sharp-eyed and sensitive, the most brilliant as well. There is also another poet and critic of this generation; though born in Guatemala, he too was Mexican: Luis Cardoza y Aragón. His texts, less precise than Villaurrutia's, are of vaster scope and, on occasion, more inspired. Out of timidity or scorn, Villaurrutia did not deal with a number of primordial subjects, and his criticism suffers from this limitation; Cardoza's, on the other hand, is marred by ideological factionalism.

I mentioned earlier an important difference between the

situation in Mexico and that in Paris. That difference was the preponderant, exaggerated, and, in the final analysis, damaging influence of political ideology. The relationship of mural painters with poets abounded in misunderstandings and conflicts, even with Cardozo y Aragón, the one closest to them. Painters tolerated poets only with the greatest reluctance. The latter expressed their opinions not in the name of doctrine but on the basis of their likes and dislikes, the freest, most individual, most capricious thing in the world. The painters claimed to be, at one and the same time, artists, critics, and doctrinaires. In Paris the community of ideas and tastes shared by the Cubists and the poet Reverdy was real and intimate; it was altogether natural, then, that he should be the theoretician of the new aesthetic conceptions. But Cubism was not a political party, nor was it in the service of an ideology: Reverdy's opinions were not articles of faith. On the other hand, Rivera, Siqueiros, and even Orozco—who was the least dogmatic—enveloped in opprobrium those who did not share their ideas. Despite these skirmishes—some of them painted and others expressed in rhyme—the criticism of the poets is part of the history of modern art in Mexico, as will be noted in the study that some North American or Japanese will one day write on such subjects as these. (Mexicans have shown a congenital distaste for tasks of this sort.) Tablada, Villaurrutia, and Cardoza knew how to see and understand and how to find words for what they saw.

Following in the footsteps of these Mexican poets, I have written about painting and sculpture for many years. Although I have also dealt with the arts and artists of other countries, I have come back again and again to writing about Mexico, a magnetic pole. Besides painting and sculpture, I have had two other passions: architecture and music. There is an unquestionable kinship between them, and it is not worth repeating a demonstration that has been performed a number of times, occasionally

as unforgettably as the one composed by Valéry in his dialogue *Eupalinos ou l'architecte*. We all know that the two arts are based on number and proportion. Naturally, the other arts also share these properties; otherwise they would not be *arts*. Nonetheless, in no other do they fuse as completely with their very being as they do in music and architecture: the two *are* proportion and number.

Furthermore, at the other extreme, the two arts border on politics. Plato and Confucius emphasized again and again the political virtues of music. In fact, not only is it capable of exciting or of calming collective passions, but, because it is number and measure, it is a perceptible expression of justice. To mete out justice is to introduce harmony between individuals. For their part, architects erect government buildings, temples, schools, public squares, theaters, gardens, stadiums, fortresses; in all these constructions, pure space—the geometry of abstract figures ruled by number and proportion—is transformed into a public space peopled by human beings and their passions. The fearful fate of architecture: in the public plaza, as perfect as a circle or a rectangle, facing the Palace of Justice and the Temple, geometries that have turned into a shape and a presence, the people hail the demagogue, stone the heretic, condemn the learned man, or are murdered by undisciplined troops. Architecture is the witness, not the accomplice of these disorders; and what is more, it is a silent reproach: those who are wise and good see in the balance of its forms the image of justice.

Since my adolescence I have visited many monuments, some still standing and others fallen; treatises and histories of architecture have always fascinated me, not so much because of their theories and hypotheses as because of their illustrations, which immediately make visible to us the cardinal virtue of the art of building: the creation of a pure space within the space of nature; thanks to the

architects with whom I've spent time I owe pleasure and instruc-
tion; at this very moment, I am a friend, as I have been for the
past fifteen years, of the architect Teodoro González de León—
an intelligence as clear and as orderly as a Palladian architectural
structure and as perfectly attuned as a sonata. . . . But a fondness
for something is one thing and competence something else alto-
gether: writing about architecture demands a store of knowledge
that I do not possess and total dedication.

The same is true of music. I have sometimes thought, con-
ceitedly, that in certain of my poems there might perhaps be per-
ceived echoes of what I have felt and thought while listening to
Handel or Webern, to Gesualdo or an Indian raga. But I have never
believed that I could write with dignified authority about subjects
having to do with music. I have not been aware of this sense of
doubt on contemplating painting: why is that? Perhaps because the
code of painting is more sensual, less abstract and rigorous than
that of music. The language of painting—lines, colors, volume—
literally enters through a person's eyes: its code is primordially
sensory; that of music is made up of units of sound that are abstract:
the musical scale. The meanings of painting are *right there in sight*;
those of music are not immediately translatable into any other
system of meaning. A Panofsky of music, capable of deciphering
the origin and the significance of each sonorous figure, is unimag-
inable. Iconology studies static representations, and music is time,
movement.

The paradox of music, a temporal art like poetry, lies in the
fact that music's characteristic manner of taking place is recurrence.
The kinship between music and poetry is based on their both being
temporal arts, arts of succession: time. In each of the two, recur-
rence, the phrase that returns and is repeated, constitutes an es-
sential element; the motifs intertwine and disentwine so as to
intertwine once again; they are a path that ceaselessly returns to

its point of departure only to depart once more and return again.[1] The difference between the two lies in the code: the musical scale and the word. Poetry is made up of rhythmic phrases (verses) that are not only units of sound but words, clusters of meanings. The code of music—the scale—is abstract: units of sound empty of meaning. Finally, music is architecture made of time. But invisible and impalpable architecture: crystallization of the instant in forms that we do not see or touch and that, being pure time, elapse. Where? Outside of time. . . . For all these reasons I haven't dared to speak of music.

In order to really *see*, one must compare what one is seeing with what one has seen. Hence seeing is a difficult art: how to compare if one lives in a city without museums or collections of art from all over the world? The traveling exhibitions of great museums are a recent phenomenon: when I was a youngster all we had available were a handful of books and mediocre reproductions. Neither I nor any of my friends had ever seen a Titian, a Velázquez or a Cézanne. Our knowledge came from books and was verbal. We were surrounded, however, by many works of art, most of them modest, a small number of them noteworthy and a very few sublime. I grew up in Mixcoac, a little town that today is a suburb of Mexico City. The balconies of my house overlooked the Plazuela de San Juan. Although the unspeakable mania of the government has rooted out every last trace of the old name of the little square, the tall ash trees are still standing, as are the manor house with pink walls, which dates from the eighteenth century, and the little seventeenth-century church. Some five hundred meters farther on, one

[1] I have taken up the subject in "Intermedio discordante," in *Claude Lévi-Strauss o el nuevo festín de Esopo*, Mexico City: Editorial Joaquín Mortiz, 1967. (English trans.: *Claude Lévi-Strauss: An Introduction*, trans. J. S. Bernstein and Maxine Bernstein, Ithaca: Cornell University Press, 1970.)

comes upon the white Chapel of San Lorenzo, the oldest in the neighborhood. It is a sort of dovecote for toy angels. Toward the south, a fifteen-minute walk away, there is another huge, airy square; it is bordered on one side by the red walls of an eighteenth-century factory and in front, across from it, by the mud walls and iron fences of old houses of the last century; at the back of it, a sixteenth-century Dominican convent seals it off. The cloister is noble and severe; the church delicate and graceful; the atrium enormous, shaded by six venerable trees.

There are countless country houses, almost all of them modeled after French ones, built at the turn of the last century and surrounded by gardens with tall, gloomy-looking trees. The gardeners of Mixcoac were famous, and one of them, forced to emigrate because of the revolutionary upheavals, found recognition and relaxation in Los Angeles. Mixcoac had been the seat of government of a tribal chieftain before the Conquest and possessed, on one of its outer edges, a pyramid as tiny as the Church of San Juan. Manuel Gamio, the archaeologist, who was just beginning his work at the time, was a friend of my family's and often came visiting. Along with the flock of my girl and boy cousins, I went with him several times to the old sanctuary. It rose from a parched yellow plain that had once been covered by water. The sight of that desolation made it hard to imagine the bright waters of the lagoon, the rushes, the reeds and aquatic grasses, the birds and the bustling pirogues. Mixcóatl, the tutelary divinity, was a heavenly god and a warrior; his blue body was the firmament, and the white circles painted on his breast symbolized the constellations. In the distance, an enormous violet-colored bulk loomed: Ajusco and its confederations of drifting clouds.

I have failed to mention something else I learned of in Mixcoac: fiestas and fireworks displays. Beyond the Plazuela de San Juan, around the Chapel of San Lorenzo and alongside enormous exca-

vations dug by a factory that made sun-dried and fired clay bricks (today, happily, transformed into Urbina Park), was a neighborhood where families of pyrotechnicians lived and worked. The craft was still hereditary and confined to certain families. Among them was a family of peerless artisans: the Pereiras. On the days devoted to patron saints and patriotic holidays, there were calls for their services from many municipalities. At that time those of us who lived in the Federal District had not lost the most elementary democratic right, the election of our mayors and city councilmen. It is often forgotten that the right to elect our authorities includes the freedom to honor, in public and in our own way, our heroes and our divinities. In Mixcoac the fireworks makers of San Lorenzo were, naturally, the ones entrusted with the holiday skyrocket displays. I still remember, in awestruck wonderment, the inventions they thought up, such as that cascade of silver and gold, one twelfth of December, falling down the facade of the church: water of light on the stone, a harmless baptism of fire on the towers, and the dark green, almost black, foliage of the ash trees. . . . That was how my apprenticeship began. The first objects I saw were the humble and ill-matched specimens of indigenous art crossed with Spanish, of the Creole- and French-influenced tastes of our grandparents. It wasn't a bad beginning.

The town of Mixcoac was not an exception. The neighboring settlements—Tacubaya, San Angel, Coyoacán, Tlalpan—also had their convents and their churches, their manor houses and their old haciendas, their sanctuaries and their pre-Hispanic ruins. So did most of the cities and country towns of the Valley of Mexico and, in fact, very nearly the entire country. Today many of those buildings are still standing, but there are countless numbers of them that have been demolished or been stripped of their honor by savagery, negligence, and the greed for cash in hand.

In 1930 I began to study for my bachelor's degree at the Colegio

de San Ildefonso (the National Preparatory School). During the
next two years and the five spent at the university, I became familiar
with the neighborhood that is known today as "the historic center
of the city": mansions, churches, public buildings, convents, mar-
kets. In very few cities of the world can so many notable construc-
tions be seen in so relatively small a space, almost all of them ruled
by the same aesthetic and yet each of them different and unique.
Some of them are magnificent, like the Plaza del Zócalo and the
buildings around it on all four sides, in particular the wavy pink
bulk of the Sagrario, others welcoming and intimate—the garden
and the Church of Loreto—or noble, like the Inquisition building,
or sumptuous, like the palace of the counts of Calimaya. In the
former mint, the Casa de Moneda—a patio with red sand, palm
trees, and huge urns with green plants—Mexican antiquities have
been set in place. It was there that I was able to see pre-Columbian
sculpture for the first time, with a sense of horror and awe. I admired
it without understanding it: I did not know that each one of those
stones was a prodigious cluster of symbols. Little by little, I caught
an inkling of their enigmas. Among my friends there was a young
man, Salvador Toscano, who was interested in our artistic past.
With him and others I wandered on Sundays and holidays through
the Valley of Mexico and various places in Puebla and Morelos:
pyramids, convents, churches, open chapels. Toscano died at a
very early age, but he had time, at least, to write and publish, in
1944, his *Arte Precolombino de México y América Central*, the first
attempt at an aesthetic (and not simply archaeological) understand-
ing of Mesoamerican cultures.

My relationship with the modern art of Mexico was both inti-
mate and daily. Each day, as I studied at San Ildefonso, I saw
Orozco's murals. With puzzled surprise in the beginning, then later
with greater and greater understanding and enthusiasm. In addition
to Orozco's paintings, which are not only the most numerous but

also the most original and powerful, there are murals by Fernando Leal, Fermín Revueltas, and others. In the lower school, David Alfaro Siqueiros left a number of murals; he never managed to finish them, but they are notable for their almost sculptural energy. In the Bolívar Amphitheater of the college is Diego Rivera's first mural, painted in encaustic, full of reminiscences, from Picasso to Puvis de Chavannes.

Perhaps it is not beside the point to recall that it was José Vasconcelos who initiated the Muralist movement. He was the Minister of Public Education during Alvaro Obregón's regime, and in 1921 he decided to commission the best-known painters of the day to decorate the walls of various public buildings. The minister of a triumphant revolution, he dreamed of the rebirth of our people and our culture. It is probably more accurate to speak of laying foundations rather than of rebirth; although the basis of the historical construct that he dreamed of was our Indo-Spanish past, the Vasconcelos of those years was possessed by an ideal that it is not an exaggeration to call cosmic. His models were not the world empires of the past but great religious constructions, and his heroes' names were Christ, Buddha, Quetzalcóatl. His summons to the painters corresponded to a vision of an organic art, so to speak, that would be the natural expression of the new universal society that was beginning in Mexico and would spread throughout all of Hispanic and Portuguese America. His decision was doubtless influenced by the precedent of the quattrocento and, above all, by Byzantine art. His visit to St. Sophia moved him to write ecstatic, brilliant pages. The example of the convents of New Spain, many of them decorated with murals, must also have impressed themselves on his mind. An admirable idea, although his good judgment can be questioned: why entrust the walls of San Ildefonso and of the Church of San Pedro y San Pablo, monuments of our past, to the creative but irreverent fury of a handful of young artists?

Perhaps because there were no other buildings available. Nonetheless, above and beyond this aesthetic inappropriateness, Vasconcelos bequeathed to us an ethical and political lesson: he allowed artists to work in freedom, knowing full well that their ideas were very different from his own.

The first murals are the ones at San Ildefonso, painted in encaustic by Fernando Leal, Fermín Revueltas, David Alfaro Siqueiros, and Diego Rivera. The first true fresco, in the same building, was the work of Jean Charlot, but he used cement and other materials that damaged the colors. In fact, the first successful fresco was the one by Ramón Alva de la Canal. He had the good sense to listen to one of the masons who were working with him and who used the popular technique employed to paint the bars where rotgut pulque was sold. Rivera later took over this technique and employed it with talent. Unfortunately, before adopting it, he used a mixture of cochineal cactus juice and coloring matter on several walls of the Secretariat of Public Education. The idea was apparently Xavier Guerrero's; the result was a disaster: in a very short time the murals were badly blistered and had to be covered with a thin layer of wax to save them. How long would this preserve them? Alva de la Canal's fresco, finished in 1922, is excellent. It is in the passageway that leads from the main patio to the street, opposite Revueltas's mural *Allegory of the Virgin of Guadalupe.*

Adjoining San Ildefonso are the church and the convent of San Pedro y San Pablo. It was a school run by the Jesuits, and it was there, in the seventeenth century, that Father Antonio Núñez de Miranda, the severe spiritual director of Sor Juana, among others, studied. In my day the convent had been made into a secondary school. In 1921, in the church, Roberto Montenegro finished the first mural of the movement. He painted it in tempera, and it soon began to come loose from the wall. In the former convent, Atl painted several curious murals (which never go beyond what that

adjective implies) and Montenegro his *Feast of the Holy Cross*. At one end there could be seen the figure of José Vasconcelos, the great protector of the Muralists. Later on, apparently by order of another Minister of Education, Narciso Bassols, the figure of Vasconcelos was painted out and that of a woman painted in to replace it. As far as I know, no one protested.[2]

My wanderings led me to explore not only the Mexico City of the Palacio Nacional, the cathedral, Santo Domingo, and their environs but also other neighborhoods far from the center of the city and in the area to the south, which up until then had been my *patria chica*, my own home ground: Tacubaya, Mixcoac, San Angel, Tizapán, Coyoacán, Tlalpan. In those years I sometimes made forays toward the north, but they soon came to an abrupt halt amid the desolation of saltpeter and pits of quicksand that had been left when the lakes dried up. One of my favorite excursions retraced the itinerary of the defeated Spaniards in their flight on the Noche Triste, the sad night of Cortés's retreat. As darkness fell, I left San Ildefonso with one or another of my friends and roamed about the Calle de Tacuba, full of echoes and a sense of the presence of ancient Mexico, before Cortés and before New Spain, but also full of a number of nineteenth-century mansions, in which there reigns supreme, as in women's bodies and fashions of that era, an aesthetic of opulent forms and fripperies that only yesterday made us smile and today touches our hearts. We lingered in the old-timers' bookstores on the Avenida Hidalgo, between the massive eighteenth-century edifices of the Alameda Central and the tiny and rather melancholy Plaza de San Juan de Dios: and alongside it, face to face, two half-sunken churches, like heavy boats run aground. One of them is dedicated to St. Anthony, the

[2] See Laurence E. Schmeckebier, *Modern Mexican Art*, Minneapolis: University of Minnesota Press, 1939.

patron saint of spinsters, abandoned women, and those of easy virtue. We went on, and when we reached the Jardín y Panteón de San Fernando, we stopped to talk and take a rest. The tall iron grillwork, the statuary, and the republican pomp beneath the dark grove of trees made me think not so much of the exploits of the liberals as of a poem by Gutiérrez Nájera:

> Don't you see by what path the twining ivy seeks its pleasure
> Amid the crannies of the dark altar?
> As it then interlocks with the marmoreal stone
> So I wish to interlock with your heart, my treasure.

We went on our way once more and, almost without our having realized it, reached the Puente de Alvarado, a famous spot where Tonatiuh, the blond conquistador, saved his life by leaning on his spear, like the athlete on his pole, in order to leap from one end of the muddy channel to the other. A bit farther on was another memorable building: Mascarones. For a number of years this former mansion housed the Faculty of Philosophy and Letters, to which I sometimes went, at the end of this period, to hear the Spanish teachers and talk with José Luis Martínez, who had recently arrived from Guadalajara. The reddish stone building is at once severe and lavish; despite the sumptuous facade, it has a sort of reserve like that of the haughty and ceremonious Creoles who built it. But the severity and solemnity disappeared the moment I crossed the threshold of the great main entrance. In the first patio a tiny garden had been laid out whose perfect proportions and enveloping, almost spiritual serenity delighted me. If I close my eyes, I can still breathe the fresh air, hear the voices and the laughter of the boys and girls as they lean on the railings, see a blue sky and some red benches, see a little tree of a transparent green that sways back and forth in the October light and almost speaks and takes wing.

Beyond Mascarones other worlds began. I wandered all about them with friends who lived in those neighborhoods. One of them was San Rafael, which still abounded in sumptuous vestiges of the days of the dictator Porfirio Díaz, although already irreparably damaged by the negligence of the current regime; the other was the secretive Santa María. With its provincial promenade, its odd museum, and its parish church, it is a town rather than a neighborhood. As I roamed about its lonely streets, I invariably remembered López Velarde. Among other notables, the novelist Mariano Azuela, the modernist poet Rafael López, and Carlos González Peña, to whom we owe the *only* modern history of our literature, lived in Santa María. Those endless strolls encouraged the exchange of ideas and confidences, controversies and sudden and ephemeral illuminations. Conversation is the great gift offered by the relations people have with each other, as long as one forgets about Eteocles and Polynices, Cain and Abel. Friendship: shared fervor for a poem, a novel, an admiration, an idea, an indignation. At exactly midnight, I left my friends and, my brain on fire, crossed the deserted streets so as to catch, past the Paseo de la Reforma, between Chapultepec and Insurgentes, the last streetcar out to Mixcoac.

But our rambles were not archaeological visits, nor did we confuse the city with a museum. Everything attracted us and everything made us linger for a moment: the celebrations and fiestas of each neighborhood, the taverns and the beer halls, the cafés and the modest eating houses, community dances, the girls' schools letting out, the movie houses and the burlesque theater, the parks and the lonely back streets. . . .

Multitude-solitude: termes égales et convertibles: Multitude-solitude: equal and exchangeable terms. And Baudelaire adds: ". . . he who does not know how to people his solitude does not know how to be alone in the midst of the crowd either." But not everything was sublime in those aimless rambles through the streets. Or sordid

either. Between one extreme and the other there stretched the immense, imprecise territory of boredom. An ailment of adolescents: with an absent-minded gesture, boredom opens the doors of poetry or of debauchery, those of solitary meditation or those of cruel and stupid diversions.

The Abelardo Rodríguez market was decorated in 1933 by a group of disciples and followers of Diego Rivera's. Although among these murals there is one by a great artist, Isamo Noguchi—his first—I remember these paintings now because of Pedro Rendón. He was a round-faced, meek-eyed young man, with shy gestures, tight-fitting clothes, and a lingering smell of fried food about him. He did not walk: he rolled along slowly, with a rhythm reminiscent of a balloon. His gentleness struck us as bovine, but it may well have been angelic. He was the local simpleton. He was also a painter and a poet. A short time before, he had had his day of glory. I have no idea whether Diego Rivera was motivated by his love of mystification and was imitating the *blagues* of the Montparnasse of his youth or whether he was out to annoy the artists of the new generation, but in any event he proclaimed Pedro Rendón the best of the young painters. At his insistence, the credulous municipal authorities gave Pedro a wall of the market on which to paint a mural. Shortly thereafter, in the same off-handed manner with which he had exalted him, Diego dropped him. People vaguely understood that Pedro had been the victim of a practical joke, and he suddenly found himself with neither friends nor defenders. Did he ever catch on that he was the laughingstock of the university crowd? I don't believe so. But in his destitution, driven by necessity, he made the rounds of the schools and faculties with a placid smile and anxious eyes. He occasionally managed to get himself invited to have a taco and a glass of pulque punch. In exchange, he had to write a sonnet in which it was obligatory to

mention the name of his benefactor or that of a friend of either sex. Pedro wrote it the way an obedient little doggie jumps through a hoop and wags its tail. How many sonnets did he write for me and my friends? Pedro: forgive them, forgive me. Like Tablada's little burro in his paradise of alfalfa, you are now in a lofty, gleaming taco stand where, at peace at last, far removed from mockery and derision, you are eating delicious delicacies made in the region beyond.

A step away from San Ildefonso we could see one of Rivera's most successful projects, the frescoes in the Secretariat of Public Education. They are surpassed perhaps only by the chapel of Chapingo. In the frescoes in the Secretariat, the numerous influences on Diego, far from submerging him, give him wings and allow him to demonstrate his great gifts. Those murals are like an immense unfolded fan that shows, successively, the artist who is at once one and many: the portraitist who at certain times is reminiscent of Ingres; the skilled disciple of the quattrocento who, if he occasionally approaches the severity of Duccio, in other murals reinvents—that is the right word—the art of color of Benozzo Gozzoli and his captivating combination of physical, animal, and human nature; the consummate craftsman of volumes and geometries who was capable of transferring the lesson learned from Cézanne to the surface of a wall; the painter who prolonged Gauguin's vision— trees, leaves, water, blossoms, bodies, fruit—and made it flower once again; and, finally, the draftsman, the master of the melodious line. Gifts of time: in those years Rivera was painting the walls of the Palacio Nacional, and I would see him high up on a scaffolding, dressed in a pair of ragged, paint-splattered overalls, armed with thick brushes and surrounded by pots of paint, helpers, and amazed onlookers.

By chance, literary and artistic friendships enabled me to meet several painters and visit their studios. One of them was Manuel

Rodríguez Lozano, whose giant-sized canvases immediately reminded me of Picasso's in his neoclassical period, which I had come to know thanks to the reproductions that were beginning to circulate at the time. Rodríguez Lozano was an excellent draftsman, an incorruptible artist, and a man of rare and caustic intelligence. In exhibition halls and in other public places I caught glimpses of Julio Castellanos, Agustín Lazo, and Carlos Orozco Romero on several occasions. Years later I was to see them and talk with them in the Café París at the gatherings presided over by Octavio G. Barreda. They showed me that painting was not, nor could it be, only mural painting: there were other worlds, other planets, other revelations. During these years a brilliant young man, practically still an adolescent, Juan Soriano, arrived from Guadalajara. We soon became friends. His conversation was a fountain of fires of every color, some of them burning-hot; his painting had the poetry of patios with tall grillwork over which peeked little girls with giddy faces, huge eyes, and enormous hair bows.

In 1937 I was in Spain and had brief glimpses of Paris and New York museums. On my return, my political and aesthetic ideas began to change. Friendship with various Spanish poets and writers who, fleeing from the war and Franco's dictatorship, had settled in Mexico, contributed to that change. Later on, I met others who had a profound effect on me: the Surrealist poet Benjamin Péret, the Peruvian César Moro, the revolutionary writer Víctor Serge, Jean Malaquais arrived in our country. I became friends with them and with other new arrivals, opened my eyes, and saw with amazement the world around me: it was the same and it was different. My admiration for the Muralists turned to impatience first of all and then, later, to reproval. With the honorable exception of Orozco, some of them were apologists, and others were fronts, for Stalin's bureaucratic dictatorship. Moreover, they had become the new academy, more intolerable than the preceding one. They impressed me as the aesthetic equivalent of the National

Revolutionary Party, which in those days had changed its name to the Party of the Mexican Revolution while leaving its composition unchanged. My reservations about the Muralists were political, moral, and aesthetic but, above all, they were legitimate and necessary: the Muralists' rhetoric was suffocating young artists. I wanted to breathe the world's free air. It was not long before I did.

In 1943 I left Mexico for many years. During the first two, I lived in the United States, in San Francisco first and then in New York. My second apprenticeship began there. I used to spend entire mornings, once or twice a week, at the Museum of Modern Art. I also went to the Metropolitan and the other museums in the city, although not as often. As I stood before paintings by Picasso, Braque, and Gris—the last in particular, for he was my silent master—I finally understood, slowly, what Cubism had been. It was the most difficult lesson of all to learn; afterwards it was relatively easy to see Matisse and Klee, Rousseau and Chirico. Kandinsky's paintings seemed like pinwheels to me and reminded me of the fireworks that I had seen on festival nights in Mixcoac:

> Silver stars that in bright gyres
> beat out, with alternate feet, sapphires.

My learning was also an unlearning. I never liked Mondrian, but through him I learned the art of stripping down to the barest essentials. Little by little I threw most of my beliefs and artistic dogmas out the window. I realized that modernity is not novelty and that being truly modern meant returning to the beginning of the beginning. A fortunate meeting confirmed my ideas: in those days I met Rufino Tamayo and his wife, Olga. I had seen them fleetingly in Mexico City several years before, but only at this point was I able to be on really close terms with them. On seeing his work, I perceived, clearly and immediately, that Tamayo had

opened a breach. He had asked himself the same question that I had asked myself and had answered it with those canvases at once refined and savage. What did they say? I translated his primordial forms and vibrant colors into this formula: the conquest of modernity is achieved through the exploration of the subsoil of Mexico. Not the historical and anecdotal subsoil of the Muralists and the realist writers but the psychic subsoil. Myth and reality: modernity was the oldest antiquity. But it was not a chronological antiquity; it lay not in the time before but right here and now, within each one of us. And I was ready to begin. And I began. . . .

I arrived in Paris in December 1945. Continuation of the process of learning/unlearning. Surrealism attracted me. At the wrong time? I would say, rather: against time. It was an antidote to the poisons of those years: Socialist realism, *littérature engagée*—politically committed in the manner of Sartre—abstract art and its sterile purity, commercialism, the idolatry of enormous printings, publicity, success. Against time: against the current. Learning and unlearning.

Going with André Breton through the exhibition rooms of an Eskimo art show and remembering now not what he said but his grave tone of voice, his attitude of reverence and nostalgia on confronting the remoteness that was *other*: the age-old sacred space peopled by changing beings, the territory of metamorphoses;

hearing Kostas Papaioannou talk of Byzantine art as the transubstantiation of temporal material into luminous vibration—being in its essence is radiant clarity, intelligent light—and a month later contemplating, in Ravenna, the mosaics of San Vitale;

the sudden appearance, on the plains of Madhya Pradesh, of the palace of Datia, a black jewel mounted atop a crag;

travels in Afghanistan with Marie José and, one morning in 1965, in the ruins of Surkh Kotal, the sight of black nanny goats on the scorched hillsides opposite the terraces built by King Ka-

nishka (in Mathura we saw, carved in red stone, his headless statue of a nomad warrior);

the three minutes of self-communion in Basho An, the minute hut on the hill covered with pines and boulders in the environs of Kampuji Temple, near Kyoto, where Bashō lived for a season. When I saw the hut, rebuilt a century later by Buson, I said to myself, "It's no bigger than a haiku," and composed these lines, which I mentally pinned to one of the pillars:

> The world is contained
> in sixteen syllables
> you in this hut;

the landing in Bombay in 1952 and, in the cave at Elephanta, my awe in the face of cosmic energy made stone and stone made a living body;

the bedazzled, irritated, skeptical, enthusiastic reading, in 1948, of André Malraux's *La monnaie de l'absolu*;

the party one evening in a little house on Utopia Road, as tedious as an argument about utilitarian philosophy—but in the basement Marie José and I saw Joseph Cornell invent, with three marbles, a celestial map and two old photographs, astronomical gardens where Almendrita plays a hoop game with the rings of Saturn;

the travel circuit of twenty-five years: circumambulations, circumnavigations, circumgyrations and aerial circumvolutions in Asia, Europe, and America;

the exploration of the tunnel of correspondences, the excavation of the dark night of language, the perforation of rock: the search for the beginning, the search for water.

———

My first notes on art subjects go back to 1940, the last to two weeks ago. I never wanted to be systematic or to limit myself to this subject or that: it made no difference to me whether I wrote a book on Marcel Duchamp or a poem in honor of my friend Swaminathan, a painter and poet. Moved by admiration, curiosity, indignation, complicity, surprise, I wrote: to comment on an exhibition or to introduce a friend to the public, at the request of a museum or on commission from a magazine. Today, as I gather together my scattered pieces on the art and the artists of Mexico, I am distressed by my deficiencies and my neglect of certain figures. There are many of them and they loom large. In my defense I shall explain that I have tried not to write a history of the art of my country but, on the margin of its history, to jot down a few quick comments: a traveler's signs of admiration.

I shall say nothing of my writings on the art of antiquity in Mexico; the very nature of their subject matter explains (and perhaps justifies) the fact that at one of their extremes they are schematic, and at the other, fragmentary. I will say even less as to my silence concerning the art of New Spain. In other of my writings I have referred, though merely in passing, to the architecture of New Spain, which to me, along with its poetry, is the great creation of that era. I add: great in Mexico and great on a world scale. As I come around to Neoclassicism and Romanticism, the lacunae become immense: I feel far removed from the anemic art of our nineteenth century. But it vexes me to have said nothing of José María Estrada and of the popular painters of that era. Another regret: I would have liked to know more about Mariano Silva Vandeira, a curious painter, now forgotten, who was discovered by Montenegro and about whom Villaurrutia wrote two pellucid pages. And Ruelas? Perhaps he died too soon. And Clausell? Perhaps he came along too late.

I have even more cause for remorse when it comes to the con-

temporary period. I confess that I regret the omissions more than the deficiencies. These latter are congenital, an integral part of my nature; the former, on the other hand, are sins, even though, for the most part, they are involuntary ones. I feel indebted, in particular, to Carlos Mérida, Julio Castellanos, Agustín Lazo, and Alfonso Michell. I cannot forgive myself for not having written anything about two women. One of them is Frida Kahlo, whom I have admired intensely ever since I saw a painting of hers for the first time in the Surrealist exposition held in 1938 in Inés Amor's gallery. The other one is María Izquierdo, who is still awaiting recognition. The most unfortunate omissions are those of certain painters who have reached their maturity today. I shall not mention all of them, so as not to feel even more ashamed of myself. Nonetheless, I must mention at least two names: that of Vicente Rojo and that of Brian Nissen. The first is as rigorous as a geometrician and as sensitive as a poet; the second is an inventor of solid forms that all at once, caught up by an enthusiastic breath of air, take off and fly: sudden, multicolored pollen. On occasion I have tried to write about these artists; each time I have given up. I am still waiting for the right half hour to come along.[3]

The omission of young painters is natural. I have not felt that I possess either the authority or the knowledge to speak of works and personalities still gestating.

Despite so many defects and gaps, all has not been lost. I have

[3] The present volume fills in some of the gaps having to do with modern and contemporary art.

With the passage of time, my debts to artists increase, as does my inability to repay them. As this book was in press, I visited a remarkable showing by Arnaldo Coen. It was not a discovery—I knew and esteemed his previous work—but, rather, the *revelation* of a painter already the master of his media and his obsessions. Something similar happened to me with another excellent artist, Roger von Gunten.

fought for the freedom of art when dogmatists and delirious dea-
conesses passed out anathemas and excommunications like ac-
cursed bread; I defended Tamayo, Gerzso, and the other
independent artists when the quaestors and censors, with their
troop of male and female constables, threatened them with the
penitential garments of heretics and those who have fallen into sin;
I have resisted confusing the tricolored flag with painting and the
catechisms of Socialist realism with aesthetics. It was a lonely battle,
but in the midst of it unexpected allies appeared: Alberto Gironella,
José Luis Cuevas, and, a little later, the painters who appeared on
the scene around 1960. This new generation had the good fortune
of coming across a generous and intelligent critic, Juan García
Ponce. Since then we have witnessed many changes. I do not
approve of all of them. I confess that some of them even terrify
me. It might not be pointless for me to take the risk yet again and
say what I think about the present-day panorama.

Modern Mexican painting began around 1920. It came into
being under the patronage of the state; it was unable to count on
an appreciable domestic market, but it did win a devoted public,
enthusiastic critics, and generous patrons in the United States.
Orozco, Rivera, and Siqueiros painted murals in New York, Chi-
cago, Los Angeles, and other cities, while their easel paintings
figure in many private collections and in the most important mu-
seums. Furthermore, a number of North American artists who
would later become famous worked alongside them or experienced
their influence. This is a chapter in the history of the art of both
countries that has yet to be written. The second period, no less
brilliant, is represented above all by one name, that of Rufino
Tamayo. A solitary rebel, he broke with official art and skin-deep
nationalism. He was not afraid of being a loner; in Mexico he
suffered the indifference of some and the hostility of others; outside
his own country he earned the recognition he deserved, first in the

United States and later throughout the world. Today his works too appear in prominent private collections and in the principal museums of America, Europe, and Asia. The artists who came along later have found it more and more difficult to gain entrée into the international sphere. These difficulties have become little short of insuperable for the youngest of them. A falling off of creative talent and imagination? No: young artists of other countries—except those lucky enough to have benefited from the fortuitous synergy of the market and private art galleries—confront the same obstacles.

We are face to face with a historical phenomenon—by which I mean to say one that is aesthetic, social, economic, and spiritual —that is affecting all the arts and that, in reality, is one more aspect of the universal crisis of modern civilization. In the sphere of art, we have been experiencing for years now the decline of the avant-garde, infected down to its very roots by two ailments that are twins and yet at the same time antithetical: academic self-imitation and the proliferation of styles and manners. Painting, sculpture, and the novel have been more gravely harmed than music and poetry, because they are more closely dependent on commercial and financial finagling. The modern movement was born shortly before the First World War and in different places simultaneously: Paris, Milan, Cologne, Berlin, St. Petersburg. It soon spread to the American continent, and its first really original center, brimming over with vitality, was Mexico City, between 1920 and 1940. Little by little, for different reasons, these centers died out, whereas the influence of New York grew, and today reigns supreme. Abstract Expressionism was born in that great city; later it was the scene of the activities of a good many artists of unquestionable talent and originality, such as Robert Rauschenberg and Jasper Johns. At the same time, the artistic market has been radically transformed: in bygone days it followed the changes in art; today it takes the lead over them. In the Renaissance there sprang up a form of production

and distribution of works of art that is dying out today. I will not pursue the subject any further, having dealt with it in other writings. Nor will I go into detail regarding the remedy: the resurrection or birth of local centers to counter the impersonality of the international market and its vogues.[4]

I need scarcely say that I am not preaching an anachronistic nationalism: I believe, and have always believed, that the arts find their way across all walls, customs barriers, and borders. But artistic creation is never passive imitation; it is a struggle, a fight. The true artist is the one who says no even when he says yes. The remedy that I am proposing is simple although it is difficult to effect: if Mexico wants to be an autonomous center of creation and distribution of works of art, it must go back to being one, as other parts of the world are doing. Autonomous means not closed but independent. In the past the state was the great protector of the arts: today this task is the responsibility of the whole of society. It is arduous but not impossible: the step that has been taken in the realm of literature can be taken in that of painting, sculpture, and music. At the beginning of these pages I referred to the free community of artists—poets, musicians, painters, and sculptors—with which the modern movement began. It was a society within society and united to it by the ties, sometimes polemical and contradictory, of living together. To rebuild that community will be, once more, to return to the beginning. I begin yet again: creation and participation.

MEXICO CITY, *March 1, 1986*

[4] See, in this volume, the essays "Price and Meaning" and "Contemporary Mexican Painting."

Pre-Columbian Art

The Art of Mexico:

Material and Meaning

Goddess, Meaning, Masterpiece

On August 13, 1790, in the course of a municipal excavation, workers tearing up the pavement of the Main Square in Mexico City discovered a colossal statue. They unearthed it, and it turned out to be a sculpture of Coatlicue, the "Goddess of the Serpent Skirt." Viceroy Revillagigedo immediately arranged for it to be taken to the Royal and Pontifical University of Mexico as a "monument of America's ancient past." Some years earlier, Carlos III had donated a collection of plaster copies of Greco-Roman works to the university and the Coatlicue was placed among them. But not for long.

Introduction to the catalogue of the Mexican art exhibit in Madrid, 1977.

A few months later, the learned professors at the university decided it should be reburied in the place where it had been discovered. The Aztec idol might revive old beliefs in the Indians' memories, and above all, its presence in those cloistered precincts constituted an affront to the very idea of beauty. Nonetheless, the scholar Antonio de León y Gama had time to pen a series of notes describing the statue and another stone that had been found near it, the Aztec calendar, or the so-called Sun Stone.

León y Gama's notes were not published until 1804, in Rome, in translation. Baron Alexander von Humboldt probably read them in this Italian translation that very year during his stay in Mexico. According to the historian Ignacio Bernal, Humboldt asked to be allowed to examine the statue. The authorities agreed. It was dug up a second time, and once the German scholar had satisfied his curiosity, it was reburied yet again. The presence of this awe-inspiring statue was unbearable.

The Great Coatlicue as she is now known by archaeologists, to distinguish her from other sculptures of the same deity—was not permanently unearthed until years after Mexico won its independence from Spain. First she was left in the corner of a courtyard at the university. Then she was put in a hallway behind a screen, like an object that provoked by turn curiosity and embarrassment. Later a place was found where she was clearly visible, able to be studied as an object of scientific and historical interest. Today she occupies one of the central places in the Museo Nacional de Antropología, in the large exhibition room devoted to Aztec culture. The vicissitudes of the Coatlicue—turning from goddess into demon, from demon into monster, and from monster into masterpiece—illustrate the changes in our sensibility that we have experienced over the last four hundred years. These changes reflect the increasing secularization characteristic of the modern age. The opposition between the Aztec priest, who worshiped her as a god-

dess, and the Spanish friar, who looked on her as a demoniacal manifestation, is not as deep-seated as it appears at first sight. For both, the Coatlicue was a supernatural presence, a *mysterium tremendum*. The difference between the eighteenth-century attitude and that of the twentieth conceals a similarity as well: the condemnation of the former and the enthusiasm of the latter are both of a primarily intellectual and aesthetic nature. From the end of the eighteenth century, the Coatlicue abandons the magnetic realm of the supernatural to take the first steps into the corridors of aesthetic and anthropological speculation. She ceases to embody a crystallization of the powers of the beyond and becomes an episode in the history of human beliefs. As she leaves the temple and enters the museum, her nature changes though her appearance does not.

In spite of all these changes, the Coatlicue is still the same. She is still the block of stone with a vaguely human form, covered with awesome attributes that were anointed with blood and perfumed with copal incense in the Main Temple of Tenochtitlán. But I am thinking not only of her material appearance but also of her psychic radiation: just as it did four hundred years ago, the statue is an object that both attracts and repels us, both seduces and horrifies us. Its powers have been preserved intact even though the form and the place of their manifestation have changed. Whether atop a pyramid or buried among the rubble of a ruined teocalli, whether placed in a roomful of antique curiosities or made a focal point of a museum, the Coatlicue always evokes amazement. It is impossible not to pause and contemplate her, if only for a moment. The mind stops dead: the enigma of the massive block of carved stone paralyzes our sight. The exact nature of the sensation that overcomes us in this moment of stillness—admiration, horror, enthusiasm, curiosity—is not important. Once again, without ceasing to be what we see, the work of art reveals itself as that which lies beyond what we see. What we call a "work of art"—an

ambiguous name, especially when applied to the works of ancient civilizations—is perhaps no more than a configuration of signs. Each viewer combines these signs in a different way, and each combination expresses a different meaning. The plurality of meanings, however, is resolved into a single *sense*, always the same: a sense that is inseparable from what is sensed.

The unearthing of the Coatlicue is a repetition, on a reduced scale, of what the European mind must have experienced when confronted with the discovery of America. The new lands appeared as an unknown dimension of reality. The Old World was ruled by the overarching symbol of the triad: three times, three ages, three persons, three continents. America had literally no place in this traditional worldview. After its discovery the triad was deprived of its prestige. No longer were there just three dimensions and only one true reality. America represented a new dimension, the unknown fourth dimension. This new dimension was governed not by the principle of the triad but by the number four. The American Indians considered space and time, or, more precisely, space/time, a dimension of reality at once single and dual, which was ruled by the order established by the four cardinal points: four destinies, four gods, four colors, four ages, four worlds beyond this earthly one. Each god had four aspects; each space, four directions; each reality, four faces. The fourth continent had suddenly emerged as a palpable presence, full to overflowing with itself, with its rivers and mountains, jungles and deserts, its fantastic gods and its treasures ready and waiting to be discovered—real in its most immediate expressions and spellbinding in its more delirious manifestations. Not another reality but rather the other aspect, the other dimension of reality. Like the Coatlicue, America was the visible revelation, in stone, of invisible powers.

As the new lands revealed themselves little by little to the eyes of the Europeans, they were seen to be products not only of history

but of nature as well. The Indian societies were looked on by the first Spanish missionaries as a theological mystery. The *Historia general de las cosas de Nueva España* (General History of the Things of New Spain) is an extraordinary book, one of the admirable founding works of the new science of anthropology. Yet its author, Fray Bernardino de Sahagún, always believed that the ancient Mexican religion was one of Satan's snares and that it had to be eradicated from the soul of the Indian. This theological mystery later became a historical problem. What changed was the mental perspective but not the conceptual stumbling block. By contrast to the cases of Persia, Egypt, or Babylonia, American civilizations were not older than that of Europe, they were different. And that difference was radical: it constituted a real "otherness."

No matter how isolated the centers of civilization of the Old World may have been, there were always contacts and links between the Mediterranean cultures and those of the Near East and between these latter and those of India and the Far East. Persians and Greeks had established themselves in India, and Indian Buddhism had spread to China, Korea, and Japan. On the other hand, although we cannot entirely rule out the possibility of contacts between the civilizations of Asia and America, it is evident that America experienced nothing comparable to this transfusion of ideas, styles, techniques, and religions that brought new life to the societies of the Old World. In pre-Columbian America there were no outside influences as important as those of Babylonian astronomy in the Mediterranean, Persian and Greek art in Buddhist India, Mahayana Buddhism in China, or Chinese ideograms and Confucian thought in Japan. There was apparently a certain amount of contact between Mesoamerican and Andean societies, yet these two civilizations owe nothing or very little to external influences. From economic practices to artistic forms, from social organization to cosmological and ethical concepts, the two great civilizations of

America were original in the primary sense of the word: their origin was internal. It was precisely this originality that was one of the causes, the decisive one perhaps, of their destruction. Originality is a synonym for "otherness" as well, and both terms bear a connotation of isolation. Neither of the two civilizations of America had an experience that was common and constant among the societies of the Old World, that is, the presence of the *other*, the intrusion of foreign civilizations and peoples. That is why the indigenous peoples of America saw the Spaniards as beings come from another world, as gods or semigods. The reason for the defeat of these peoples is to be sought not so much in their technical inferiority as in their historical isolation. Their mental universe included belief in another world and its gods, but not the idea of another civilization and its inhabitants.

From the beginning, the European historical mind found itself confronted with the impenetrable civilizations of America. From the second half of the sixteenth century there were multiple attempts to suppress certain differences that seemed to deny the unity of humankind. Some claimed that the ancient Mexicans were one of the lost tribes of Israel; others attributed to them a Phoenician or a Carthaginian origin; still others, like the Mexican scholar Sigüenza y Góngora (the nephew, on his mother's side, of the great Spanish poet), thought that the similarities between certain Christian ceremonies and some of the rites of ancient Mexico were a distorted echo of the preaching of the Gospel by the apostle Saint Thomas, known among the Indians as Quetzalcóatl (Sigüenza also believed that Neptune had been a great chieftain, a founding father of Mexican civilization). The Jesuit Athanasius Kircher, a walking encyclopedia obsessed by everything having to do with Egypt, argued that pyramids and other phenomena were tangible proof that Mexican civilization was an overseas version of Egyptian civilization, an opinion that must have delighted one of his readers

and admirers, Sor Juana Inés de la Cruz. . . . A resurgence of American "otherness" followed each of these exercises in concealment. It was irreparable. In the very last years of the eighteenth century the recognition of this irreducible difference marked the beginning of true understanding. A recognition that involved a paradox: the bridge between myself and the other is based not on a similarity but on a difference. What links us is not a bridge but an abyss. Humankind is a plurality: human beings.

Stone and Movement

Art survives the societies that create it: it is the visible tip of the submerged iceberg that every civilization represents. The recovery of the art of ancient Mexico has taken place in the twentieth century. First there was archaeological and historical research; later, aesthetic comprehension. It is often said that this understanding is an illusion: what we feel when confronted by a relief at Palenque is not what a Maya experienced. That is true. But it is also true that our feelings and thoughts on seeing the work before us are quite real. Our understanding is not an illusion: it is ambiguous. This ambiguity is present in all our views of works from other civilizations and even when we contemplate works from our own past. We are not Greeks, Chinese, or Arabs; yet neither can we say that we fully comprehend Romanesque or Byzantine sculpture. We are condemned to translate, and each of these translations, whether it be of Gothic or Egyptian art, is a metaphor, a transmutation of the original.

In our efforts to recover the pre-Hispanic art of Mexico two important factors came into play. The first was the Mexican Revolution, a phenomenon that profoundly modified our view of the past. The history of Mexico, especially as regards its two great

turning points, the Conquest and Independence, can be seen as a twofold separation: first, from the Indian past and, second, from New Spain. The Mexican Revolution was an attempt, only partially successful, to reestablish the ties that had been broken by the Conquest and Independence. We suddenly discovered ourselves to be, in the words of the poet López Velarde, "a Castilian and Moorish land with Aztec streaks." It is not at all strange, then, that modern Mexicans, dazzled by the splendid ruins of the ancient civilization recently unearthed by archaeologists, should have wanted to retrieve and exalt this impressive heritage. Yet this change in our historical perspective would have been insufficient had it not coincided with another change in the aesthetic awareness of the West. The change was gradual and took centuries. It began at almost the same time as European imperial expansion, and its first expressions are to be found in the chronicles written by the Spanish and Portuguese navigators, conquistadors, and missionaries. Later, in the seventeenth century, the Jesuits discovered, and became enamored of, the civilization of China; their passion was to be shared a century later by their enemies, the philosophers of the Age of Enlightenment. At the dawn of the nineteenth century the German Romantics had a fascination for both Sanskrit and Indian literature, a fascination that reappears when modern aesthetic awareness discovers the art of Africa, America, and Oceania at the beginning of our century. In teaching us how to appreciate objects ranging from a black mask to a Polynesian fetish, modern Western art has cleared the path for us to comprehend the art of ancient Mexico. The radical "otherness" of Mesoamerican civilization is thus transformed into its opposite: thanks to modern aesthetics, these works, which seem so distant, are also our contemporaries.

I have mentioned the distinguishing features of Mesoamerican civilization as originality, isolation, and something I have had to

call "otherness." I should also add two more characteristics: spatial homogeneity and temporal continuity. In the territory of Meso-america—a rugged land of contrasts, in which every climate and every landscape coexist—several cultures arose whose limits more or less coincided with geographical boundaries: the Northeast, the high central plateau, the coast of the Gulf of Mexico, the valley of Oaxaca, Yucatan, and the low-lying regions of the Southeast, extending to Guatemala and Honduras. The diversity of cultures, languages, and artistic styles does not break apart the essential unity of this civilization. Although it is not easy to mistake a Mayan work for one from Teotihuacán—the two poles or extremes of Mesoamerica—in each of the great cultures there are certain common denominators. Here is a list of the most outstanding ones as I see them:

the cultivation of corn, beans, and pumpkins or squash;

the absence of draft animals and, as a consequence, of the wheel and the cart;

a rather primitive technology that never went beyond the Stone Age, except in certain activities, such as exquisite workmanship in gold and silver;

city-states with a military and theocratic social system, in which the merchant class played an outstanding role;

hieroglyphic writing, codices, a complex calendar based on the combination of a 260-day cycle, or "year," and a solar year of 365 days;

the ritual game played with a rubber ball (this game is a prototype for certain modern sports, like basketball or soccer, in which two teams play against each other with a ball that bounces);

a highly advanced astronomical science, inseparable from astrology and from the priestly caste, as in ancient Babylonia;

maritime trade centers not unlike our modern "free ports";

a worldview that combined the revolutions of the stars with the rhythms of nature in a kind of dance of the universe, an expression of the cosmic war that was, in turn, the archetypal model for ritual wars and human sacrifices on a grand scale;

an extremely severe ethico-religious system that included practices such as confession and self-mutilation;

cosmological speculation in which the notion of time played a cardinal role, with an impressive emphasis on the concepts of movement, change, and catastrophe—a cosmology that, as Jacques Soustelle has demonstrated,[1] was also a philosophy of history;

a religious pantheon ruled by the principle of metamorphosis: the universe is time, time is movement, and movement is change, a ballet of masked gods dancing the terrible pantomime of the creation and destruction of worlds and of human beings;

an art that had already aroused the amazement of Dürer before it astonished Baudelaire, one with which temperaments as different as the Surrealists and Henry Moore have identified themselves;

a poetry that combines sumptuous imagery and penetrating metaphysical insight.

The temporal continuity is no less remarkable than the spatial unity: an existence that lasted four thousand years, from the birth of the first settlements in the Neolithic period until its destruction in the sixteenth century. Mesoamerican civilization, strictly speaking, begins around 1200 B.C. with a culture that, faute de mieux, we call Olmec. We owe to the Olmecs, among other things, hieroglyphic writing, the calendar, the first advances in astronomy, monumental sculpture (the colossal Olmec heads), and the irregular carving of jade, found elsewhere only in China. The Olmecs are the common trunk bearing the great branches of Mesoamerican

[1] Jacques Soustelle, *L'univers des Aztèques*, Paris: Hermann, 1979.

civilization: Teotihuacán in the high central plateau, El Tajín in the Gulf, the Zapotecs (Monte Albán) in Oaxaca, the Mayas in Yucatan and in the lowlands of the Southeast, Guatemala, and Honduras. The high point of this Mesoamerican civilization begins around 300 A.D. and is characterized by the formation of city-states ruled by powerful theocracies. At the end of this era, barbarians descend from the North and create new states. Another era begins, a notably militaristic one. In 856, on the high central plateau, Tula is founded, in the image and likeness of Teotihuacán—the Alexandria and the Rome of Mesoamerica. In the tenth century its influence extends to Yucatan (Chichén Itzá). In Oaxaca, the Zapotecs, driven out by the Mixtecs, decline. In the Gulf: Huastecs and Totonacs. Tula falls in the twelfth century. "Warring kingdoms" once again, as in China before the Hans. The Aztecs found Mexico City–Tenochtitlán in 1325. The new capital is haunted by the specter of Tula, as Tula was by that of Teotihuacán. Mexico City–Tenochtitlán was a real imperial city, and on the arrival of Cortés in 1519 it had more than half a million inhabitants.

The history of Mesoamerica, like that of every other civilization, consists of great upheavals and rebellions, yet there were no thoroughgoing changes comparable, for instance, to the Christian transformation of the world of antiquity in Europe. The cultural archetypes remained essentially the same from the time of the Olmecs until the final collapse. Another notable and perhaps unique feature: the coexistence of an unquestionable primitivism in the technical domain—I have already pointed out that in many ways the Mesoamericans never went beyond the Neolithic—with highly developed religious conceptions and an art of great complexity and refinement. The discoveries and inventions of Mesoamerica were numerous, and among them were two that were really exceptional: the zero and positional numeration. Both had been discovered previously, and entirely independently, in India. Mesoamerica shows,

once more, that a civilization is to be measured not, or at least not solely, by its techniques of production but by its thought, its art, and its attainments in the realm of ethics and of politics.

In Mesoamerica an advanced civilization coexisted with a rural way of life not very far removed from that of the archaic villages before the urban revolution. This division is reflected in Mesoamerican art. Village artisans made objects for everyday use, ordinarily out of clay or other fragile materials, objects that charm us by their grace, their fantasy, their humor. In such objects, utility is not at odds with beauty. Also belonging to this type of art are the many magical objects that transmit that psychic energy defined by the Stoics as "universal sympathy," that vital fluid which links all animate beings—humans, animals, plants—with the elements, the planets, and the stars. The other art is that of great cultures. The religious art of theocracies and the aristocratic art of princes. Religious art was almost invariably monumental and public, aristocratic art ceremonial and lavish. Like so many other civilizations, Mesoamerica never conceived the concept of pure aesthetic experience. In other words, aesthetic pleasure, whether its source was popular and magical art or religious art, was not isolated but, rather, linked with other experiences. Beauty was not a separate value; sometimes it was conjoined with religious values and sometimes with usefulness. Art was not an end in itself but a bridge or a talisman. A bridge—the work changes the reality that we see for another: Coatlicue is the earth, the sun is a jaguar, the moon is the head of a decapitated goddess. The work of art is a medium, an agency for the transmission of forces and powers that are sacred, that are *other*. The function of art is to open for us the doors that lead to the other side of reality.

I have spoken of beauty. This is a mistake. The word that really suits Mesoamerican art is *expression*. It is an art that *speaks*, yet it says what it has to say with such concentrated energy that its speech

is always expressive. To express: to squeeze out the juice and the essence, not only of the idea but of the form as well. A Mayan deity covered with attributes and signs is not a sculpture that we are able to read like a text but, rather, a sculpture/text. A fusion of reading and contemplation, two acts that in the West are dissociated. The Great Coatlicue takes us by surprise not only because of her dimensions (two and a half meters tall and weighing two tons) but because she is a concept turned to stone. If the concept is terrifying—in order to create, the earth must devour—the expression that gives it material form is enigmatic: every attribute of the divinity—fangs, forked tongue, serpents, skulls, severed hands— is represented realistically, but the whole is an abstraction. The Coatlicue is, at one and the same time, a charade, a syllogism, and a presence that is the condensation of a *mysterium tremendum.* The realistic attributes are combined in accordance with a sacred syntax, and the resulting phrase is a metaphor that conjoins the three times—past, present, future—and the four directions. A cube of stone that is also a metaphysic. The lack of humor and the pedantry of bloodthirsty theologians is, of course, the danger of this art. (In all religions, theologians bear a close relationship to executioners.) At the same time, how not to see in this rigor a twofold loyalty to the idea and to the material in which it is made manifest: stone, clay, bone, wood, feathers, metal? The "stoniness" of Mexican sculpture, so greatly admired, is the other face of its no less admirable conceptual rigor. Fusion of matter and meaning: the stone speaks, is an idea, and the idea becomes stone.

Mesoamerican art is a logic of forms, lines, and volumes that is at the same time a cosmology. There is nothing farther removed from Greco-Roman and Renaissance naturalism, based on the representation of the human body, than the Mesoamerican conception of space and time. For the Mayan or Zapotec artist, space is fluid; it is time that has become extension, and time is solid: a block, a

cube. Moving space and frozen time: two extremes of the cosmic movement. Convergences and separations of that ballet in which the dancers are stars and gods. Movement is dance, dance is play, play is war: creation and destruction. Human beings do not occupy the center of the game, but they are the givers of blood, the precious substance that makes the world go round and the sun come up and the maize grow.

Paul Westheim points out the importance of the stepped fret, the ornamental pattern in the form of steps, a stylization of the serpent, of the zigzag effect of the bolt of lightning and of the wind that ripples the surface of the water and the waving fields of maize.[2] This same form is also the representation of the grain of maize that descends into and ascends from the earth just as the priest goes up and down the steps of the pyramid and just as the sun climbs upward in the east and plunges downward in the west. As a sign of movement, the Greek stepped fret represents the stairway of the pyramid, and the pyramid is nothing but time turned into geometry, into space. The pyramid at Tenayuca has fifty-two serpent heads: the fifty-two years of the Aztec century. The pyramid of Kukulkán at Chichén-Itzá has nine double terraces (the eighteen months of the year), while its staircases have 364 steps plus one on the top platform (the 365 days of the solar calendar). At Teotihuacán, each of the two staircases of the Pyramid of the Sun has 182 steps (364 plus one for the platform at the apex), and the temple of Quetzalcóatl has 364 serpent fangs. The pyramid at El Tajín has 364 niches and one hidden one. Marriage of space and time. Movement expressed by the geometry of stone. And human beings? They are one of the signs that universal movement traces and erases, traces and erases. . . . "The Giver of Life," according to the Aztec poem, "writes with flowers." His songs shade and

[2] *The Art of Ancient Mexico*, New York: Anchor Press, 1965.

color those who are to live. We are creatures of flesh and blood, yet as insubstantial as the colors of painted shadows: "Only in the hues you paint us in do we live, here on earth."

MEXICO CITY, *September 1, 1977*
Sábado 1, MEXICO CITY, *November 19, 1977*

Laughter and

Penitence

At dawn, a shudder runs through objects. During the night, become one with the darkness, they have lost their identity; now, not without hesitation, the light re-creates them. I already sense that that boat run aground, on the mast of which a charred parrot sways back and forth, is the couch and the lamp; that decapitated ox amid sacks of black sand is the desk; within a few moments the table will again assume the name *table*. The sun enters through the slits in the blinds of the back window. It has come from far away and is cold. It thrusts forward a glass arm, which breaks into tiny

Foreword to *Magia de la risa* (The Magic of Laughter). Texts by O. P. and Alfonso Medellín Zenil. Photographs by Francisco Berevido. Mexico City: Colección de Arte de la Universidad Veracruzana, 1962.

shards when it touches the wall. Outside, the wind scatters the clouds. The metal blinds screech like iron birds. The sun takes three more steps. It is a sparkling spider rooted to the spot in the middle of the room. I draw the curtain back. The sun does not have a body and it is everywhere. It has crossed mountains and seas, journeyed all night long, gotten lost in the city's neighborhoods. It has finally entered, and as though its own light were blinding it, it is feeling its way about the room. It is looking for something. It gropes along the walls, forces its way between the patches of red and green of the painting, climbs the staircase of books. The shelves have turned into an aviary, and each color shouts out its note. The sun goes on searching. On the third shelf, between the *Diccionario etimológico de la lengua castellana* and *La garduña de Sevilla y anzuelo de bolsas*, leaning against the freshly whitewashed wall, the ocher color of tobacco, feline eyes, its eyelids slightly swollen from its pleasant sleep, topped by a cap that accentuates the deformation of the forehead and on which a line traces a spiral that ends in a comma (there the wind wrote its true name), a dimple and two ritual incisions in each cheek, the little head laughs. The sun halts and looks at it. It laughs and looks straight back at it without blinking.

At whom or why is the little head on the third shelf laughing? It is laughing along with the sun. There is a complicity, whose nature I cannot manage to get to the bottom of, between its laughter and the light. With its eyes half-closed and its mouth half-open, sticking its tongue out just a little way, it is playing with the sun the way a bather plays with the water. Solar heat is its element. Is it laughing at human beings? It is laughing to itself, just because. It ignores our existence; it is alive and is laughing along with everything that is alive. It is laughing so as to make things germinate and so as to make tomorrow germinate. Laughing is a way of being born (the other way, our way, is to cry). If I could laugh the way

it does, without knowing why. . . . Today, a day like any other, beneath the same sun as on every other day, I am alive and I laugh. My laughter resounds in the room with the rattle of little round pebbles falling into a well. Is human laughter a fall, do we humans have a hole in our souls? I fall silent, feeling ashamed. A while later, I laugh at myself. The grotesque, convulsive sound once again. The laughter of the little head is different. The sun knows it and falls silent. It is in on the secret and doesn't tell; or else it tells in words I don't understand. I have forgotten, if at any time I ever knew it, the language of the sun.

The little head is a fragment of a clay doll found in a secondary burial ground with other idols and potsherds, in a spot in the middle of Veracruz. I have a collection of photographs of these figurines on my work table. Mine was like one of them: its face leaning slightly upward toward the sun, with an expression of unspeakable pleasure; its arms in a dance gesture, its left hand open and its right clutching a rattle in the shape of a gourd; around its neck and hanging down across its breast, a necklace of bulky stones; and clad in nothing but a narrow band of cloth over its breasts and a short skirt reaching from the waist to the knees, both the breast band and the skirt decorated with what is known as a Greek stepped fret, a border with a step design. Mine, perhaps, had another decoration, wavy lines, commas, and in the middle of the skirt, a so-called spider monkey, its tail gracefully curled and its breast opened by the priest's knife.

The little head on the third shelf is the contemporary of other disturbing creatures: big-nosed deities, with headdresses in the form of a bird flying downward; sculptures of Xipe-Tlazoltéotl, a double god, dressed as a woman, the lower part of its face covered with a mask of human skin; figures of women who died in childbirth (*cihuateteos*), armed with a shield and a wooden club; "palms" and ritual axes, in jade and other hard stones, representing a necklace

of severed hands, a face with the mask of a dog or a head of a dead warrior, its eyes closed and in its mouth the green stone of immortality; Xochiquetzal, the goddess of marriage, with a child; the earth jaguar, with a human head in its maw; Ehécatl-Quetzalcóatl, the lord of the wind, before his metamorphosis in the high central plateau, a god with a duck's beak. . . . These works, some of them terrifying and others fascinating, almost all of them admirable, belong to the Totonac culture—if we may really identify as Totonac the people who, between the first and the ninth century of our era, erected the temples of El Tajín, turned out little laughing figures by the thousands, and carved "yokes," axes, and "palms," mysterious objects about whose function or use very little is known but that, by their perfection, illuminate us with the instantaneous self-evidence of beauty.

Like their neighbors the Huastecs, a nation of conjurers and magicians who, Sahagún tells us, "did not regard lust as a sin," the Totonacs reveal a less tense and a happier vitality than that of the other Mesoamerican peoples. Perhaps that is why they created an art equidistant from Teotihuacán severity and Mayan opulence. El Tajín, unlike Teotihuacán, is not petrified movement, time stopped dead: it is dancing geometry, undulation, rhythm. The Totonacs are not always sublime, but they seldom make us sick to our stomachs, like the Mayas, or overwhelm us, like the peoples of the high plateau. Sumptuous and sober at the same time, they inherited the solidity and the economy, if not the power, of the "Olmecs." Although the line of Totonac sculpture lacks the concise energy of the artists of La Venta and Tres Zapotes, its genius is freer and more imaginative. Whereas the "Olmec" sculptor draws his works out of the stone, so to speak (or, as Westheim writes, "He does not create heads, but heads of stone"), the Totonac transforms his material into something different, sensual or fantastic, and always surprising. Two families of artists: in the one, artists

use a material; in the other, they are its servants. Sensuality and ferocity, a sense of volume and line, seriousness and a smile, Totonac art rejects the monumental, knowing that true grandeur is balance. But it is a balance in motion, a form suffused by a breath of life, as is seen in the succession of lines and undulations that give the pyramid of El Tajín an animation that is not at odds with solemnity. Those stones are alive and they dance.

Is Totonac art a branch of the "Olmec" trunk, the one that is closest and most full of life? I do not know how this question could be answered. Who were the "Olmecs," what were their real names, what language did they speak, where did they come from, and where did they go? Certain archaeologists have pointed out Teotihuacán presences at El Tajín. Medellín Zenil thinks, and his reasons are well founded, that there were also Totonac influences at Teotihuacán. And who were the builders of Teotihuacán, what were their names, where did they come from, and so on? Jiménez Moreno ventures the opinion that perhaps it was the work of Nahua-Totonac groups. . . . "Olmecs," Totonacs, Pololoca-Mazatecs, Toltecs: names. Names come and go, appear and disappear. Works remain. Amid the ruins of the temples demolished by the Chichimec or by the Spaniard, above the mountain of books and of hypotheses, the little head laughs. Its laughter is contagious. The windowpanes, the curtain, the etymological dictionary, the forgotten classic, and the avant-garde review laugh; all the objects laugh at the man bent over the sheet of paper, searching for the secret of laughter among his collection of index cards. The secret is elsewhere. In Veracruz, in the red and green darkness of El Tajín, in the sun that each morning climbs the steps of the temple. He returns to that land and learns to laugh. He looks once more at the seven streams of blood, the seven serpents that spurt out of the trunk of the figure that has been decapitated. Seven: the number of streams of blood in the relief of the pelota game at Chichén

Itzá; seven: the number of seeds in the fertility rattle; seven: the secret of laughter.

The attitude and the expression of the figurines call to mind the image of a rite. The ornaments of the headdress, Medellín Zenil emphasizes, bear out this first impression: the commas are stylizations of the monkey, the double or *nahual* of Xochipilli; the geometrical designs are variations of the sign *nahui ollín*, the moving sun; the plumed serpent, as is almost unnecessary to mention, designates Quetzalcóatl; the Greek stepped fret alludes to the serpent, the symbol of fertility. . . . Dancing creatures who appear to celebrate the sun and the sprouting vegetation, intoxicated by a transport of joy that finds expression throughout the entire range of jubilation: how not to associate them with the divinity that later, on the high central plateau, was called Xochipilli (1 Flower) and Macuilxóchitl (5 Flower)? I do not believe, however, that these are representations of the god. They are most likely figures belonging to his retinue or individuals who, in some way or other, play a role in the worship of him. Nor do they appear to me to be portraits, as has been suggested, even though the individuality of the facial features and the abundant variety of smiling expressions, in my opinion unparalleled in the entire history of the plastic arts, might well incline us to accept this hypothesis. But the portrait is a profane genre, which makes its appearance at a late date in the history of civilizations. The Totonac dolls, like the saints, demons, angels, and other representations of what we inaccurately call "popular art," are figures associated with some sort of festivity. Their function in the solar cult, to which they unquestionably belong, perhaps fluctuates between religion properly speaking and magic. I shall attempt to justify my supposition in a moment. For the time being I shall merely say that, against the background of the rites dedicated to Xochipilli, their laughter has an ambivalent resonance.

The function that causality fulfills among us is carried out among Mesoamericans by analogy. Causality is open, successive, and practically infinite: a cause produces an effect, which in turn gives rise to another. . . . Analogy or correspondence is closed and cyclical: phenomena rotate and repeat themselves as in a series of mirrors. Each image changes, becomes one with its contrary, detaches itself, forms another image, unites once again with another, and finally returns to the point of departure. Rhythm is the agent of change. The privileged expressions of change, as in poetry, are metamorphoses and, as in ritual, masks. The gods are metaphors of the rhythm of the cosmos; for each date, for each measure of the dance of time, there is a corresponding mask. Names: dates: masks: images. Xochipilli (his name on the calendar is 1 Flower), the deity of song and of dance, an infant sun who sits on a large shawl decorated with the four cardinal points, clutching a baton with a transpierced heart, is also, without ceasing to be himself, Cintéotl, the deity of sprouting maize. As though it were the rhyme of a poem, this image summons up that of Xipetótec, the god of maize but also of gold, a solar and procreative god ("our lord the flayed one" and "he who has a virile member"). A divinity that embodies the masculine principle, Xipe is coupled with Tlazoltéotl, the goddess of harvests and childbirth, of confession and steam baths, the grandmother of gods, the mother of Cintéotl. This later male deity and Xilomen, the young goddess of maize, are closely related. Both are allied with Xochiquetzal, forcibly taken away by Tezcatlipoca from the youthful Piltzintecutli—who is none other than Xochipilli. The circle closes. It is quite possible that the pantheon of the people of El Tajín, at their apogee, was less complicated than what this hasty enumeration suggests. It does not matter: the principle that ruled divine transformations was the same.

There is nothing less arbitrary than this disconcerting, dazzling succession of divinities. The metamorphoses of Xochipilli are those

of the sun. They are also those of water or those of the various phases of growth of the maize plant, and, in short, those of all the elements, which intertwine and separate in a sort of circular dance. A universe of antagonistic twins, governed by a logic as rigorous, precise, and coherent as the alternation of verses and stanzas in a poem. Except that here the rhythms and rhymes are nature and society, agriculture and war, cosmic sustenance and the food of human beings. And the sole subject of this immense poem is the death and resurrection of cosmic time. Human history turns into that of myth, and the sign that orients the lives of men and women is the same one that rules over the whole: *nahui ollín*, movement. It is poetry in action, whose final metaphor is the real sacrifice of human beings.

The laughter of the little figures begins to reveal to us all of its mad wisdom (I use these two words deliberately); they are a faint reflection of some of the ceremonies in which Xochipilli plays a part. In the first place, decapitation. This doubtless has to do with a solar rite. It appears as early as the "Olmec" era, on a stele from Tres Zapotes. Moreover, the image of the sun as a head separated from its trunk is a representation that occurs spontaneously as a trope for the human mind. (Did Apollinaire know that he was repeating an age-old metaphor when he ended one of his most famous poems with the phrase *Soleil cou coupé*—sun with its head cut off)? Some examples: the Nutall codex shows Xochiquetzal beheaded in the pelota game, and in the fiesta devoted to Xilonen, a woman, an incarnation of the maize goddess, is decapitated on the very altar of Cintéotl. Decapitation was not the only rite. A lunar goddess, an expert wielder of the bow and arrow and a hunt-ress like Diana, though less chaste, Tlazoltéotl was the patroness of the ceremony of transpiercing sacrificial victims with arrows. We know that this rite originated on the coast, in precisely the region of the Huastecs and Totonacs. It seems pointless, finally, to dwell

on the sacrifices associated with Xipe the Flayed One[1]; it seems worthwhile, though, to point out that this type of sacrifice also formed part of the worship of Xochipilli: the Magliabecchi codex represents the god of the dance and of joy dressed in a monkey skin. Hence, it is not preposterous to suppose that the figurines laugh and shake their magic rattles at the moment of the sacrifice. Their superhuman joy celebrates the union of the two facets of existence, just as the stream of blood of the decapitated victim turns into seven serpents.

The game of pelota was the scene of a rite that culminated in a sacrifice by beheading. But we run the risk of not understanding its meaning if we forget that this rite was in fact a game. In every rite there is an element of play. It might even be said that games are the root of ritual. The reason is obvious: creation is a game; by that I mean to say, the contrary of work. The gods, by essence, are gamesmen. By playing games, they create. What distinguishes gods from men is that they play and we work. The world is the cruel game of the gods and we are their toys. In every mythology the world is a creation: a gratuitous act. Humans are not necessary beings; they are not self-sustaining but, rather, dependent on an alien will: they are a creation, a game. The rite destined to preserve the continuity of the world and of human beings is an imitation of the divine game, a representation of the original creative act. The boundary between the profane and the sacred coincides with the line separating rite from work, laughter from seriousness, creation from productive tasks. All games were originally rites, and even today they follow ceremonial rules; labor destroys all ritual: when work is being done there is neither time nor space for play. In

[1] In the sacrifices associated with Xipetótec, "they killed and skinned many slaves and captives . . . and wore their skins" (Fray Bernardino de Sahagún, *Historia general de las cosas de Nueva España*, Book II).

ritual the paradox of games rules: the last shall be first, the gods make the world out of nothingness, life is earned by death. In the sphere of work there are no paradoxes: thou shalt earn thy bread by the sweat of thy brow; every man is the offspring of his works. There is an inexorable relationship between effort and its fruit: to be of profit, work must be productive; the usefulness of ritual lies in its being an immense waste of life and time meant to ensure cosmic continuity. Ritual accepts all the risks of the game, and its gains, like its losses, are incalculable. Sacrifice assumes its natural place in the logic of the game; hence it is the center and the consummation of the ceremony: there is no game unless there is a loss, and no rite unless there is an offering or a victim. The gods sacrifice themselves when they create the world, because every creation is a game.

The relationship between laughter and sacrifice goes back as far in time as ritual itself. The bloody violence of bacchanalia and saturnalia was almost invariably accompanied by screams and great bursts of laughter. Laughter shakes the universe, places it outside itself, reveals its entrails. Terrifying laughter is a divine manifestation. Like sacrifice, laughter negates work. And not only because it interrupts the task at hand but also because it questions the seriousness of that task. Laughter is a suspension and, on occasion, a loss of judgment. Hence it takes all meaning away from work and consequently from the world. In fact, work is what makes nature meaningful; it transforms nature's indifference or its hostility into a fruit, makes it productive. Work humanizes the world, and this humanization is what confers meaning on it. Laughter returns the universe to its original indifference and extraneousness: if it has a meaning at all, it is a divine one, not a human one. Through laughter the world turns into a playing field once again, a sacred precinct, not a place for work. The nihilism of laughter serves the gods. Its function is no different from that of sacrifice: to reestablish

the divinity of nature, its radical inhumanity. The world is not made for humans; the world and humans are made for the gods. Work is serious; death and laughter rip off its mask of solemnity. Through death and laughter, the world and human beings become toys once again.

Between human beings and gods there is an infinite distance. From time to time, by means of ritual and sacrifice, humans accede to the sphere of the divine—but only to fall, after an instant, back into their original contingency. Humans may resemble deities; deities never resemble us. Alien and strange, the deity is "otherness." It appears among humankind as a tremendous *mystery*, to use Otto's well-known expression. Incarnations of an inaccessible beyond, the representations of deities are terrifying. In another of my writings, however, I have attempted to distinguish between the terrifying nature of the deity and the experience, perhaps still more profound, of sacred horror.[2] The tremendous and the terrible are attributes of divine power, of its authority and proud arrogance. But the very heart of divinity is its mystery, its radical "otherness." Yet "otherness," properly speaking, produces not fear but fascination. It is a repulsive experience, or, more accurately, a revulsive one: it involves opening the entrails of the cosmos, showing that the organs of gestation are also those of destruction and that, from a certain point of view (that of divinity), life and death are the same thing. Horror is an experience that is the equivalent, in the realm of feelings, to paradox and antinomy in the realm of the mind: the god is a total presence that is an immeasurable absence. In the divine presence all presences manifest themselves, and therefore everything is present; at the same time, as though it were all a game, everything is empty. The apparition of divinity shows the

[2] *El arco y la lira*, Mexico City, 1956, pp. 123–131. (American ed.: *The Bow and the Lyre*, trans. Ruth L. C. Simms, Austin: University of Texas Press, 1973.)

obverse and the reverse side of being. Coatlicue is what is too full, overflowing with all the attributes of existence, a presence in which the totality of the universe is concentrated; and this plethora of symbols, meanings, and signs is also an abyss, the great maternal mouth of the void. To rob the Mexican gods of their awesome and horrible nature, as our art criticism sometimes tries to do, is tantamount to subjecting them to a double amputation: as creations of the religious genius and as works of art. Every divinity is tremendous, every god is a source of horror. And the gods of the ancient Mexicans possess a charge of sacred energy that can be adequately described only as fulminating. That is why they fascinate us.

A tremendous presence, the god is inaccessible; a fascinating mystery, he is unknowable. But attributes fuse in his impassivity. (*Passion* appertains to gods who take on human form, as Christ did.) The gods are beyond the seriousness of work, and therefore their activity is play; but the game they play is an impassive one. The Greek gods of the archaic period smile, to be sure; their smile is the expression of their indifference. They are in on the secret: they know that the world, human beings, and they themselves are nothing save figures of Fate; for the Greek gods, good and evil, death and life are mere words. The smile is the sign of their impassivity, the indication of their infinite distance from human beings. They smile: nothing changes them. We do not know whether the gods of Mexico are laughing or smiling: their faces are covered by a mask. The function of the mask is twofold: like a fan, the mask both hides and reveals the divinity. In other words: it hides the deity's essence and manifests his terrible attributes. In both ways it places an unbridgeable distance between human beings and the deity. In the game of impassive divinities, what place does laughter have?

The little Totonac figures laugh in broad daylight and with their faces uncovered. We find in them none of the divine attributes. They are not a tremendous mystery, nor does an all-powerful will animate them; neither do they possess the ambiguous fascination of supernatural horror. They live in the atmosphere of the divine but they are not gods. They do not resemble the deities they serve, even though one and the same hand has fashioned them. They are present at the gods' sacrifices and participate in their ceremonies as survivors of another age. But even though they do not look like the gods, they bear an obvious family resemblance to the little female statues of the "preclassic" period of the central region of Mexico and other places. I mean to say not that they are those statues' descendants but that they live in what is almost the same psychic ambience as do the innumerable representations of fecundity in the Mediterranean area and, also, as do so many objects of "popular art." This mixture of realism and myth, of humor and innocent sensuality also explains the variety of expressions and facial features. Though they are not portraits, they are indicative of a very alert and keen observation of the mobility of the face, a *familiarity* almost always absent in religious art. Do we not find the same spirit in many of the creations of our contemporary craftsmen? The figurines belong, spiritually, to an era predating the great religious rituals—before the indifferent smile and the terrifying mask, before the separation of gods and human beings. They come from a world of magic ruled by the belief in the communication and the transformation of beings and things.[3]

Talismans, amulets of metamorphosis, the smiling terra-cotta figures tell us that everything is animate and that everyone is every-

[3] I do not mean to say that magic literally antedates religion, as Frazer believed. In every religion there are magic elements, and vice versa. Nonetheless, the magic attitude, from the psychological point of view, is the basis of the religious attitude, and in this sense it is prior to it.

thing. A single energy animates the whole of creation. Whereas magic affirms the fraternity of all things and creatures, religions separate the world into two parts: creators and their creation. In the world of magic, communication and, consequently, metamorphosis are attained through procedures such as imitation and contagion. It is not hard to discover in the little Totonac figures an echo of these magic recipes. Their laughter is communicative and contagious; it is an invitation to *general animation*, a summons tending to reestablish the circulation of the breath of life. The rattle contains seeds inside, which, as they collide with each other, imitate the sounds of rain and storm. The analogy with the *tlaloques* and their vessels leaps to the eye: it would not be beyond the realm of probability that there exists a more precise relationship between the little statues and Tlaloc, one of the most ancient divinities of Mesoamerica. And not only that: "The number seven," Alfonso Caso says, "stands for seeds." It was an auspicious number. I believe that here it evokes the idea of fertility and abundance. Between the tense seriousness of work and divine impassivity, the figurines reveal to us an even older realm: magic laughter.

Laughter predates the gods. On occasion, the gods laugh. Be it derision, threat, or delirium, their stentorian laughter petrifies us with fear: it sets creation in motion or rends it to bits. At other times, their laughter is the echo of or the nostalgia for the unity that has been lost, namely, that of the magic world. To tempt the sun goddess, hidden in a cave, the goddess Uzamé "bared her breasts, raised her skirts, and danced. The gods began to laugh, and their laughter made the pillars of heaven tremble." The dance of the Japanese goddess obliges the sun to come out. In the beginning was laughter; the world begins with an indecent dance and a guffaw. Cosmic laughter is puerile laughter. Today only children laugh in a way that recalls the little Totonac figures. Laughter of the first day, wild laughter and still close to the first tears: accord

with the world, dialogue without words, pleasure. To pick the fruit, it suffices to reach out one's hand; to make the whole universe laugh, it suffices to break into laughter. Restoration of the unity between the world and humankind, childish laughter also announces their clear separation. Children play at looking each other straight in the eye: the one who laughs first loses the game. Laughter has its price. It has ceased to be contagious. The world has become deaf, and from now on it can be subdued only with effort or with sacrifice, with work or with ritual.

As the sphere of work grows broader, that of laughter shrinks. To become human is to learn to work, to turn serious and sedate. But work, by humanizing nature, dehumanizes men and women. Work literally dispossesses humankind of its humanity. And not only because it turns the worker into a wage earner but also because human beings' lives become one with their livelihood. Wage slaves become one with their implements; they are branded by their tools. And all work tools are serious. Work devours the being of the human individual; his or her face becomes immobile, unable either to laugh or to cry. Human beings, it is true, are human thanks to work; it is necessary to add that they become fully so only when they free themselves from labor or transmute it into a creative game. Until the modern era, which has made of work a sort of religion without rites but with sacrifices, the superior life was the contemplative one; and in our own day the rebellion of art (possibly illusory, and in any event aleatory) lies in its gratuitousness, an echo of the ritual game. Work consummates the victory of humankind over nature and the gods; at the same time, it uproots human beings from their native soil, dries up the fountain of their humanity. The word *pleasure* has no place in the vocabulary of work. And pleasure is one of the keys of being human: nostalgia for the original unity and a sign pointing to the reconciliation with the world and with ourselves.

If work requires the elimination of laughter, ritual freezes it into a convulsive grin. In their play, the gods create the world; when they repeat this game, human beings dance and laugh, laugh and shed blood. Rite is a game that demands victims. It is not strange that the word *dance*, among the Aztecs, also signified *penitence*. Rejoicing that is penance, a fiesta that is suffering, the ambivalence of ritual reaches its high point in sacrifice. A superhuman bliss illuminates the face of the victim. The enraptured expression of the martyrs of all religions never ceases to surprise me. Psychologists offer us, to no avail, their ingenious explanations, valid until a new hypothesis turns up: something still remains to be said.[4] Something inexpressible. That ecstatic joy is as unfathomable as the grimace of erotic pleasure. Unlike the contagious laughter of the Totonac figurines, the sight of the victim arouses our horror and our fascination. It is an intolerable spectacle, and nonetheless one from which we cannot wrest our eyes. It attracts and repels us and in both ways it creates an insurmountable distance between the victim and ourselves. And yet, isn't that face which contracts and distends until it freezes in an expression that is at once penitence and rejoicing the hieroglyph of the original unity, in which everything was one and the same? That expression is not the negation of laughter but its reverse side.

"Happiness is one," Baudelaire says; by contrast, "laughter is double or contradictory; hence it is convulsive."[5] And in another passage in the same essay: "In the earthly paradise (whether it lies in the past or is yet to come, a memory or a prophecy, depending on whether we imagine it as theologians or as Socialists) . . . hap-

[4] A recent hypothesis attributes the expression of ecstatic bliss of many of the little figures to the effects of a drug ingested before the sacrifice.

[5] *Curiosités esthétiques: De l'essence du rire et généralement du comique dans les arts plastiques* (1855). (Aesthetic Curiosities: On the Essence of Laughter and the Comic in General in the Plastic Arts.)

piness is *not* a part of laughter." If happiness is one, how could the laughter of paradise be excluded? I find the answer in these lines: laughter is satanic and "is associated with the accident of the fall of long, long ago . . . laughter and pain are expressed by the organs where the rule and the knowledge of good and evil reside: the eyes and the mouth." So then, in paradise no one laughs, because no one suffers? Can happiness be a neutral state, beatitude born of indifference, and not that supreme degree of felicity attained only by blessed souls and the innocent? No. Baudelaire says that the happiness of paradise is not human and that it transcends the categories of our understanding. Unlike this happiness, laughter is neither divine nor holy: it is a human attribute and therefore resides in those organs that, from the beginning, have been regarded as the seat of free will: the eyes, mirrors of vision and origin of knowledge, and the mouth, the servant of the Word and of judgment. Laughter is one of the manifestations of human freedom, lying between divine impassivity and the irremediable gravity of animals. And it is satanic because it is one of the marks of the breaking of the pact between God and his creatures.

Baudelaire's laughter is inseparable from sadness. It is not childish laughter but what he himself calls "the comic." It is the modern laugh, the human laugh par excellence. It is the one we hear every day as defiance or resignation, vainglorious or desperate. This laughter is also what has given Western art, for several centuries now, some of its boldest and most impressive works. It is caricature and, likewise, it is Goya and Daumier, Brueghel and Hieronymus Bosch, Picabia and Picasso, Marcel Duchamp and Max Ernst. . . . Among us it is José Guadalupe Posada and, at times, the best Orozco and the most direct and fierce Tamayo. Age-old laughter, the revelation of cosmic unity, is a secret lost to us. We catch glimpses of what it must have been when we contemplate our figurines, the phallic laughter of certain African sculptures, and so

many other unusual, archaic, or remote objects, which had just barely begun to penetrate the Western conscience when Baudelaire was writing his reflections. Through these works we intuit that happiness was indeed one and that it embraced many things that later appeared to be grotesque, brutal, or diabolical: the obscene dance of Uzumé (the Japanese call it "the monkey dance"), the scream of the bacchante, the funeral chant of the Pygmy, the winged phallus of the Roman. . . . Happiness is a unity that does not exclude a single element. The Christian conscience drove laughter out of paradise and transformed it into a satanic attribute. Since then it has been the sign of the underworld and its powers. Only a few centuries ago it played a cardinal role in witch trials, as a symptom of demoniacal possession; co-opted today by science, it is hysteria, a psychic disorder, an anomaly. And yet, be it a sickness or a mark of the devil, age-old laughter has not lost its power. Its contagion is irresistible, and it is for that reason that those who "are stricken with mad laughter" must be isolated.

Laughter unites; the "comic" accentuates our separation. We laugh at others or at ourselves, and in both cases, Baudelaire points out, we affirm that we are different from what provokes our laughter. An expression of our distance from the world and from others, modern laughter is above all else the emblem of our duality: if we laugh at ourselves it is because there are two of us. Our laughter is negative. It could not be otherwise, since it is a manifestation of the modern conscience, the divided conscience. If it affirms this, it denies that; it does not assent (you are like me), it dissents (you are different). In its most direct forms—satire, derision or caricature—it is polemical: it accuses, it puts its finger on the sore spot; the sustenance of the loftiest poetry, it is laughter gnawed away by reflection: Romantic irony, black humor, blasphemy, grotesque epic (from Cervantes to Joyce); as thought, it is the only critical philosophy because it is the only one that truly destroys

values. The knowledge of the modern conscience is a knowledge of separation. The method of critical thought is negative: it tends to distinguish one thing from another; to do so successfully, it must show that this is *not* that. As the scope of the meditation becomes broader, the negation grows: thought places reality, knowledge, truth in question. Turned back on itself, it cross-questions itself and places consciousness under interdict. There is a moment when reflection, on reflecting itself in the purity of consciousness, denies itself. Born of a negation of the absolute, it ends in an absolute negation. Laughter accompanies consciousness on all of its adventures: if thought thinks itself, it laughs at laughter; if it thinks the unthinkable, it dies laughing. Refutation of the universe by way of laughter.

Laughter is the beyond of philosophy. The world began with a great burst of laughter and is ending with another. But the laughter of the Japanese gods, at the heart of creation, is not the same as that of the solitary Nietzsche, already free of nature, "a mind that plays innocently, that is to say, unintentionally, out of an excess of strength and fecundity, with everything that up until now has been called the holy, the good, the intangible and the divine . . ." (*Ecce Homo*). Innocence does not lie in the ignorance of values and ends but lies in knowing that values do not exist and that the universe keeps going to no intent or purpose. The innocence Nietzsche sought is the awareness of nihilism. Confronted with the dizzying vision of the void, a unique spectacle, laughter is also the only possible response. When it arrives at this farthermost point (beyond it, all there is is nothingness), Western thought examines itself before dissolving in its own transparency. It does not judge itself or condemn itself: it laughs. Laughter is a theorem of that atheology of totality that kept Georges Bataille awake at night. A theorem that, by its very nature, is not fundamental but ridiculous: it is not a foundation of anything, because it is unfathomable and

everything falls into it without ever touching bottom. "Who will laugh till he dies?" Bataille asks himself. Everyone and no one. The rational, Stoic formula of antiquity was to laugh at death. But if, as we laugh, we are dying: is it us laughing or is it death?

The sun isn't leaving. It is still stubbornly insisting on staying in the room. What time is it? One numeral more or one less moves my hour, the hour of my definite loss, ahead or back. Because I am lost in infinite time, which did not have a beginning and will not have an end. The sun lives in another time, it is another time, finite and immortal (finite: it runs out, it gets used up; immortal: it is born, reborn with the childish laughter and the stream of blood). Beheaded sun, flayed sun, sun in the flesh, sun that is a youngster and an oldster, sun that is in on the secret of true laughter, that of the little head on the third shelf. In order to laugh that way, after a thousand years, it has to be utterly alive or completely dead. Is it only skulls that laugh perpetually? No: the little head is alive and laughing. Only living beings laugh like that. I look at it again: on its headdress a line traces a spiral that ends in a comma. There the wind has written its true name: I call myself liana twined around trees, monkey who hangs over the dark green abyss; I call myself ax to split open the breast of the sky, column of smoke that opens the heart of the cloud; I call myself sea snail and labyrinth of wind, whirlwind and crossroad; I call myself nest of serpents, sheaf of centuries, reunion and dispersion of the four colors and the four ages; I call myself night and I give off light like flint; I call myself day and pluck out eyes like the eagle; I call myself jaguar and I call myself ear of maize. Each mask, a name; each name, a date. I call myself time and shake a clay rattle with seven seeds inside.

PARIS, *February 4, 1962*

Puertas al campo

Reflections of
an Intruder

Since my adolescence I have had a fascination with the civilization of ancient Mexico. Fascination in every sense of the word: attraction, repulsion, bewitchment. On a number of occasions, not without fear, I have dared to write about that world and its works, or, more precisely, about that world of works, almost always enigmatic and frequently admirable. Naturally, my reflections on the art of Mesoamerica have been marginal notes, the individual reflections of a writer, not the judgments of a specialist. However, in those writings I have always tried to abide by the rules of modern historians, even when their classifications and nomenclatures impressed me as being too general or vague and confused. For example, to apply the term *classic* to the period of the apogee of Mesoamerican civilization, between the second and the tenth cen-

tury A.D., implies a certain disdain for the different meanings that this term has had and still has in the history of the arts. I agree that the style of Teotihuacán might be called *classic*, if we force the meaning of the word a bit, but can its contemporary, Mayan art, be called lascivious and delirious? I have the same reservations about the expression *Western culture* to designate that of the quite crude peoples of the west of Mexico. Not only words but concepts have given rise to doubts on my part. I have never believed that the ruling regimes in the societies of the so-called classical period were really *theocracies*. I set even less store by the theory that those "theocracies" were peaceful. On this latter point, I have concurred with the opinion of a number of specialists in Mexican history—Caso, Toscano, Westheim—who did not share, especially following the discovery of the frescoes of Bonampak, in 1946, the ideas of Thompson, Morley, and others as to the peaceful nature of the Mayan "theocracies." The same might be said for Teotihuacán, an imperialist city, as Ignacio Bernal calls it in a brilliant essay on the subject.[1]

The first of my essays and notes were written more than twenty years ago, and the most recent in 1977. Since then, studies in Mayan epigraphy and iconography have gradually modified our view of that world. Although in the central zones, Veracruz and Oaxaca, the changes have not been as radical, it is impossible to dismiss the field research of Dillon and Sanders in Teotihuacán, Matos in the Main Temple of Mexico City, and Nigel Davies's in Tula. Davies is the author of penetrating essays on the end of Toltec society and the ideas that people had of their own past, a curious combination of myth and history, circular time and linear time. Among all these research projects—and still others that for brevity's sake I shall not mention—those having to do with the Mayan area

[1] "Teotihuacan," *Plural*, nos. 21, 22, and 23 (June, July, and August 1973).

have been, as I have already said, the ones of greatest significance. This dazzling series of discoveries has culminated in the recent extraordinary exhibit of Mayan dynastic and ritual art organized by Linda Schele and Mary Ellen Miller in Fort Worth, under the auspices of the Kimball Museum. Schele and Miller are also the authors of *The Blood of Kings: Dynasty and Ritual in Maya Art* (1986), a work notable both for the text and for the illustrations and drawings that accompany it.

The amazing decipherment of Mayan writing, a task that is not yet ended, makes us see with new eyes more than a thousand years of the history of that people. The first and most remarkable surprise: the Mayas were not absorbed only in studying the movements of the stars and the planets in the sky, as was still thought only some fifteen years ago; their inscriptions and reliefs also relate the histories of the rise, the battles, the victories, the ceremonies, and the deaths of a great number of kings, among them the great Pacal, who ruled Palenque for almost seventy years (615–683). The first step was taken by the Russian linguist Ruri V. Knorosov, who had "the audacity to revive the discredited 'alphabet' that had been left us by Fray Diego de Landa."[2] Although Knorosov failed in his attempts at decipherment, his hypothesis was basically correct: Mayan writing, like Japanese, combines ideograms and phonetic signs. Certain researchers took up this hypothesis, and in 1958 Heinrich Berlin, in his analysis of Pacal's sarcophagus, in the Temple of Inscriptions at Palenque, showed that the glyphs referred to the figures that decorate the great stone. In 1960 Tatiana Proskousiakoff of Harvard University asserted that Mayan inscriptions were primarily historical. In the following decade, "the reconstruction, complete or partial, of the dynastic history of various Mayan

[2] Michael D. Coe, preface to *The Blood of Kings*.

cities became possible . . . and at Palenque, for instance, twelve royal generations have been reconstructed."[3]

The history of these investigations and discoveries has been extremely impressive and varied, but I do not have the space to examine it here. The reader can find more detailed information in Coen's preface to *The Blood of Kings* and in the final chapter of that book, entitled "The Hieroglyphic Writing System." In the final analysis, it must be said that we are still a long way from a complete understanding of Mayan writing. It has been possible to read many inscriptions because they appear in reliefs, steles, and vase paintings alongside representations of scenes in which several individuals participate. The function of the inscriptions is analogous to that of the captions and titles at the bottoms of photographs or prints. The iconographic representation is, invariably, the subject of the inscription. Because of their very function, the texts are extremely simple, although fairly often the fondness of Mayan scribes for wordplay makes a literal understanding of the glyphs difficult. The authors of *The Blood of Kings* confess that the "texts that are not accompanied by an image directly related to the subject of them are not decipherable."

The main consequence of these discoveries has been the disappearance of the hypothesis of "peaceful theocracies." In its place there appears a world of city-states waging continual war against others and ruled by kings who proclaim themselves of divine blood. The object of these wars was not the annexation of territory but the levying of tribute and the capture of prisoners. War was the duty and the privilege of kings and the military nobility. The prisoners belonged to that class, and their final fate was sacrifice, either at the top of the pyramid or in a game of pelota, which was not so much a game, in the modern connotation of the word, as a

[3] *The Blood of Kings.*

ritual ceremony that almost always ended in sacrifice by decapi-
tation, as can be seen in the relief at Chichén Itzá and at other
sites, both inside and outside the Mayan area. (The striking relief
of the game of pelota at El Tajín is a notable example.) The rite,
common to all of Mesoamerica, could be likened, at first glance,
to the Roman gladiatorial sacrifice. There is an essential difference,
however: the latter was profane, whereas the sacrifice in the game
of pelota was a ritual that had its place within the religious logic
of the "floral war." The Mayan city-states and the armed strife
between them are reminiscent of the Greek cities, of the Warring
Kingdoms of ancient China, of the medieval monarchies at the end
of the Middle Ages, and of the republics and principalities of Italy
in the Renaissance. Unlike what happened elsewhere, however,
all those centuries of wars did not lead to the constitution of a
hegemonic state or a universal empire. Mayan history is by nature
at once hallucinatory and circular.

Schele and Miller emphasize the central function of the insti-
tution of monarchy among the Mayas and the dynastic nature of
their history. In fact, most of the inscriptions refer to the deeds of
sovereigns; likewise, many of the figures that appear in the reliefs
of monuments and on the steles are stylized representations of
kings, their wives, and their retinues. This dynastic art is akin to
that of the pharaohs of Egypt and to that of the rajas of ancient
Kampuchea. It also calls to mind that of the absolute monarchs of
Europe, such as the Sun King of France in the seventeenth century.
Was Palenque Pacal's Versailles? Yes and no. Mayan cities were
something more than residences of the king and his court. The
very word *monarchy* admittedly implies a court; the Mayan kings
were the focal point of a refined and aristocratic society made up
of high dignitaries, their wives, and their kin. These courtiers were
unquestionably warriors: this is a trait common to all monarchies
in history. Another feature that appears in this type of society: the

existence of military and semi-priestly confraternities whose members belonged to the aristocracy. The admirable frescoes of the fortress-sanctuary of Cacaxtla, obviously the handiwork of Mayas, are representations of the two military orders, the order of the jaguar warriors and that of the eagles. The continuous presence of representations of these two orders in different places and on monuments belonging to different eras is a sign that we are dealing with a permanent and, so to speak, constitutive element of Mesoamerican societies.

Once we accept the view of the Mayan world that the new historians offer us, we must give it the proper shadings and nuances of color. The purely dynastic and warlike conception has obvious limitations. Carried away by their legitimate enthusiasm as discoverers, Schele and Miller sometimes minimize, in certain passages of their remarkable and revolutionary book, certain traits of Mayan culture that in my view are no less characteristic. Their portrait of the Mayan world is, at times, an upside-down image of that of Thompson and Morley, for whom the true Mayan history was that of the sky overhead; here below, under the rule of the "peaceful theocracies," nothing happened. In the new conception, history descends from heaven and returns to earth: many things happen here below. The trouble is that they always turn out to be the same thing: kings who ascend to the throne, wage wars, conquer or are conquered, die. In this way, one generalization is replaced by another. Allow me to explain: the image that Schele and Miller present us with is authentic, but it covers over more complicated realities. The very subtitle of their book, moreover, says as much: *dynasty and ritual* in Maya art. The dynastic element is interjected into ritual; ritual, in turn, originates in a cosmogony: it is its symbolic representation.

Until a very short time ago it was believed that Mesoamerican cities were not really cities but ceremonial centers inhabited solely

by priests and a small number of bureaucrats. We now know that they were real cities, that is to say, centers of economic, political, military, and religious activity. One of the most noteworthy discoveries of recent years is that of the existence of an intensive agriculture, without which the survival of urban centers is impossible. Apart from agriculture: craftwork and trade. René Dillon's research in Teotihuacán has shown that that great city was a commercial and manufacturing center of the first order. In Teotihuacán there were whole districts of foreigners: artisans and craftsmen whose products, from pottery to weapons and carved precious stones, were distributed throughout Mesoamerica. Teotihuacán is not unique: the great urban centers of Mesoamerica were also centers of craftwork on a grand scale and of the international distribution of those products.

Trade requires the existence of a class, tradesmen, specialized in that activity. International trade, in turn, is indistinguishable from the foreign policy of a nation. Finally, international politics and war are two manifestations of the same phenomenon, the two arms of the state as it thrusts itself outward. Not only is there a close relationship between the class of warriors and that of tradesmen but often there is a fusion between them. The activity of tradesmen, like that of warriors, is oriented outward, though not to wage war on the outsider and dominate him but to trade with him. In Tenochtitlán tradesmen formed a class apart, and their activities included espionage. The figure of the courtier splits down the middle into that of the warrior and that of the tradesman.

For the Mesoamerican peoples, trade and war were inseparable from religion. It is impossible not to note the crucial role of rites in the activities of warriors and tradesmen. A warrior or a tradesman was not only a social category but a religious one as well. To understand the social function of warriors and tradesmen one must

inquire into the rites that were associated with those professions. Rites are manifestations of myths, and myths are expressions of cosmogonies. What we know about Mesoamerican religions allows us to say that, despite the diversity of names of the gods and other differences (the unusual place of Huitzilopochtli in the Aztec pantheon, for instance), all these religions are variations of the same cosmogonic myths and the same theology. The religious background common to all the Mesoamerican peoples is a basic myth: the gods sacrificed themselves to create the world; the mission of men is to preserve universal life, including their own, by feeding the gods with the divine substance: blood. This myth explains the central place of sacrifice in Mesoamerican civilization. War is therefore not only a political and economic dimension of the city-states but a religious dimension as well. War and trade are a politics and, at the same time, a ritual.

The triangle stands revealed: tradesmen, warriors, and priests. In the center: the monarch. The king is a warrior, a priest, and, at certain moments in the rite, he is a divinity. In the essay cited above, Bernal says that "in Tula and in Tenochtitlán there was a continual symbiosis between the chieftain, the priest, and the warrior." I need hardly remind the reader that the Mexican *tlatoanis* were not only the military and civilian chiefs of Tenochtitlán but also its high priests. Linda Schele, for her part, points out that the Mayan kings always appear with the attributes and signs of divinities. To sum up: the city led us to trade, trade to politics and war, war to religion, religion to sacrifice. In the Mesoamerican myth of creation the twofold nature of sacrifice appears with perfect clarity: to create the world, the gods shed their blood; to keep the world in existence, men must shed their blood, which is the food of the gods. The figure of the monarch-god is the visible manifestation of the dual nature of the sacrifice: the king is a warrior (he sacrifices prisoners) and he is a god (he sheds his own blood). The sacrifice

of others takes place in the "floral war"; self-sacrifice, in the ascetic practices of monarchs.

Mayan art has expressed in unforgettable works—reliefs, frescoes, paintings, drawings, and incisions carved in jade, bone, and other materials—the two forms of sacrifice. The chivalrous-warrior manifestation appears with extraordinary power in numerous reliefs and, in particular—at least for a modern imagination and sensibility—in the frescoes of Cacaxtla. This fortress-sanctuary, firmly implanted a long way from the Mayan area, reminds me of the commanderies of the Templars in the Near East: buildings at once military and religious, convents that are strongholds surrounded by enemies, and castles inhabited by aristocratic brotherhoods of warrior-priests. In Cacaxtla two murals, one facing the other, offer us representations, in vivid colors and perfect though overly decorative draftsmanship, the deities of the two military orders, the eagle and the jaguar. In the central esplanade there is a vast fresco—partially damaged—whose subject is a battle. The whole brings to mind certain compositions by Uccello, both because of the rhythm and the disposition of the figures and because of the play of complementary oppositions of colors, lines, and forms. The splendor of the garments of the combatants, the bright glint of lances, shields, wooden swords with flint edges and arrows: the battle is reminiscent of the pomp of the tourneys of the florid Gothic. Ballet of forms and vivid colors, a hallucinatory and hideous dance, blue-green plumes waving, pools of blood, disemboweled men, faces bashed to pieces. The fresco glorifies the "floral war" and its lugubrious harvest of flowers: the hearts of the prisoners. The medieval tourney was a courtly ceremony, erotic and cruel; the battle of Cacaxtla is the representation of a terrifying rite, a drama that ends in the sacrifice of the captives.

The other aspect of the sacrifice is no less impressive: the ascetic

and penitential practices of the kings and their consorts. The monarchs were of divine blood; hence, in certain ceremonies, as is only to be expected, they shed their own blood. The rite repeated the myth of the creation of the universe and, *by reproducing it*, ensured the continuity of life. The blood of the prince and that of his consort gave new vitality to social ties, made the earth more fertile and victory over the enemy a certainty. In Kampuchea the worship of the lingam (the virile member) of the god Shiva was identified with the person of the king: the monarch *was* the divine lingam. Among the Mayas, the blood of the monarch was the blood of the gods: therefore he was obliged to shed it. Self-sacrifice was the privilege of the monarch and his consorts but was also extended to the priest class and the nobility: there are a number of representations of high dignitaries practicing the bloody rite. Sacrifice was, literally, a sacrament: hence it is not surprising that the instruments used to carry it out (lancets, usually the spines of stingrays) were deified. The incisions and perforations could be made anywhere on the body, but especially in three areas: the earlobes, women's tongues, and men's penises (prepuces).[4] The Mayan kings, their wives, and their courtiers perforated and lacerated their bodies with the sacred lancets. The blood was collected in vessels that were also sacred and that contained bits of paper that were burned during the sacrifice. Union of blood and fire.

The ceremonies were both private and public. The former were celebrated inside the temples and in the secrecy of the royal chambers, attended perhaps by a limited number of priests and courtiers. One of the reliefs from Yaxchilán (Lintel 24, British Museum, London) is a stylized portrait of the king Jaguar Shield and his

[4] The anatomy and physiology of the Mayas, no doubt magical and symbolic, that are associated with cosmogonic myths have scarcely been studied. The historian López Austin has carried out valuable research in the Nahua area.

consort, Lady Xoc. The king's attire is that of penitents: his head is covered with a plumed panache, and he is carrying on his back the shrunken head of a sacrificed victim. The king is clutching an enormous torch, doubtless because the ceremony was held at night or in an underground chamber. The torch sheds light on a strange scene: Queen Xoc is kneeling, dressed elaborately: a diadem, a magnificent sleeveless blouse with geometric designs, earrings, necklaces, bangles. Her eyes are filled with devotion and she is pulling through her perforated tongue a long cord with thorns. The cord falls into a basket containing blood-soaked paper. The glyphs indicate the date of the ceremony (October 28, 709), the names of the penitents, and the ritual ceremony of taking blood from one's own body.

In another relief we see Jaguar Bird, the son of Jaguar Shield, practicing the same rite. He is accompanied by his *cahal*, that is to say, the governor of a dependent territory. The king is sumptuously dressed, and he bears on his back, as a decoration, a mask of his father, Jaguar Shield. The monarch's penis, covered by a divinized lancet that ends in a feathered panache, is dripping blood that Jaguar Bird is sprinkling about with his hands, and the drops are falling into a basket that contains paper that will later be burned. This ceremony may have taken place in public in an unenclosed space. Let us imagine the scene: the sun, the pure blue, cloudless sky, the lofty pyramids painted in vivid ritual colors, the crowd, the snow-white shawls and the bright-hued panaches, the music and the dancers, the feathered headdresses and the braziers of copal, the nobles and the priests. Among these last two, many had gone through a period of fasts, privations, and loss of blood in ceremonies analogous to those that I have described. At exactly the right moment, at the auspicious hour, the king and queen, chosen because of the favorable conjunction of the stars and the planets, make their appearance. Clad in ritual garments that reveal

their divine nature, they stand stock-still in the middle of the tall platform, and "in full view of everyone, he lacerates his penis and she her tongue." The blood soaks long strips of paper that the acolytes collect in vessels and braziers. The fire and the blood, set aflame and turned into a column of smoke, ascend heavenward. The participants, Linda Schele says, were prepared psychologically and physiologically—fasts, bloodlettings, faith, enthusiasm, terror—so that they would experience a visionary trance.

The ritual bloodlettings had a dual purpose: to ensure the continuity of life through a ritual that was the symbolic reproduction of the divine creation and to bring about a vision of the other world. It is a well-known fact that a considerable loss of blood produces chemical and psychic reactions conducive to hallucinatory experience. Furthermore, the Mayas used drugs and had recourse to enemas to bring on visionary states.

Although Mayan art has left numerous representations of these experiences, it is only today that we have a fairly clear understanding of their meaning. This is, beyond question, one of the greatest merits of Schele and Miller. One relief from Yaxchilán (Lintel 25, British Museum, London) that belongs to the Jaguar Shield series, shows the same Queen Xoc in a trance (October 24, 681). She is again kneeling, dressed in a *huipil* and crowned with a diadem covered with symbols. As ornaments she is wearing a long jade necklace, a pectoral of the sun god, and other adornments. With her left hand she is holding a sacramental dish with blood-soaked paper and two lancets; her right hand is extended in the gesture of making an offering. At her feet, as usual, is the basket with bloodstained bits of paper, the lancets of the self-sacrifice, and the cord with sharp thorns. From the basket there rises a fantastic two-headed serpent that writhes in the air. The blood turned to fire and the fire turned to smoke have turned into a vision. Xoc looks upward: between the enormous jaws of the serpent a warrior with

the attributes of Tlaloc appears, equipped with a shield and armed with a lance, which he aims at the queen. Is the warrior a forefather or a god? Perhaps both: Xoc was of divine blood. The god that visits her is the spirit of one of her ancestors.

The vision of the fantastic serpent appears in reliefs and on steles, vase paintings, and other objects. Among all these works is one that is admirable: a conch shell. By means of incised marks and designs, the artist has given the shell the form of a human head that represents the god who announces the appearance of the divine serpent. The object may be called, without exaggeration, the sculpture of a scream; what I mean to say is that the scream, instead of vanishing in the air, is embodied in a human face. In a fold of the conch shell there are several intertwined lines that form an extremely refined design. Seen from one angle, the lines go to make up the figure of a young hero, seated on a cushion that serves him as a throne, and, opposite him, the sign of the lunar goddess. Seen from the opposite angle, the lines form another figure: a young man who is embracing a fantastic serpent, his head uplifted, await-ing the apparition that will materialize through the jaws of the prodigious reptile. The young hero is none other than Hun-Ahu, one of the divine twins of the *Popul Vuh*, the book preserving the history and tradition of the Quiché, a Mayan people. Here the divine rite repeats the human one: the gods too lacerate their bodies and invoke the serpent that brings visions. The image of the serpent is repeated with obsessive frequency: the visions do not come forth from individual imagination but have been codified into a ritual. Unlike our dreams and visions, they are the expression of collective beliefs. The serpent is a true archetype. A channel of communi-cation between the world of humans and the infernal world, gods and ancestors appear between its jaws.

Mayan art astonishes me in two ways. In the first place, by its realism, or to be more precise, by its literalness: the images it

presents us can *be read*. They are not illustrations for a text: they are the text itself. Contrary to those of modern art, they are not merely images: they are image-signs. By grouping them together and placing them in a certain order, the artist presents us with a text. This literalness refers, on a primary level, to subjects that have to do with realistic, often historical events: battles, processions of captives, sacrifices, scenes from a game of pelota, or episodes drawn from daily life, some of them tender and affectionate, others savage, and still others comic. But this literalness also extends to the supernatural world and to the syntax of symbols, that is to say, to the forms in which these latter combine so as to create wholes that are real discourses and allegories. For instance, on seeing the trimphant dance of King Chan-Bahlún in the underworld, *we read* that he has vanquished the gods of death and that he will ascend to the world above; the same operation, at one and the same time intellectual and perceived by the senses, takes place once again before Pacal's tombstone, though here the symbols are far more complex; in the same way, when we contemplate the ceremony of Queen Xoc, we read her vision of the serpent and hear, figuratively, the message of her divine ancestor.

The other way, less frequent but more completely and intensely, that Mayan art amazes me lies in its transformation of literal realism into an object that is a metaphor, a palpable symbol. Image-signs, without ceasing to be signs, become altogether one with the forms that express them and even with the material itself. Nuptials of the real and the symbolic in a single object. The conch shell that I mentioned is a notable example. Its practical function is to be a trumpet, probably used in a self-sacrifice ceremony. But the conch-shell trumpet turns into a god, the god into a scream, and the scream into a face. Not only are we offered the crystallization of an idea in a material object, but the fusion of the two is a genuine metaphor, not a verbal but a sensory one. The idea is

transformed into matter: a form that, when we touch it, turns into a thought, a thought that we can stroke and make resound.

The fusion between the literal and the symbolic, matter and idea, natural reality and supernatural, is a constant note not only in Mayan art but in that of all the peoples of Mesoamerica. In my opinion their art is a key for understanding their civilization a little better. It is impossible to understand in purely economic terms, for instance, the function of trade and of pre-Columbian markets. On the one hand, as we have seen, trade leads us to politics and war; on the other, to religion and ritual. The same thing happens with war: it is not only a dimension of the foreign policy of the city-states but also a religious expression, a rite. The axis of that rite is dual: the sacrifice of prisoners and self-sacrifice. Ascetic practices, in turn, are conjoined with visions of the other world. Finally, the supernatural realm of the imaginary has been codified by a collective religious thought that amazes us by its rigor and by its powers of illusion.

Mesoamerican civilization is, like its works of art, a complex of forms animated by a strange but coherent logic: the logic of correspondences and analogies. The history of these peoples—be it their economy, their politics, or their wars—is expressed, or, rather, is materialized, in rites and symbols. Like the conch shell, their history is a material object and a symbol: a scream-sculpture. Mesoamerican history can be seen as an immense and dramatic ritual ceremony. The subject of this ceremony, tirelessly repeated in countless variations, is none other than the myth of origin: creation/destruction: creation/destruction: creation. . . . The doing away with linear and successive time: the myth (history) is repeated over and over again like the days and the nights, the years and the epochs, the planets and the constellations.

In the last fifteen years researchers—almost all of them from the United States—have shed considerable light on the great

enigmas of the history of Mesoamerica. Although their work has been prodigious, many questions still have not been answered, among them a major one that several generations of historians have asked themselves: how and why did the Mesoamerican civilization of the classic period decline so suddenly? Throughout the entire territory, at very nearly the same time, the city-states collapse and in less than a century turn into abandoned ruins. Modern historians are still unable to answer this question. Nonetheless, their discoveries have been so substantial that, by changing the traditional perspective, they oblige us to formulate this question in a radically different way. I shall explain forthwith.

The transition between the cultures of the classic period and those of the postclassic was summed up until just a short time ago in this simple formula: the (unexplained) end of theocracies and the birth of expansive militarist city-states. The archetype of the latter was Tula and later on, in its image and likeness, Mexico City–Tenochtitlán. We know today that the classic period was also an era of wars and that the protagonists of these armed struggles were city-states with political regimes not much different from those of the postclassic period. In both periods the central political reality was the king, surrounded by a military-priestly class. If we go from politics and war to religion and art, the borderline between the two periods also becomes more and more subtle: the myths, the rites, and the cosmogonies, and the artistic styles as well, are very much alike. In general, the creations of the postclassic period are derivations and variations of those of the classic era. The same can be said of the economy and of the other aspects of community life. Hence, the distinction between one era and the other becomes tenuous and at times disappears altogether. The old classifications and nomenclatures collapse: isn't it time to rethink the history of Mesoamerica?

Since the gradual downfall of so many ideas and concepts, what is still left standing? In the first place, the unity of Mesoamerican

civilization. This is a fact that does not require demonstration: it leaps to the eye. Not only was there continuous interrelationship and influence among the various societies and eras—Olmecs, Mayas, Zapotecs, the people of Teotihuacán and El Tajín, Tula, Cholula, Mitla, Tenochtitlán—but cultural forms and expressions too were similar, from cosmogonic myths and artistic styles to political and economic institutions. Alongside this unity, as its natural complement, extraordinary continuity. It was a continuity that extended over more than two millenniums. There were, to be sure, changes and alterations in Mesoamerica, but not the abrupt ruptures or revolutionary transformations that took place on other continents. Mesoamerica did not experience religious mutations such as the abandonment of pagan polytheism in favor of Christian monotheism, the appearance of Buddhism or that of Islam. Nor were there the scientific, technical, and philosophical revolutions of the Old World.

We must not confuse continuity with immobility. Mesoamerican societies did move, but their movement was circular. With a certain cyclical regularity, city-states fall, the victims of internal upheavals or of other causes; a perpetual rebeginning: new and semibarbarous peoples assimilate the preceding culture and begin all over again. Each rebeginning was a reelaboration and recombination of inherited principles, ideas, and techniques, re-creations and superimpositions: Mesoamerican history has the obsessive circular characteristics of its myths. The causes of the circularity of this process are many. Nonetheless, I must repeat what I have written elsewhere: the determining factor was the lack of contact with other civilizations. The history of peoples is the history of their clashes, encounters, chance meetings with other peoples and with other ideas, techniques, philosophies, and symbols. As in the realm of biology, history is repetition and change; mutations are almost always the result of intermixtures and grafts. The immense

and prolonged historical solitude of Mesoamerica is the reason for its grandeur and for its weakness. Grandeur, because it was one of the few really original civilizations in history: it owes nothing to others; weakness, because its isolation made it vulnerable when confronted with the experience that is central both in community life and in biology: the experience of the *other*.

Isolation was the principal cause of the fall of the Mesoamerican peoples, and all the other causes—biological and technical, military and political—derive from it. The lack of immunity against viruses and European epidemics decimated the indigenous peoples; their technical and cultural inferiority made them victims of the firearms, the cavalry, and the iron armor of the conquistadors; their internal rivalries, which Cortés took advantage of with the utmost cleverness, were no less crucial. Concerning this last point I must say something that historians usually omit: the divisions among the Indians were the natural result of the circular nature of Mesoamerican history. The strife between city-states lasted as long as their civilization did, that is to say, two thousand years. Unlike what happened in other parts of the world, however, these hostilities did not lead to the creation of a universal state. Neither Tenochtitlán nor its predecessors—Tula and Teotihuacán—achieved such a thing either. But did they really try to? I doubt it: among the philosophical and political ideas of Mesoamericans there was no such thing as the notion of a universal empire.

I still haven't mentioned the most serious, the really decisive factor: the psychological paralysis, the stupor that immobilized them when they encountered the Spaniards. Their utter confusion was the terrible consequence of their inability to *think them*. They were unable to think them because they lacked the intellectual and historical categories into which to fit the phenomenon of the appearance of beings who came from somewhere unknown. Their only recourse for classifying them was to use the sole category they

had at their disposal to account for the unknown: the sacred. The Spaniards were gods and supernatural beings because the Mesoamericans had only two categories to understand other men: the civilized, settled one and the barbarian. Or, as the Nahuas called them, the Toltec and the Chichimec. The Spaniards were neither the one nor the other; therefore they were gods, beings who came from the beyond. For two thousand years the cultures of Mesoamerica lived and grew all by themselves; their encounter with *the other* came too late and in conditions of terrible inequality. Hence they were annihilated.

<div align="right">

MEXICO CITY, *October 25, 1936*
Vuelta 122, MEXICO CITY, *January 1987*

</div>

Bustos

I, a Painter, an Indian
from This Village...

As I was preparing to write these pages on Hermenegildo Bustos, I thought about his story yet again, and once more I marveled. How to explain it? We are accustomed to seeing in every fact the consequence of other facts, which, linked together, determine it and in a manner of speaking produce it. Historians have endless discussions as to the causes of the decadence of Rome (discussions that include the question of whether the very notion of decadence is pertinent), but none of them denies that every historical fact is the result of the joint action of other facts, factors, and causes. In the realm of art the concatenation between traditions and schools, society and personalities is no less visible and decisive. Whether the subject is politics and social changes or the arts and ideas, history admittedly always resists rigidly deterministic explanations; in any

historical phenomenon there is invariably an unpredictable element—the age-old vicissitudes of fortune, happenstance, genius, individual temperament. But the appearance on the scene of the painter Hermenegildo Bustos in the little village of La Purísima del Rincón, in the middle of the last century, confronts us with a really extraordinary fact. Bustos is neither the heir nor the initiator of a pictorial movement: his art begins with him and ends with him. He had neither teachers nor comrades nor disciples; he lived and died in isolation in a remote village in central Mexico, a region also isolated, in those years, from the world's great artistic currents. Bustos's painting—at once profoundly traditional and intensely personal—is, however, part of the great tradition of portrait painting, and within that tradition it occupies a unique place.

Confronted with Bustos, we can only repeat that "the Spirit bloweth where it listeth." This is an explanation that has never ceased to scandalize rationalists, ever since antiquity. Porphyry (c. 233–304 A.D.) was already making mock of Christians and Jews who believed in an omnipotent god who performed miracles, such as bringing the sun to a halt, parting the sea in two, or turning stones into bread; no, God neither wants to do nor can he do anything except what is true, just, and good; God cannot violate the order and the laws of the universe, just as he cannot reject the axioms of geometry: that would be tantamount to rejecting himself. I will not be so bold as to gainsay the philosopher, but it is nonetheless quite true that the unexpected is all around us and challenges us each and every day; not only does it border on the unexplained but also, at times, it is indistinguishable from the inexplicable. To neutralize it we have recourse to nouns and concepts such as luck, chance, accident, or exception. These terms reveal our perplexity, but they do not provide us with the key for deciphering enigmas; they are ways of classifying a fact that is out of the ordinary, but not of understanding it or of understanding its

reason for being. From the perspective of the history of art, Bustos's painting strikes me as inexplicable. At the same time, it is a visible reality, one that had an origin that was not miraculous but commonplace: a man named Hermenegildo Bustos, about whom we know a handful of dates and biographical anecdotes but of whom we also possess a self-portrait, one of his masterworks. Isn't that enough?

Less than thirty kilometers from the city of León, in the state of Guanajuato, are two tiny adjacent villages: La Purísima (Virgen) del Rincón and San Francisco del Rincón. They were founded in 1603 and inhabited by Otomi and Tarascan Indians. The population today is still predominantly indigenous, although the native languages have been forced out by Spanish. The region is a rich one, thanks to its agriculture and its trade; it was also prosperous in the past because of its silver mines: in the sixteenth century the three great mining centers of the world were Guanajuato, Zacatecas, and Potosí (Bolivia). The prosperity brought by silver mining lasted, with ups and downs, until the early years of the nineteenth century. On the other hand, agriculture has continued to be, up to our own day, the principal resource of the population. "The villages of Rincón," Raquel Tibol says in the monograph she has written on Bustos, "enjoyed a stability without great extremes of material fortune: neither abysmal poverty nor spectacular prosperity."[1] La Purísima grew more rapidly than San Francisco, and around 1860 it already had some sixteen thousand inhabitants. Apart from the haciendas that surrounded it, the village had orchards, a flourishing craft industry, and active commercial dealings with neighboring León. The population lived modestly but knew no great hardships. It was made up of day laborers, craftsmen, small and medium-sized

[1] *Hermenegildo Bustos, pintor del pueblo*, Guanajuato, 1981.

landowners, tradesmen, and a number of clergymen. There was a primary school, an orchestra, and an amateur theater group directed by the village priest. Civic parades and religious processions were frequent, there was no electric lighting, and the village was linked with León by a stagecoach service.

Though the villagers of La Purísima experienced the upheavals of the era and participated in the battles between conservatives and liberals, the trait that best characterizes them is traditionalism. The nucleus of this traditionalism was Catholicism in its Hispano-Mexican version: ritualism, intense collective piety, worship of images, an abundance of fiestas and ceremonies. The Church, in both the material sense and the institutional and psychological, was a refuge, an inspiration, a guide, and the voice of conscience. The other axis of village life was the family. Between public and family life, interests and passions wove a net of affinities and enmities: interchanges of goods and products, parties, marriages, baptisms, funerals, and also rivalries between clans and families, grudges and quarrels. A rhythmical life but one jolted by passions, lust and jealousy in particular, and their violence: lovers' elopements, abductions, and bloody revenge by offended fathers, brothers, and husbands were not infrequent. Together with the passions and their havoc, the marvels and horrors of nature: eclipses, floods, droughts, comets.

All these upheavals, both the human and the natural ones, were explicable by reference to traditional values and doctrines. Thanks to the Church, the world, even in its aberrations, had coherence and a meaning. Religion linked the village not only with the vast supernatural and natural forces that rule the cosmos and people's souls but also with the past and the present of Mexico. The history of the nation was one with that of the Catholic religion. Finally, with its institutions and doctrines but above all else with its images—the Savior and his mother, the prophets and martyrs, male

and female saints—the Church tied La Purísima and its people to
Rome and the Old World. Hispano-Mexican Catholicism, in ad-
dition to being a vision of this world and the next, a collective
morality and a bond between Mexicans, was a bridge between
Mexico and centuries-old European culture. The first thing that
the eyes of Hermenegildo Bustos—a pure Indian, as he proclaimed
with pride—saw were copies, reproductions, and imitations of Eu-
ropean religious images.

Hermenegildo Bustos's birth certificate has been lost, but we
know, through an account written in his father's own hand, that
Hermenegildo was born on April 13, 1832. The painstaking José
María Bustos carefully noted down the day of the week of his son's
birth (a Wednesday), the hour (11:30 in the morning), the name
of the midwife, the names of the godparents and that of the village
priest who baptized him, but he neglected to record the name of
his son's mother! It was Juana Hernández. The father was the bell
ringer of the parish church of the village. Hermenegildo too had
close ties to the parish church. We do not know if he was really
its sacristan, as one critic or another maintains, or if he carried out
in it various restorations of altars, paintings, and sculptures. He
also took care of the tidying up of the images and their vestments,
as well as the decorating of the church when there were religious
festivals. Hermenegildo's life was divided between his occupations
in the parish church, where he spent his mornings, and his profes-
sional work in the afternoons in his little studio.

While it is difficult to establish a chronological account of his
life and works, it is not at all hard to form an idea of his character
and his everyday activities. A number of Hermenegildo Bustos's
papers have been preserved, among them a calendar for the year
1894 in the margins of which, in a tiny and delicate hand, he noted
down with maniacal impartiality the events of each day, particularly
natural phenomena—storm clouds, freezes, downpours—and vil-

lage scandals. His occupations and preoccupations in the course of
the other years of his life must not have been very different: life
in La Purísima went by with the same regularity and steady pace
as the beads of the rosaries told by the most devout women in the
village. What was more, Bustos made a deep impression on his
contemporaries and left behind him a legend that has come down
to us. It is not hard to separate in it the reality from mere fantasy.
His fervent and vainglorious biographer Pascual Aceves Navarro
attributes endless talents to him.[2] He no doubt exaggerates—it is
unlikely that Bustos was an architect, a theater director, and a
watchmaker—but not all that much. Even though Bustos's most
heartfelt vocation was painting, in the traditional village in which
his life was spent specialization and the division of labor had not
arrived at today's extremes.

At the age of twenty-two he married Joaquina Ríos, who was
barely fifteen. Theirs was a childless marriage, stable but perhaps
not very harmonious. Bustos was easily infatuated and had several
mistresses and either one or two children with one of them, María
Santos Urquieta. He had a garden with fruit trees and vegetables,
which he cultivated himself with the help of one or two day laborers.
Lust and eccentricity; he lived with an owl, a dog, and a chatterbox
of a parrot. He maintained somewhat sarcastically that they were
all the family he had. He was a real *bricoleur*, handy with all sorts
of tools, and the variety of his occupations and activities never
ceases to amaze me: an ice cream vendor, healer, keeper of a garden
and an orchard, pawnbroker, musician, tinsmith, construction fore-
man, carpenter, sculptor, painter. In summer he had his wife make
lemon ice cream, which he himself hawked all over the village; he
erected walls, repaired roofs, and rebuilt the chapel of the Señor
de las Tres Caídas; he lent money on articles he accepted in pawn

[2] *Hermenegildo Bustos, su vida y obra*, Guanajuato, 1956.

and grew leeches for bloodletting and rented them out; his infusions and concoctions of aromatic and medicinal herbs were famous; he strummed on the guitar, plucked on the mandolin, blew the saxophone, and played in the municipal band that performed in the main square every Sunday; he fashioned a water clock and accurately readjusted the sundial of the parish church; he excelled at carpentry and made tables, beds, chairs, cupboards, and above all, coffins—among them his wife's and his own, which he kept in his little studio until his death; he was a tailor, and he himself cut and sewed his suits in accordance with the dictates of his ecclesiastico-military fancies; he also cut and fitted the garments of the virgins and saints on the altars; he was a tinsmith, and as director and leader of the pious battalion that paraded on holy days, he made the armor, the shields, and the helmets of the troops and the officers; he was a goldsmith and made necklaces, brooches, and rosaries; he was a sculptor and carver: certain wooden images of saints and virgins of his have been preserved, and an *Ecce Homo* has been kept in the parish church of La Purísima; he left a series of masks used for the dramatizing of scenes of the Passion during Holy Week; he was not a scholar, but his familiarity with Church ceremonies—he heard Mass every day and took frequent Communion—caused him to read manuals of piety and learn a number of phrases in Latin.

A man of caustic humor, he is credited with memorable witticisms. For instance, he often used to say that in this world there were only three notable persons: His Holiness the Pope (Pius X); Porfirio Díaz, dictator of Mexico; and Hermenegildo Bustos, a painter and know-it-all. He wore clothes of his own invention and made himself a dress suit that consisted of a green jacket with gold buttons, like a military officer's, with three crosses and his name, H. Bustos, embroidered on the collar, two more crosses on his chest, a red sash, and cowboy breeches—the uniform of a militia

half republican and half celestial. He wore an Indochinese straw hat, and among his musical instruments was a Chinese *pi-pa*. How could he have come by it? There are two photographs of Herme-negildo and Joaquina, his wife. On one of them there is an inscription that reads: "We were photographed by the village priest, Mr. Gil Palomares, on April 13, 1901." He was seventy-nine years old and she seventy-two. In one of the photographs the couple is seated; in the other one, the better one, the two of them are standing. Joaquina is dressed in the style of village women of the time: a long skirt and a wide shawl that envelops her entire head and half her body. The only thing visible is her face: serious, furrowed with wrinkles, and unquestionably Indian. Hermenegildo is wearing his dress uniform, the famous green jacket, buttoned only halfway, giving us a glimpse of a pleated shirt and a sash with tassels that are not hard to imagine being red or royal purple. Hermenegildo was not very tall, and perhaps to compensate for this drawback, he has his left arm resting on his wife's shoulder, a gesture at once familiar and imperious. His head held high; eyes deep-set and half-closed, as if to see the camera lens better; between his eyebrows a depression: the crease in his scowling brow, a geological fold from which his nose descends majestically; a thick, graying mustache; a broad lower lip; a firm chin, prominent cheekbones, a broad forehead, his hair sparse and cut very short. Joaquina's face reveals resignation, weariness, and a certain impassivity; Hermenegildo's is vivacious and intelligent: deeply tanned skin, powerful muscles and bones. The face of an Indian but also that of a Tartar. The face of a birdman that sees from afar and penetrates deeply. Hermenegildo Bustos died six years after this photograph was taken, in 1907, at the age of seventy-five, a year after the death of his wife. When she passed on, he asked one of his neighbors to help him prepare her for burial, closed the house without allowing anyone to come in, and spent the night

alone with her. With the same serenity and the same reserve he gave instructions as to how he himself was to be buried. . . . Eccentric, capricious, miserly, diligent, withdrawn, astute, religious, sarcastic, imaginative, punctilious, lustful, devout, perspicacious, keen-sighted: a real "oddball," or, as people said in the seventeenth century, a monster.

We would not remember Hermenegildo's personality and his skills in the mechanical arts, the two things no doubt exaggerated by the villagers' imagination, had it not been for his excellence as a painter. During his lifetime, he was esteemed and admired by his peasant neighbors of La Purísima and San Francisco del Rincón. His fame surely went beyond the limits of the two villages and reached other places in the vicinity; among the portraits painted by Bustos there are several of people who lived in León and other adjoining locales. His fame, however, was local and confined to a very precise geographical area: La Purísima and its environs. His clientele was made up of people from these parts. It is also worth noting that it was not limited to any one class or social category; among his models there are clerics, tradesmen, owners of orchards, farmers, craftsmen, families who were reasonably well-off, and many women of different classes and social statuses: young ones, married ones, widows, the proprietress of a pulque bar, zealously devout churchgoers. All these villagers were people of modest means, although there were naturally differences between a humble farmer and a more or less affluent tradesman. Bustos's works evolved in three directions: paintings and murals based on religious subjects, ex-votos, and portraits. For these works he received modest fees, and in that sense he was a professional painter, even though he always insisted—out of humility or out of defiance?—on calling himself an amateur.

Not many examples of his religious painting have been preserved. That is not surprising: for one thing, since he was a slow

and careful painter, his work is not abundant; for another, he must
not have had many commissions outside of La Purísima and San
Francisco del Rincón: his fame was not great enough to attract the
high-ranking prelates of León and Guanajuato. Moreover, in those
years the Church had already ceased to be the great patron of the
arts. Bustos did easel paintings on religious subjects and several
murals. Among the former is a curious allegory, *Beauty Vanquishing
Power*, in which we see a lion and a pretty girl, armed with a pair
of enormous shears, who is cutting what may be either the mane
or the claws of the beast. A reminiscence of St. Mary the Egyptian?
Rumor has it that the feminine figure is that of his beloved, María
Santos Urquieta. . . . The murals of the Golden Altar of the parish
church of La Purísima represent scenes of the Passion of Christ
and were not executed by Bustos alone but "retouched," as he
himself writes in an inscription. But when Bustos speaks of "re-
touching," as Raquel Tibol remarks with discernment, "he is re-
ferring to something more than restoration work. He adds entire
sections of his own invention. For example, in the panel of the Via
Crucis in which Jesus meets the Virgin, the faces of the women
are his work." This is quite true: those countenances could only
be those of villagers of La Purísima. In the pendentives of the
dome of the parish church there are four paintings: St. Bernard,
St. Ildefonso, St. Bonaventura, and St. Alfonsus de' Liguori. They
are without doubt his work, for underneath the last one there
appears the following inscription: "Hermenegildo Bustos, an am-
ateur and a native of this village, painted them." Neither the oils
nor the murals are memorable: they are rather impersonal examples
of the religious painting of that period. Copies of European copies.

 The ex-votos are better. Painted on small-sized sheets of brass,
they represent events worth being remembered: the donor gives
thanks to the Virgin or to a saint to which he is especially devoted
for having saved him from some grave peril: a fall down a staircase,

an attack by malefactors, the charge of a fighting bull, a malignant fever. From the eighteenth century until well into the twentieth, thousands of ex-votos have been painted. Those painted by Bustos conform to the unspoken rules of tradition: they are popular paintings in the strict sense of the word, thereby distinguished from his religious painting, halfway between academic and popular art. But nothing would cause us to linger over Bustos's ex-votos were not several of them something more than examples of a traditional, stereotyped art. Bustos complacently adopted the facilities of style of the genre; moreover, among the ex-votos that are attributed to him there are a goodly number that in all likelihood are not by him: they are in no way different from hundreds of others. But there are a few of them that immediately captivate us, not because of the ingeniousness of the draftsmanship and of the subject— miracles that in the end become monotonous—but because of the vivacity and the veracity of certain faces. The ex-voto ceases to be just another example of an impersonal tradition and becomes an authentic and intensely personal work of art: the portrait of a unique individual.

A more or less skillful painter of traditional religious images and of popular ex-votos, Bustos deserves to be remembered for what he really was: an extraordinary portraitist. The religious paintings are works of mild interest, and only exceptionally do the altarpieces depart from the strictures and conventions of a traditional formula. In all these works Bustos is a real amateur; by contrast, in the portraits he reveals himself to be a minor master. Minor because of the limitations of the genre, because of the small number of his paintings, and even because of their modest dimensions; a master because of his intensity, his penetration, and, not infrequently, his perfection. Standing before these works one is impelled to ask oneself: where, how, and from whom did he learn the art of painting? Thus, the question that I asked myself when I began these

pages reappears. It is not easy to answer it, but I shall at least try to place it in its historical context.

After his death, Bustos was almost entirely forgotten. Like the rest of the country, La Purísima did not escape the upheavals of the Mexican Revolution. Around 1920, when peace has been restored, Mexicans begin to look back attentively at their past, seeking in their history proof not of what they once were but of what they are. They take off in search of themselves. Popular art seems to them, at one and the same time, a sign of what they have been and a promise of the survival of the nation. In 1933 the painter Roberto Montenegro publishes a book, *Pintura mexicana (1800–1860)*, among whose plates is a portrait of Joaquina Ríos (Bustos's wife) by an unknown hand.[3] The error was soon rectified: at the time, Francisco Orozco Muñoz had already begun his patient investigation, and a few years later, little by little, critics and connoisseurs of Mexico discovered Bustos's work and his personality. Orozco Muñoz's activity was decisive. Born in San Francisco del Rincón, he was a poet and a diplomat. He lived for many years in Belgium, where he married an intelligent woman named Dolly van der Wel, who was an art lover as well. In Belgium he was also able to familiarize himself with the Flemish painters of the fifteenth century, Jan van Eyck in particular, an artist for whom he felt genuine devotion. Perhaps the fortunate combination of his admiration for these artists and his love for his native land—not forgetting the crucial factors: his sensibility and his intelligence— explain why, on seeing the Flemish portraits, Orozco Muñoz remembered the little paintings on sheet brass that he had seen, as a child and adolescent, in his own house and in those of other

[3] See Raquel Tibol's monograph for a succinct but complete account of the process of discovering and rescuing Bustos and his painting.

families in San Francisco del Rincón. An indication of the affinity he established between the Flemish portraitists and the modest Bustos is the fact that, on discovering on the back of the Bustos's self-portrait the inscription, self-assured in its modesty, "I painted a portrait of myself to see if I could," he immediately thought of van Eyck's motto: *Als ik Kan* ("As best I can"). Orozco Muñoz succeeded in collecting a considerable number of works by Bustos but never wrote about him. Almost everything that was written about Bustos in this first period, however, shows the traces of Orozco Muñoz's conversations concerning him. Orozco Muñoz enjoyed showing his collection and talking about his discoveries.

The few critics who dealt with Bustos's work between 1930 and 1950 looked on Bustos as a "primitive," even though certain of them realized how inappropriate the term was. There is nothing primitive or naive in works such as Bustos's *Self-Portrait* (1891), his *Woman with Flowers* (1862), his portrait of Alejandra Aranda (1871), or the one of Francisca Valdivia (1856). For that reason Walter Pach astutely stated that Bustos, rather than a "primitive" (what exactly does this vague term mean?), was a self-taught artist: "a few books about the use of oils and the preparation of colors (a task he performed himself, like the painters of yesteryear), plus the contemplation of the works of art that exist in any village of Mexico that has been in existence for a long time, constituted the technical background of his craft."[4] In the same seminal essay, Pach points out that, at an early age, Bustos "intended to receive a bit of training" but that, discouraged by the ridicule of the other students, "he immediately went back to the countryside whence he had come and solved the problems of art through his own resources." It is evident that the origin of this information was something told Pach

[4] "Descubrimiento de un pintor americano," *Cuadernos Americanos*, November-December 1942.

in a private conversation with Orozco Muñoz, the source of everything that the researcher knew about Bustos. This was very vague information, but in 1952 more details were forthcoming. In that year the first great retrospective of Bustos's work, organized by Fernando Gamboa, was held. The catalogue noted that, although Bustos had tried to study the art of painting in León with Herrera as his teacher, "at the end of six months he left this bad mentor since the teacher, instead of giving his pupils lessons, used them for various chores." The source of this statement is undoubtedly the same as Pach's: everything points to Orozco Muñoz, the one who knew the oral traditions of El Rincón. I emphasize that we are dealing here with an oral tradition: to date, not a single document has been found that proves that Bustos was ever in the studio of the academic painter Juan N. Herrera. The hypothesis would appear to be plausible, given how close León and La Purísima are to each other; nonetheless, it seems unlikely that a humble villager without material resources such as Bustos would have succeeded in entering an academy in the city of León. With what qualifications, what patrons, and what money would he have been able to do so?

In 1963 a historian of Mexican art, Gonzalo Obregón, published an essay in which he maintains that Bustos was a disciple of Herrera's.[5] He offers no documentary proof and bases his claim on the proximity of León and on internal criticism: it is impossible that Bustos could have attained by himself the mastery of his craft that his portraits attest to. Obregón is of the opinion that Bustos studied more than six months with Herrera: in his earliest paintings he already reveals a remarkable technical skill. This is true: the portraits of the *Priest* (1850) and of his father (1852), painted when

[5] "Un pintor desconocido: Juan N. Herrera, 1818–1878," *Artes de México*, no. 138, 1963.

Bustos was between eighteen and twenty, are mature works. The second of the portraits is a composition at once luminous and somber: the white shirt, the black jacket, the gleam of the dark hair, the swarthy complexion, the defiant mouth, the eyes that gaze searchingly at us from close up. According to Obregón, these early demonstrations of his mastery of the art of painting are proofs of a prolonged apprenticeship: Bustos must have studied with Herrera from 1848 to 1851, between the ages of sixteen and nineteen. Later on, he returns to his native village and "finds himself alone, influenced by no one, and his art tends toward the popular." In addition, an economic factor: "his clientele in La Purísima was not going to be able to give him as much as the well-to-do townspeople of León." In Obregón's view, there is an involution: left to his own devices and faced with a poor and ignorant clientele, Bustos regresses to a popular style, although he retains a certain quality he owes to Herrera.

I deem this hypothesis untenable for three reasons. The first of them is the lack of documents: everything is based on supposition, including Bustos's attendance at Herrera's studio for several months. The second: from the earliest to the very last, Bustos's portraits are remarkable, and often they are perfect: there are no great changes between those at the beginning and those at the end. His clumsy drawing of figures and the awkwardness of his perspectives is also notable from the very beginning. The first thing that a student in an art academy learns, before he ever models facial features, is to draw a figure and acquire a thorough grounding in the art of drawing in perspective. It is most unlikely that the process was reversed in Bustos's case. To remedy this defect in his reasoning, Obregón resorts to an even flimsier hypothesis, that of Bustos's "involution." No: Bustos's mastery of the art of portrait painting and his shortcomings in other technical aspects of draftsmanship are owed to the very fact that he never studied in an

academy. My third reason, finally: not only did Bustos occasionally declare himself to be a *pintor aficionado*, that is, an amateur painter without benefit of academic studies, but also, on the Golden Altar of the parish church, he signs, in 1903: "Hermenegildo Bustos, a self-taught painter in his seventy-second year." After that, all we can do is return to the suppositions we put forward earlier: Bustos's teachers were certain books, a few images, and above all, his eyes, which searchingly penetrated whatever he saw; his memory, which retained what he had seen; and his artist's hand and imagination, which reproduced and transfigured it.

Bustos did not paint landscapes or interiors or nudes. Perhaps he was prevented from it by his awkwardness at rendering figures, backgrounds, and relative distances. Perspective was not his strong point. In the case of nudes we must also take into account the prudishness of the Mexican provinces. We have two still lifes of his in which various fruits, some vegetables, a frog, and a scorpion appear. The painter got around the difficulties of composition by lining the fruits and vegetables up in rows. Rather than paintings, the two still lifes give the impression of being illustrations from a treatise on horticulture. The portraits, on the other hand, are nearly always remarkable for their lifelikeness, their modeling, their colors, and their firm, flexible, and subtle draftsmanship (qualities that, in him, are not contrary but complementary). The excellence of his line merits emphasis: his drawing, as I have already noted, is self-assured and clear yet light and, in a manner of speaking, reflective; what I mean thereby is that the hand that draws the lines serves the eye that is looking and the mind that is measuring and that, as it measures, compares and constructs. To Bustos, line, instead of constituting a composition, is an exploration. None of the line drawings with which I am familiar is a work in itself: they are studies, sketches for the future portrait. Nonetheless they have a charm all their own: they are the presentiment of a work, the

prefiguration of a face. I am thinking of the preliminary sketch for the portrait of his wife: it is hard to forget those eyes that gaze with a certain surprise at the world from beneath thick eyebrows and a forehead that tends to be daydreamed rather than actually drawn. The young woman's face is a fruit caught at the very moment that it first begins to open: how did that delicious, immature oval ever turn into the severe features of the matron of the portrait and the resigned and somewhat stolid face of the photograph of 1901?

Bustos's drawings were probably exercises in visual memory; they also served to familiarize him with the model and *se faire la main*—to train his hand. Later he began to paint directly on the sheet of brass or the canvas, either in monochrome or in very faint colors; after that, he applied the color, delicately and carefully. His touch is firm but never violent: there is nothing extreme about his brush strokes. Bustos's sensibility was alien to any sort of expressionism. Walter Pach wonders how it was possible for the artist, using this procedure, to paint compositions in which the modeling appears to be supported by the firm underpinning of draftsmanship. Perhaps the answer lies in what I pointed out above: visual memory. When he painted, Bustos followed the mental outline of his drawings: his hand painted; his memory drew. Hence the need for preliminary sketches. In the end, whatever his method may have been, it is unquestionable that Bustos's oils reveal an extraordinary draftsman. Like the bones that, covered by muscles and skin, form and shape the features of a face, his line supports the pigments and the patches of color. It is an invisible architecture.

Bustos paints to perfection what is most difficult, complex, and mysterious, the human face, but he is wide of the mark when it comes to a human body, a grove of trees, or a composition with three books, a tumbler, and a lamp on a table. This explains the strict limits he places on himself, based on the nature of his talents and his shortcomings. He eliminated backgrounds, did not paint

interiors or scenes, and reduced his models to the essential: the face. We have some clue to their role in society because of the clothes that they are dressed in, their jewelry and adornments, and sometimes the object that they are holding in their hands: a book, a coin, a flower, a card with their name on it, a schoolboy's slate. He usually portrays them in three-quarter profile and from the waist up. Except in one case, a portrait of a woman that reveals her bare shoulders—the décolleté neckline of her thin blouse affords a glimpse of the nascent curve of large, firm breasts—Bustos shows his models completely dressed. Their garments cover them and define them: a farmer, a tradesman, a priest, a widow, an unmarried woman, the mother of a family. Nonetheless, all these portraits radiate—or, rather, exude—a powerful carnal presence. The body has become energy, has ceased to be form and volume, and has been converted into a facial expression, an ardor, a gaze. If I were asked to define in just one word the impression that these portraits give me, I would answer without hesitation: intensity. The line, the modeling, the colors, the volumes, everything turns into a concentrated energy. Behind the impassivity of these dark-skinned faces, the viewer senses fervent passions and deeply buried desires, an immense vitality at once suppressed and stubborn.

It is only natural that the few critics who have been concerned with this small body of work—yet, even within its small range, quite often perfect and, within its rather reduced limits, almost always extremely personal—have looked to tradition in search of antecedents and parallels. Through his realism, his indifference toward social rank and toward the conventions and formulas of ideal beauty, as well as through his visual economy and his "essential-ism"—something quite different from the search for what is char-acteristic and for what is odd—in short, through his equidistance from classical idealism, the Baroque, and Expressionism, Bustos

puts us in mind of the origins of the art of portraiture: the Flemish painters of the fifteenth century. When he paints a portrait, he is not seeking to represent an ideal type, as did the great artists of the Renaissance, nor is it his aim to represent a singularity or an exception, in the manner of Baroque and modern artists: he does portraits of real persons, and this calls the Flemish painters to mind. But the moment the resemblance is pointed out, it disappears: comparing Bustos with Jan van Eyck, as certain critics have done, is foolhardy. Attributing a close similarity to the two of them diminishes Bustos, and even reduces him to almost nothing. Van Eyck is a beginning, or more precisely, is *the* beginning, of the great art of portrait painting in the West; Bustos is a mere moment of that tradition, scarcely more than a blink of the eye: a minor master. But the comparison, however exaggerated, is a useful one. In Bustos we do not find the mysterious interiors of the Flemish artist, with their commingling of daily life and symbolic objects, windows like bays of light and mirrors with secret reflections, the conjunctions of light and dark in the fabrics and the metals, but there is the same passion for human truth and the same sense of integrity toward what our eyes see: a person, a unique and vulnerable being. To paint a face is not so much a consecration as a recognition, a feeling of kinship.

We owe to Walter Pach a more modest comparison: Bustos's paintings remind this critic from the United States of the anonymous portraits of the Fayum. These works, less complex than those of the Flemish painters, indeed bear certain surprising resemblances to Bustos's portraits. Nevertheless, as will be seen, these similarities fail to conceal notable and more profound differences. Pach pointed out the resemblance, but he was unwilling or unable to develop his idea further; nor have those who later came to the same conclusion done so either. The similarities leap to the eye: the small dimensions of the works, the absence of backgrounds,

the faces seen in three-quarter profile (although in the Fayum tablets frontal representation is also frequent), the human figure reduced to the face and the upper portion of the trunk alone, the attention paid to emblematic details (the diadem of golden leaves in the portrait of a priest of the cult of Serapis and the breviary and cross in that of a village priest of La Purísima del Rincón, the tablet and stylus held in the hands of a Greek teacher and the chalk and slate in those of a Mexican schoolboy); in a word, the realism of the portraits: the artists of the Fayum and Bustos endeavored to represent not types but, rather, real-life individuals in the flesh. They did their best, above all, to be truthful, without idealizing or embellishing the model. These similarities are not illusory; they are superficial. There are profound differences between the portraits painted on the sarcophagi in which the mummies of the landholders of Arsinoitico province lie and the portraits of Bustos's villagers.[6] These differences have to do with the social function of the paintings, but also with their formal elements and their deep underlying meaning.

The portraits of the Fayum are doubly anonymous: we do not know the names of the artists who painted them, and only in rare instances have the names of the persons portrayed come down to us. The oldest examples go back to a hundred years or so after the fall of Ptolemaic Egypt beneath Roman domination (30 B.C.) and the last of them to the fourth century. Not only the continuity of this tradition—more than three centuries—is remarkable, but so is the fact that for such a long time appreciable stylistic variations do not appear. Without denying the charm, as well as the psychological truth and the religious pathos, of many of these portraits, we are unquestionably in the presence of a collective canon that prohibits all change and individual variation. For more than three

[6] The Fayum of today was called Arsinoitico in antiquity, in honor of Arsinoë II, the wife and sister of Ptolemy Philadelphus.

hundred years, hundreds of executors of portraits repeated, more or less successfully, a formula. The Fayum portraits belong more to the history of religion than to that of art. Since their discovery, in the last years of the past century, more than seven hundred tablets have been recovered. That would appear to be a great many, but it is only a small proportion compared to what has been lost or what still lies hidden in the cemeteries of this region. All those whose portraits were painted belonged to the affluent class of the province: landholders and their families, holders of high office and matrons, Roman officials married to ladies of the native aristocracy, priests of the official cult. Finally, the province of the Fayum was one of the richest regions of outstandingly rich Egypt, and its ruling class was made up of a cosmopolitan population—Romans, Greeks, Egyptians, Syrians—in constant touch with Alexandria, Athens, Rome, and the other centers of the empire.

A quick look at Bustos's world and a brief examination of the nature of his art and the circumstances surrounding it will suffice to demonstrate the contrast between his art and that of the Fayum. The dominant notes of the latter are continuity, impersonality, and uniformity. Bustos's art is profoundly individual; he was self-taught, and his traditionalism is not a heritage but a conquest and almost an invention. The other differences are no less significant. His models did not belong to the ruling class of Mexico or even of his province: they were humble people from his little village. Nor are they anonymous: we know their names and, in many cases, the date of their birth, that of their marriage, their civil status, their profession, how many children they had and what their names were, their exact height, and other curious details. Bustos's works are few, and they cover barely half a century of the obscure life of a small corner—the name of his village could not be more appropriate[7]—of a province of Mexico, a part of the country isolated

[7] *Rincón* in Spanish means "corner."—TRANS.

from the world in those days. Lastly—a major difference—each portrait by Hermenegildo Bustos was a different experience. Each one of these works was an aesthetic and human adventure: a confrontation and a meeting.

The portraits of the Fayum are one of the very last expressions of the old ancient burial rites of the Egypt of the Pharaohs. The fact that these funeral rituals, associated with the cult of Isis and Osiris, were perpetuated down to the era of Roman domination is a proof not only of Egyptian traditionalism but of the almost indestructible nature of religious beliefs. From the beginning, the mummies of well-off individuals were kept in sarcophagi that imitated the shape of the human body. Archaeologists call these sarcophagi "anthropomorphic," but Klaus Parlasca, in the interesting and informative essay that he has devoted to the subject, thinks that they ought to be called "osiroform," since they are related to the worship of Osiris, the god of the dead, of vegetation, and of resurrection.[8] The custom continued to be observed under the Ptolemaic dynasty and during the period of Roman domination. The sarcophagi were placed in a special room devoted to ancestor worship, in which rites on holy days, libations, and funeral banquets were held. After two or three generations, the mummies were removed to cemeteries. In the region of the Fayum, the sarcophagi, "for reasons of space," were placed one on top of the other and often were kept in storage cupboards. At first only the name of the dead person was inscribed on the upper part of the sarcophagus, but in the era of Roman domination the custom of placing on it a wooden plaque with a portrait of the dead person, painted in encaustic, was introduced. It is not hard to imagine the emotion of the devout on finding themselves, on the appointed days, face to

[8] "Le mummie del Fayyum," *Gente del Fayyum, FMR,* no. 13, May 1983. This number also contains essays by Giorgio Manganelli and Gianni Guadalupi.

face with the mummy and the portrait of their grandfather or their mother.

In the sarcophagi of the Fayum two traditions fuse: the cult of Osiris (under the Hellenistic form of Serapis), with its promise of resurrection, and the Roman portrait that reproduces, in order to perpetuate them, the physical characteristics of an individual and, through them, his or her psychological type. Roman realism in the service of Egyptian eschatology. In my opinion, however, there is another element in the portraits of the Fayum mummies: vivacity, the love of the characteristic and the singular that is distinctive of Alexandrian art. Despite the uniform technique employed in painting them, there is such a variety of countenances, temperaments, and personal traits in these portraits that the viewer cannot help but think of the characters of the New Comedy or of Meleager's poems. From the names that appear on the sarcophagi we know that many of the dead were Greek or at least had adopted Greek culture. Hellenism did not disappear from Egypt until the Arab invasion. In short, the room where the mummies of forebears in Arsinoitico were preserved housed an assembly of those on the point of attaining immortality through the dual action of Serapis and the art of the portrait painter. It was an immortality limited to people of means who were able to pay the mounting costs of mummification and the honorarium of the artist. The portraits of the Fayum occupy a place within a religious ritual founded on the belief in resurrection. But these portraits are not sacred images or relics: they are a sort of ultraterrestrial passport, identification documents for a supernatural journey.

Hermenegildo Bustos's art, despite his association with the Church and his devotion, is essentially profane. It is not part of a burial rite, nor does it refer to a belief in the world beyond; nor is it related to death or any other nontemporal reality. Parlasca finds a curious analogy between the art of the Fayum and the custom,

among the Polish aristocracy of the seventeenth century, of placing a portrait of the deceased person, painted by an artist who specialized in portraiture of individuals who had died, atop the coffin. It is a custom that we also find in Mexico. Portraiture of the dead—distinguished citizens, nuns, clergymen, children—was very common throughout the eighteenth and nineteenth centuries. However, unlike his contemporaries, Bustos hardly ever painted portraits of dead people. The exception is the portrait of a *Dead Little Girl* (1884). The client of the artist of the Fayum, on viewing the portrait of his forebear, held a silent dialogue with a dead person; Bustos's client held a dialogue with him- or herself. The realism of the artists of the Fayum is an impersonal formula required by the Greco-Roman culture of their clients. Bustos's taste coincided with that of his clients: his art is born of the convergence between his personal vision and collective taste.

Like the art of the Fayum, that of Mexico is the result of a conjunction of outside influences and local realities. In the Fayum, the art of a dominant group—Greeks and Romans—becomes part of the religious tradition of ancient Egypt; in the case of Mexico, the religion and the art of Europe fructified the sensibility and the imagination of a populace that the Conquest had reduced to a sort of spiritual orphanhood. Bustos's attitude toward artistic tradition is not one of mere submission; he not only proclaims that he is an "amateur" and that he had no teachers but also proudly states that he is *Indian*. On the reverse side of his self-portrait he writes, "Hermenegildo Bustos, Indian of this village of Purísima del Rincón." At the bottom of the portrait of Father Martínez he repeats, "I, Hermenegildo Bustos, amateur painter, an Indian from this village. . . ." Citing still more quotations would be fruitless, whereas what is worthwhile is emphasizing their meaning: to Bustos, painting is an individual experience, a test. Hence he wrote

on the reverse of his self-portrait, "to see if I could." In this test his entire being is at stake, and something else besides: his racial identity. Bustos firmly asserts himself with regard to tradition, and this self-definition is a dual one: that of a marginal artist who had no academic training and that of an Indian. His traditionalism is remarkably modern and, to a certain degree, polemic.

It is not necessary to carry the comparison to greater length: Bustos's art is definitely historical. It erupts from the encounter between the painter and his model, is nourished by the confrontation of two othernesses, and is metamorphosed into a work that expresses not a nontemporal truth but an instantaneous perception: the mobility of a face, arrested for the space of an instant. Calling this art *historical* may perhaps lead to confusion. All the arts are historical, since they are human creations; by that I mean that all of them are born within history and all of them, in one way or another, are an expression of it. All of them, in one way or another too, transcend it, and at times deny it. Bustos's art, however, is historical in a more limited and particular sense. In the first place, it bears no relation to any of those ideas or nontemporal entities that express a society and in which it recognizes itself: the cross, the crescent, the hammer and sickle, the rising sun. In his painting there are no mythologies, symbols, or allegories. It is not a vision of this world or of the world beyond. Neither landscapes nor paradises nor hells. Nor is there history in the usual sense of the word: heroes, traitors, tyrants, martyrs, multitudes, happenings. He painted not events but the very *act of happening*. For Bustos, as for all of us, time *goes by*, but not in specially chosen places, or in historical settings, but on the outskirts, in nameless places. Each of his paintings is dated and was painted in a definite place, but these dates are private and this place lies outside of history with a capital *H*. So then, in what sense is his painting historical? It originates in time, expresses time: it is pure time. A portrait is the

testimony, fixed and momentary, of the encounter between two persons—dialogue, conflict, discovery—that leads to a recognition. The other is presented as a corporeal presence. That presence speaks to us, looks at us, hears us, and we hear it, speak to it, and look at it. We thus discover that the presence is a person, or, as people used to say, a *soul*. A unique being, like ourselves, vulnerable and enigmatic. When we view a painting by Bustos, we repeat this discovery; time, the substance of history, reveals itself for a moment: it is a human face.

MEXICO CITY, *March 1984*
FMR 31, MILAN, *March 1985*

Mural Painting

Re / Visions:

Mural Painting

Expressionisms

How would you distinguish between Mexican Muralism and the other Expressionist tendencies of the century?
 The Mexican Muralist movement has unmistakable character-
istics all its own. It is not going too far to say that it occupies a
unique place in the history of the art of the twentieth century. On
the one hand, it is a consequence of European artistic movements

The origin of this text was an interview broadcast on French television, in a series
devoted to Expressionism, one of the chapters of which is Mexican Muralism.
When I transcribed it, I decided to make it into an imaginary dialogue and added
considerable material to it. Finally, before sending it off to the printer's, in May
1986, I revised it once again and added more than thirty pages.

of the early years of this century; on the other, it is a response to those movements that, in a certain way, is a negation of them as well.

In Mexican mural painting there is a sort of rift between its aesthetic ambitions and its ideological ambitions. But to understand this rift one needs to bear in mind the historical and social circumstances that made the birth of this artistic movement possible at the beginning of the twenties. Without the Mexican Revolution mural painting would not have existed—or would have been very different.

In what sense was the Mexican Revolution a decisive factor in the Muralist movement?

Among the revolutions of the twentieth century, the Mexican Revolution was a unique phenomenon. A nationalistic and agrarian revolt, it was not an ideological revolution. It was not the work of a party, and it had almost no program: it was a popular explosion, a spontaneous uprising that had not just one head but many. I have always wondered whether it was a revolution, in the modern sense of the word, or a revolt. I am of the opinion that it was a revolt. Something like an explosion of the underground life of Mexico. Our revolution brought forth, as in the delivery of a child, an unknown Mexico. Except that the child that was born in 1920 had existed for centuries: it was the popular and traditional Mexico, hidden by the previous regime. A Mexico that today both progressive-minded leftists and progressive-minded rightists have buried once again. The Mexican Revolution was the discovery of Mexico by Mexicans. I have suggested that it was something like a gigantic revolt; I now add another word: a revelation. The Revolution revealed Mexico to us. Or better put: it made us look back so as to see it. And it made painters, poets, and novelists above all look back: Azuela, Rivera, Martín Luis Guzmán, Orozco, López Velarde, Vasconcelos.

The Revolution was a return to the source, but it was also a beginning, or more precisely, a rebeginning. Mexico turned back to its tradition not in order to repeat itself but in order to initiate another history. This was the idea, a more or less confused one, that inspired the new regime and particularly the Minister of Public Education of those years, José Vasconcelos. A man of genius. Vasconcelos summoned artists to collaborate in the task of making or of remaking Mexico. In the same way he summoned both poets and ballerinas, painters and musicians. Traditional songs and dances were taught to schoolchildren, popular art was extolled, books and magazines were published, and walls were assigned to one painter or another. Vasconcelos believed in the mission of art. He also believed in freedom and therefore forced no aesthetic or ideological dogma on the artists. In his artistic policy he was inspired not only by the example of the great religious painting of the Middle Ages and of the Renaissance but also by that of New Spain, particularly that of the sixteenth century: in almost all the convents of that era, mural painting has a choice place. But unlike the Church, Vasconcelos allowed the artists to work entirely on their own terms.

Vasconcelos soon left the Ministry of Education. Although they did not share his ideas, his successors perceived the political usefulness of them: the young revolutionary state had need of a sort of legitimization or cultural consecration, and what better consecration than mural painting? That was the way in which a mistake began which ended with the perversion of Mexican mural painting: on the one hand, it was a revolutionary art, or one that called itself revolutionary; on the other, it was an official art. I will return to this subject later. For the moment, I merely want to point to the circumstances surrounding the birth of Mexican mural painting: the revelation of the real Mexico that the Mexican Revolution

represented and, at the same time, the political and ideological necessities of the new revolutionary regime.

Can it be said that mural painting is an expression of the Mexican Revolution?

Yes and no. Historical and political circumstances do not explain everything. The Revolution had revealed the people of Mexico and their traditional arts; revolutionary governments, in turn, need the consecration, so to speak, of artists. What was essential, however, was the appearance of a group of artists who saw reality with different eyes, with new eyes, and not with those of academic art. For a Mexican artist of the nineteenth century, it would not have been easy to *see* the pre-Columbian artistic heritage or the richness and originality of popular art. Here the other decisive circumstance, not political but aesthetic, not national but international, intervenes: the lesson of modern European art. The great European aesthetic revolution, which began in the early years of the nineteenth century with the Romantics, taught us to see the arts and traditions of other peoples and civilizations, from Oriental and African ones to those of pre-Columbian America and Oceania. Without the modern artists of the West who made the totality of non-Western styles and visions their own, the Mexican Muralists would not have been able to understand their indigenous Mexican tradition. Mexican artistic nationalism was a result of the cosmopolitanism of the twentieth century.

Mexican mural painting is the result both of the change in social awareness that the Mexican Revolution represented and of the change in aesthetic awareness represented by the European artistic revolution of the twentieth century. I should add that the Muralists were rather timid in their use of pre-Columbian and popular forms. It is odd, but Rivera, a great connoisseur of modern styles and a great admirer of pre-Columbian art, reveals in his forms a quite academic and European vision of the indigenous world. Siqueiros

was closer to Baroque art and Italian Futurism than to Mexican popular art. The same can be said of Orozco: he had a greater affinity for European Expressionism than for the traditional arts of Mexico. There is nothing farther removed from the hieratic and geometric style of pre-Columbian artists than Orozco's pathos or Siqueiros's dramatic gestures. Although pre-Hispanic art is frequently a terrifying art, it is not one that shouts. There are no exclamations in Mesoamerican art. In point of fact, the artist who has most successfully carried to their ultimate limits both the lesson of pre-Columbian art and that of popular art has been Rufino Tamayo.

Can you tell us anything further about the relationships between Muralism and European art?

Mexican Muralism owes a great many debts to modern European painting. It must not be forgotten that Diego Rivera spent almost fifteen years in Europe. He took part in the artistic life of Paris, was a friend of Modigliani's and of Juan Gris's, had bitter quarrels with Pierre Reverdy, and those who are curious about literary and artistic history will find his name associated with many of the battles and incidents of the era.

Rivera's case, moreover, is not unique. A number of Hispano-American artists and poets have played parts in the artistic movements in Paris in the course of this century. In addition to Rivera, one would have to mention Picabia (Hispano-Cuban), Marius de Zayas (Mexican and a New Yorker), Huidobro and Matta (Chileans), Lam (Cuban), and others who in different periods lived on close terms with the European avant-garde, especially Surrealism.

Like yourself . . .

And also like the Peruvian poet César Moro and, more recently, the painter Alberto Gironella. . . . Let's go back to Rivera. In the evolution of Rivera's art, there is a Cubist interval. Diego Rivera's Cubism belongs to his second period, as this tendency is reaching

its end. It is revealing that from that time on he was renowned for his love of folk anecdote and of vivid colors that are far removed from Cubist austerity. Rivera was a painter who possessed many resources, but in my opinion he was an academic painter. His Cubism came from outside, and the same can be said of his other manners and styles. His art does not spring from within himself. In Rivera there is ability, great ability, at times mastery, unquestionable talent, but never, or almost never, passion. Exterior painting, the diametrical opposite of Orozco's. Rivera was an eclectic artist who combined several manners. Instead of inventing, he adapted and combined styles, sometimes with great dexterity. I am thinking of those walls (the Secretariat of Public Education; the chapel of Chapingo) where he combines with real talent the dual lesson of the fresco painters of the quattrocento and of Gauguin. The latter was fundamental to his interpretation of nature and of Mexicans. Rivera's Indian men and women come from Gauguin. There is another painter with whom he has an unquestionable affinity at certain times: Ensor. I am referring to the most popular Ensor, that of the famous *Entry of Christ into Brussels*, for example. It is curious that criticism has never stopped to consider this affinity. A similar one, which I believe has not been noticed either: Léger. Léger's evolution somewhat resembles Rivera's. Like Rivera, Léger went from Cubism—although Léger's Cubism was more rigorous, daring and inventive—to a more direct and popular art, one of whose greatest charms lies in that strange and marvelous alliance between the machine and the female body. In Rivera, too, eroticism appears coupled with mechanization.

Rivera was the most cultivated, pictorially speaking, of the Muralists, but the others were also familiar with the experiments and achievements of modern painting. In Siqueiros there are echoes, both in his painting and in his aesthetic preoccupations, of Italian Futurism. The attempt to paint movement is something

that Siqueiros shares with a Boccioni. As for Orozco: apart from the influence of Daumier and Toulouse-Lautrec, there are coincidences and affinities with German Expressionism and with artists whose work derives from Fauvism, such as Rouault. I also find Ensor in Orozco every so often, and, naturally, Kokoschka.

The art of the Muralists belongs, doubtless, to the Expressionist current, but what is your view of the relationships between European Expressionism and the Mexican movement?

To begin with, there is something that calls for an explanation: it is sometimes forgotten that so-called Mexican Expressionism is not limited to Muralism alone. Posada, the woodcut engraver, was an extraordinary Expressionist without realizing it. Rufino Tamayo is one too, in his own way. The same can be said of José Luis Cuevas. The Muralists are different, both from the chronological and from the aesthetic viewpoint. Modern art in Mexico begins with them, and as a movement Muralism marks a beginning on the American continent as well; moreover, its Expressionism had unique traits. Its relationship with European Expressionism was, so to speak, a polemic kinship. To explain this relationship one needs to begin at the beginning.

The two great European movements with which Mexican Muralism shows affinities and similarities are Fauvism and Expressionism. The former was French and Mediterranean; the latter, German, Flemish, Nordic. Both movements make their appearance around 1905 and precede Mexican Muralism by many years. There is no question that our painters not only were familiar with these currents and tendencies but also assimilated and adapted them, almost always with talent and in a very personal way. And what is more, the common sources of Fauvism and Expressionism were Van Gogh and Gauguin. The two of them, along with Cézanne, as the Expressionist Nolde put it, "were the 'icebreakers of modern art.' " I have already pointed out that Rivera carries on the lesson

he learned from Gauguin. And also, although not in as obvious a way, that of that other first-rate grandfather: the Douanier Rousseau. In Orozco's case other names could be mentioned: Daumier, Toulouse-Lautrec. So the Muralists drank from the same sources as the Expressionists and the Fauves.

Beyond this common origin, the affinities between the Muralists and the Expressionists are continuous, constant. Similarities that are not always influences but coincidences, or rather, convergences. This is demonstrably true, above all, of two artists in whose works Expressionism appears to be most conspicuous: Orozco and Siqueiros. Rivera is quite different. His most direct relationship is with Fauvism. Grosz, Otto Dix, Kokoschka, Rouault, and Ensor belong, by contrast, to the same spiritual family as Orozco. A painter of compact masses and solid volumes such as Permeke is reminiscent of the Siqueiros of the thirties, not of the Muralist but of the easel painter, who perhaps represents the best Siqueiros.

Aren't you exaggerating?

Only a little bit. As a Muralist, Siqueiros was a great inventor of forms, but his rhetorical rigidity and his ideological simplemindedness worked to his detriment. A disconcerting alliance between plastic invention and clichés. In his easel painting, these defects are not as noticeable. Very often Siqueiros's portraits are remarkable for the vigor of the draftsmanship, the economy of line, the sober modeling, and the color, which, though violent, is almost never strident. He was a master of ochers. His best portraits border on relief and even on sculpture. Siqueiros assimilated with great talent the lesson of the Byzantines and also of pre-Columbian masks. His art moves between two extremes: the Byzantine Pantocrator, as in the dramatic and manly *Christ of San Ildefonso*, and Aztec sculpture, as in the burial scene of the same mural. At a later period, other portraits of his (those of María Asúnsolo, for instance) call to mind not so much the great Spaniards, which some maintain,

as the modern painter who followed in their footsteps: Manet. Not only has Siqueiros left us a number of splendid portraits, but—I don't know if anyone has already remarked on the fact—among his best paintings there is also a series whose subjects are enormous gourds and other humble fruits. Such a theme could not be more traditional and less ideological. They are taciturn fruits that bring to mind gigantic decapitated heads or melancholy planets. They are compositions in which the two defects of nearly all his work appear: overdramatic gestures and bombast. They are forms, merely *forms*, that radiate concentrated emotion.

You were speaking a while ago of Fauvism and Expressionism . . .

It seems to me that comparison between the two tendencies helps one understand the unique nature of the Expressionism of Mexican mural painting. The relationship between Fauvism and Expressionism is, at one and the same time, intimate and contradictory. Fauvism is a dynamic, sensual art, intoxicated with sensations, luminous, possessed of a vitality that it is not inaccurate to call erotic. There is good reason why the central figure was Matisse, the most painterly painter of this century and the only one whose painting deserves, without affront, to be called happy in our ignoble era. Expressionism too is dynamic, but its dynamic nature is subjective; it does not seek reconciliation with natural forces as Fauvism does but, rather, seeks to delve more deeply into the triple rift: that between humankind and nature, that between human beings, and that between human beings and their own selves. Expressionism, cruel when it is not ironic, is almost always pathetic. Fauvism is orgiastic; Expressionism is critical. For the former, reality is a source of marvels; for the latter, of horrors. Fauvism is a great exclamation of wonderment and applause in the presence of life; Expressionism is a cry of unhappiness and a moral accusation.

Mexican Muralism—with the notable exception of Rivera—is

closer to Expressionism than to Fauvism. Because of his tastes, his sensibility, and his feeling for form, Rivera is a very different painter from his two comrades and rivals. If the opposition between the Romantic and the classic artist were still valid, it is obvious that Orozco and Siqueiros would be Romantics and Rivera classic. This is true, above all, because of the superiority of his draftsmanship and because of his sense of composition. His color is never inharmonious, and his line, at times too placid, never writhes or becomes bent and twisted. Neither torture nor contortion, the two poles of Orozco and Siqueiros as draftsmen. There is a trait, moreover, that radically separates him from his comrades and for which he earns our forgiveness for his many miles of flat and monotonous painting: his love of nature and his love of the female form. Intertwining trees, flowers wet with dew, and women who also have something of the nature of plants. Not materialist but animist painting.

The world of Orozco and of Siqueiros is different. Their deformations of the human figure are very far from the sensuality of the Fauves; as in the Nordic Expressionists, these distortions have not only an aesthetic meaning but a moral one as well. In both artists the pictorial image—intense, brutal, rent apart—is not so much a vision of the horror of the world as a judgment and a condemnation. A critical art, an art of negation and sarcasm. The first difference appears here: European Expressionism and Mexican Muralism are subjective visions of reality, but the subjectivism of the Europeans is above all a matter of sensibility, whereas that of the Mexicans is not only emotional and psychological but ideological (and moral in Orozco's case). Expressionism is the art of certain very intelligent artists who have rejected intelligence or who see in it nothing more than a weapon for taking their vengeance on the stupidity and evil of the world; the Muralists, again with the exception of Orozco, believed in reason, even reason in the paradoxical and contradictory form of dialectics. Expressionism was

pessimistic and Muralism optimistic (except, yet again, for Orozco). Expressionism was an art against society and the state; although many of the Expressionists earned fame and money, none of them turned into an official artist; Muralism was the art of a young nationalistic state, and its most characteristic works were painted on the walls of government buildings. Beyond the formal similarities and the affinities of sensibility and aesthetic conception, there is a profound divergence between the two movements. They are two paths that cross but then take off in different directions.

Diego Rivera

Doesn't what you have said about Fauvism and Expressionism strike you as too categorical? Nobody mentioned Fauvism in reference to Mexican painting . . .

You're right. I used that term to emphasize, by contrast, the markedly Expressionistic nature of Mexican Muralism. Fauvism, understood as implying sensuality and violent color, seemed to me a useful term to highlight the unique place of Diego Rivera and his painting. But I admit the term fits him only in part. His evolution was an extremely complex one, and the changes in painting throughout the Europeanized world between 1900 and 1920 are reflected in it.

You also said that Diego had been an academic painter.

I did not mean by that something solely pejorative. The academic artist is one who learns his art in an academy and who is a master of that art. There are admirable examples: Raphael, Ingres. The artist who allows himself to be dominated by his technique and who turns his art into recipes is also academic, although in a negative sense. Both extremes are to be found in Diego.

You also said that he lacked passion . . .

Once again: I must give the proper shading to this statement. Diego lacked the pathos and the fury of Orozco, but he was not a cold painter: he was a sensual painter, in love with this world and its forms and colors. That was why I thought of Fauvism when I spoke of his love of nature and of women. How can we forget the earthy beauty of the nudes of Chapingo? But he was *also* a cold painter: the Diego Rivera who is didactic, discursive, prolix.

There is something else: you called him eclectic.

Eclecticism has a bad reputation. In ethics it is confused with "undue lenience." That is unfair: a person can be tolerant without being indiscriminately accommodating. In matters concerning ethics and politics, Diego was the opposite of an eclectic: he was an authoritarian and a fanatic. In art, eclectism sometimes denotes an absence of personality and originality. Not always: Poussin was eclectic, as was Picasso, in his own wild way. There are two families of artists: those who define themselves by their negations and exclusions and those who aspire to integrate different manners and styles in their work. Diego belongs to the second of these families. In this sense he is closer to Poussin than to Cézanne, to mention painters of the past. In the strict domain of painting, he was not a revolutionary or an innovator: he was an assimilator and an adapter. Like Poussin's, his eclectism was a search for a complete art that would include many tendencies. He did not always achieve this effect: there are times when the alien presences are too visible; at other times, however, they fuse in his powerful vision, although they do not disappear completely. This is true, above all, in his formative years.

Only then?

No. There are examples in his entire body of work, both in his murals and in his easel paintings. I will mention one among many of the latter: the *Portrait of Ana Mérida* (1952) is a late pastiche of Marcel Duchamp's *Nude Descending a Staircase* (1911). But this is

not too much to his discredit: artists must be judged by their successes, not by their failures. Diego had many great successes.

Little has been written about his formative years.

That is true and it is too bad. Those years are the key to his evolution. In recent years, however, criticism has begun to take an interest in his years in Madrid and Paris. Ramón Favela has published an excellent essay on the subject.[1] Favela points out that Rivera returns to Mexico at the age of thirty-four. He was a wholly mature man, a trained artist. He had spent fourteen years in Europe. The critics have been wrong to ignore those decisive years.

It is necessary to keep in mind as well that Diego was a precocious artist.

That is quite true. He entered the Academia de San Carlos at the age of twelve. He studied there with such distinguished academic artists as Rebull, Parra, Favrés, and the great Velasco. At the age of twenty, in 1907, with a scholarship awarded him by the Porfirio Díaz government, he moved to Madrid and studied with another noted painter, the academic realist Eduardo Chicharro. His painting of that era wavered between the Symbolism that was then the rage in Mexico and traditional Spanish realism. Unlike Barcelona, Madrid had been impervious to the various movements that had been scandalizing Paris and Europe since the final years of the past century. Although the years that Diego spent in Madrid gave him a solid technique, they did not open up new paths for him.

Perhaps that is why he leaves Madrid in 1909 . . .

And settles in Paris. But he follows the rear guard and cultivates, belatedly, an Impressionism derived from Monet. In 1910, a relapse

[1] *Diego Rivera: The Cubist Years*, Phoenix Art Museum, 1984. (There is a Spanish translation, which I have not consulted.) An edited version of Favela's essay appears in *Diego Rivera* (Mexico City: Fundación Televisa, 1983), a collection edited by Manuel Reyero, which also contains essays by Salvador Elizondo, Adrián Villagómez, and by Reyero himself.

into Zuloaga. Then, after that, a leap: through Signac and Pointillism, he comes to know the work and the aesthetic of Seurat. Almost at the same time and in an opposite direction, he undergoes the influence of Derain, the Fauve. According to Rivera, it was in this period that he discovered Cézanne, whose example remained with him throughout his entire career. But Favela has shown that Diego's painting was very far removed from Cézanne's aesthetic. In reality, following in the footsteps of his friend Angel Záraga, he found his source of inspiration in El Greco. This influence, Favela maintains, was conjoined with that of certain pre-Cubist canvases painted by Braque around 1907 and 1908. The result of this dual and divergent fascination was a memorable work, his first great painting: *The Adoration of the Virgin* (1913). Immediately thereafter, he takes another leap, a more timid one this time, toward a worldly "Simultaneism": the portrait of Best Maugard, in which Delaunay's dynamic mechanical wheels become stage decorations. Friendship with Modigliani, who painted a wonderful portrait of his Mexican friend. In 1914 he meets Juan Gris.

Another major meeting.

Yes, even though Diego embraced Cubism for only a few years. He came to this movement at a late date. Between 1914 and 1917 Diego painted remarkable canvases. His composition was impersonal, but that defect is not all that serious since Cubism, because of its classicist ambitions, was a school that encouraged impersonality. The color was vivid and strong; in all likelihood, orthodox Cubists found those bright-colored compositions decorative. In 1914, Diego's first and only individual show in Paris was held, in the tiny gallery of Bertha Weill, a long-time friend of Picasso's who had, however, had a falling-out with him. A *maladresse*: the organizer of the show was Weill. She signed the presentation text with only the initial of her first name (B.) and took advantage of the occasion to poke fun at the Spanish painter and his friends. Favela says that this text was the cause of the silence that surrounded the

exhibition. No: Apollinaire wrote two articles on it, brief but favorable ones, in which he tries to apologize for Rivera. After reprinting the offensive text, he states that Rivera was doubtless innocent, since the preface treats with contempt the modern art that the painter loves.[2] In those years Rivera admired Picasso and described himself as his disciple. Apollinaire, a close friend of the Spaniard's, knew this; he forgave Rivera because he was convinced of Rivera's innocence.

Favela and others see in this incident and in the dispute with Reverdy three years later the origin of a conspiracy by painters, critics, and galleries against Rivera. They exaggerate. The truth is that his painting, though not lacking in interest and merit, was not particularly intriguing: it opened up no new paths. Rivera was a late practitioner of Cubism. It is just as erroneous to maintain that Diego, motivated by his revolutionary convictions, broke with galleries and with "bourgeois art" during those same years. It is closer to the truth to presume that, in the face of the difficulties that he was encountering in Paris, he thought of going back to his homeland as a way out. It was a fortunate choice: the return to Mexico was yet another beginning—the definitive one.

But there were other skirmishes . . .

Diego was a friend of Gris and of Lipchitz. In June of 1917 he signed with them, and with Metzinger, Lothe, and Severini, a public statement against Apollinaire.[3] A few months before, in

[2] *Chroniques d'Art, 1902–1918*, Paris: Gallimard, 1960.

[3] On June 24, *Les mamelles de Tirésias*, "a Surrealist drama" by Apollinaire, had its premiere in Paris. The stage sets and costumes were by Serge Férat. The press spoke, vaguely, of Cubist staging, and this sufficed to unleash the wrath of Gris and of other Cubists, who looked with disfavor on Férat. The protest of these painters stated, in rather moderate tones: "We, Cubist painters and sculptors, protest against the irksome connection that people are trying to establish between our works and certain literary and theatrical fantasies that it is not our place to judge. . . ." The public declaration hurt Apollinaire's feelings, and in a

May, Rivera had come to blows with the poet Pierre Reverdy, at a gathering at André Lothe's. This is not the only instance of physical violence in Diego's career. In Mexico City he went out walking during a storm with a heavy cane from Apizaco in order, he said, "to help criticism find its bearings." Reverdy was a touchy man too, famous not only for his poems and essays but also for his sudden outbursts of anger. People still talk of his bitter quarrel with Vicente Huidobro over the paternity of "Creationism." In his review, *Nord-Sud*, Reverdy devoted a most amusing article to his fisticuffs with Diego. But it is absurd to attribute Reverdy's satirical attack—as some do, more or less rashly, in Parisian circles—to his lack of sympathy for Socialism. That subject played no part in the argument, and Rivera himself would have been amazed if anyone had mentioned it in connection with Cubism. In May 1917, not even Lenin knew that he would assume power in October.

In the following year Diego abandoned Cubism.

Yes, but not in order to embrace the still nonexistent "Socialist realism." It is errant nonsense to say that he abandoned Cubism because of his revolutionary convictions, which in turn also impelled him to break with galleries and "bourgeois art." It is impossible to find in the Rivera of those years the least trace of revolutionary political preoccupations. He had arrived in Europe in 1907, on a scholarship awarded him by a leading figure of the

letter to Reverdy he writes: ". . . the band of those who have invaded Cubism and with whom I never wanted to be associated hit on the idea that the right moment had come to attack Serge and me. . . . They thereby gave me the opportunity to separate myself from commercial Cubism. . . . I'll stick with the great painters of Cubism. . . . I feel sorry for Gris but he had no reason to get involved in this row. . . ." Immediately thereafter, he breaks with Gris in another letter: "I hereby inform you that our friendship has ended. . . . Don't forget, furthermore, that the play is *Surrealist*, and that the word *Cubism* has been carefully avoided." (See Pierre Marcel Adéma, *Guillaume Apollinaire*, Paris: La Table Ronde, 1968.)

old regime, Teodoro Dehesa, the governor of Veracruz; in 1910 he returns to Mexico for a few months, and on November 20, that is to say, the very day on which the Mexican Revolution begins, Rivera holds a showing of his works at the Academia de San Carlos. It does not seem as though the painter realized that serious social upheavals were beginning: his exhibition was opened by Doña Carmen Romero Rubio, Porfirio Díaz's wife. Almost all the paintings were sold, and Rivera returned immediately to Paris, in all likelihood with the same stipend from the state government in Veracruz.[4]

Like all the other Mexicans living in Europe, Diego no doubt followed with great emotion and anxiety the events taking place in Mexico, though he gave proof of no definite political and social inclination. In 1914, when war broke out in Europe, he thought for a brief time of enlisting as a volunteer in the French Army: an odd decision for a revolutionary! Nor, during the first year of his return to Mexico, did he give evidence of ideological tendencies toward Marxism. His first mural, *Creation*, in the Simón Bolívar Amphitheater, is an allegorical composition with mythological and religious motifs. In like manner, his first frescoes in the Secretariat of Public Education (1923) reveal no ideological tendency. Only in 1924, in the same building, does he begin to paint revolutionary subjects.

How do you explain his abandonment of Cubism in 1917?

It is hard to answer your question. Most Cubists were exploring other paths in those years. But there is no doubt whatsoever that Diego did not leave Cubism for social painting; nor did he venture into new territory: he went back to Cézanne. Hence his insistence on asserting repeatedly that he had discovered Cézanne in 1910; by so claiming he wanted to show that his evolution had been

[4] Ramón Favela, *Diego Rivera*.

similar to that of the great Cubists: Picasso, Braque, Gris. The return to Cézanne in 1917, after his Cubist experience, is yet another proof of Diego's traditionalism. It is a constant note in his entire body of work, as I have said before. Elie Faure approved of the change, but that critic's applause, though it spurred him on, did not open the doors of the galleries to him, nor did it open those of critical recognition. At this moment, when all of Europe was reeling, destiny intervened: in 1920 he met Alberto J. Pani, the Minister of Mexico in Paris. Pani was an art lover; he lent his patronage to Zárraga and other painters and redid our Mission in art deco style (the Mission was ruined by his barbarous successors). Diego painted his portrait and Pani bought from him *The Mathematician,* one of his best paintings. Shortly thereafter, Pani arranged a trip to Italy for him, sponsored by the University of Mexico, that is to say, by José Vasconcelos, who at the time was its rector. In Italy Diego encounters the Byzantine mosaics of Ravenna, meditates upon the lesson of the quattrocento, and studies the masters of Siena. In the following year, called back by the government, he returns to Mexico. I think this all too brief account gives some idea of his complex evolution.

Diego was a great easel painter . . .

Yes. Some of his oils are not inferior to his best mural paintings. I have referred to the *Adoration of the Virgin* (1913) and *The Mathematician* (1919) but there are others. Salvador Elizondo rightly mentions the forceful portrait of the powerful Guadalupe Marín (1938) and two extraordinary nudes of 1939, *Ballerina in Repose* and *Dance on Earth.* Certain compositions with flowers and fruit could be added to the list, as well as many portraits, especially of nameless individuals, little village boys and girls. These latter works are unforgettable.

Prejudices and Spiderwebs

Let us go back to Muralism. What is your present opinion?

It is difficult to make an overall judgment. Orozco, Rivera, and Siqueiros were very different. Each of them was a powerful personality, and it is not possible to judge the anarchic Orozco and two ideological artists such as Rivera and Siqueiros by the same criterion. In general, I might say that Mexican mural painting impresses me by its vigor. And by how much of it there is! It is impossible to be indifferent to so many miles of painting, some abominable and some admirable. It is a painting that often irritates me but at times also excites me. It can be neither hidden nor disdained: it is a powerful presence in the art of this century. Before judging it, however, we ought to correct a number of misapprehensions that intrude themselves between it and the viewer. These mistaken ideas are emotional and ideological veils that keep us from really *seeing* it.

What are these mistaken ideas?

In the first place, nationalism. Mexican mural painters have been turned into plaster saints. People contemplate their paintings the way devout believers contemplate sacred images. Their walls have become not painted surfaces that we may view but fetishes that we must venerate. The Mexican government has made a national cult of Muralism, and, naturally, criticism is proscribed in any and every cult. Mural painting belongs to what might be called the Wax Museum of Mexican Nationalism, presided over by the head of Juárez the Taciturn. Apart from this sentimental misconception, the aesthetic incongruity. Many of the Muralists' works were painted in venerable buildings dating back to the seventeenth and eighteenth centuries. An intrusion, an abuse, something like putting a Phrygian cap on the Venus de Milo. What does the Colegio de San Ildefonso, a masterpiece of the architecture of New

Spain, have to do with the frescoes that Orozco painted there? Rather than real mural painting, a number of them are enlarged lithographs, despite the fact—I do not deny it—that they are impressive ones.

The third misapprehension is more serious. It is a moral and political one. Those works that call themselves revolutionary and that, in the cases of Rivera and Siqueiros, give proof of a simplistic and Manichaean Marxism, were commissioned, sponsored, and paid for by a government that had never been Marxist and that had ceased to be revolutionary. The government allowed artists to paint on the walls of government buildings a pseudo-Marxist version of the history of Mexico, in black and white, because such painting helped to give it the look of being progressive-minded and revolutionary. Populist and progressivist nationalism has been the mask of the Mexican state. As for Rivera and Siqueiros: they couldn't have helped but realize that in Mexico they could paint with an independence that they never could have had in Russia. Hence there was a dual complicity, that of government administrations and that of artists. Here again I must make an exception for Orozco. He was the most rebellious and the most independent of these artists; he was probably also the best of them. An impassioned, sarcastic, and religious spirit, he was never the prisoner of an ideology: he was the prisoner of himself. His contradictory and vehement genius made him fall at times into a melodramatic rhetoric, but at other times it sheds radiant light on his work and lends it a moving authenticity.

The ideological and political misconception has also affected criticism and distorted certain central incidents in the history of Muralism. An attempt has been made to cover up the meaning of the initial phase, and the participation of certain artists, such as Jean Charlot, or of certain personalities, such as José Vasconcelos, has been disparaged and efforts made to conjure it away. There were those who tried to ignore the fact that it was Charlot, and not

Rivera or Orozco, who discovered Posada; nor is any mention made of his theoretical works, which played a decisive role at the very beginning of the movement. Moreover, it is to Charlot that we owe its very first fresco. As for Vasconcelos: his part in it was crucial. Possessed by the phantoms of Byzantium and of the early Renaissance, that is to say, by the idea of "public art," he called on artists to paint the walls of various government buildings. Vasconcelos was not, of course, the inventor of modern Mexican painting, but would our mural painting exist without him?

I must now mention another such omission, a much more serious one, on the part of several critics and historians: in its early years, between 1921 and 1924, which were the ones that gave it a character and an appearance all its own, mural painting did not yet have the uniform ideological coloration that ended up petrifying it in a rhetoric of revolutionary commonplaces. To confirm this, one need only take a quick look at the murals painted in the earliest stage. Roberto Montenegro finished the first wall in 1921, in the Church of San Pedro y San Pablo. The subject: landscapes and architectures; the technique: tempera (employed with so little practical experience that the paint very soon began to peel away). In the adjoining convent of San Pedro y San Pablo, Dr. Atl painted, in 1922, several landscapes and esoteric compositions; in the same place and the same year, Montenegro executed a composition in encaustic, *The Day of the Holy Cross*. In the Colegio de San Ildefonso several painters showed the same inclination toward the painting of religious festivals: a mural by Fernando Leal represents the fiesta of the Holy Lord of Chalma (1922). Jean Charlot painted *The Fall of Tenochtitlán* (1922), a masterwork thanks to its dynamic composition and its rhythm; Ramón Alva de la Canal, using the technique of the painters of cheap pulque bars, painted a fresco that has as its subject the erection of the first cross on the beaches of Mexico.

Another example: the unfinished murals by Alfaro Siqueiros,

also at San Ildefonso. They are memorable. I am thinking of his tragic Christ, of his angels with Byzantine colored wings, and above all, of his *Burial of a Worker*, a composition imbued with profound and manly piety that I unhesitatingly call religious. The walls painted by Orozco between 1923 and 1927 are of many varieties: religious, such as those on the subject of Franciscans and Indians; allegorical, such as the Botticellian *Maternity*; and the monumental one representing Cortés and Malinche. Others are aggressively anti-clerical and antibourgeois, more in the anarchist tradition than in the Marxist. Others, finally, are satires of the revolutionary movement, *The Trinity*, for instance. In the Bolívar Amphitheater, in the same building, Rivera painted, as I mentioned before, a symbolic and mythological allegory. I have already spoken of Diego's first frescoes in the Secretariat of Public Education (1922–23), very far removed from the ideological aesthetic that he was to adopt shortly thereafter.

On July 9, 1922, José Vasconcelos, inaugurating the new build-ing of the Secretariat of Public Education, delivered a speech out-lining, in succinct but clear terms, the plan for his historical and cultural project. This project—his and the new revolutionary government's—was *national*, but not, he said, "because it is aiming at shutting itself up within our geographic borders but because its intent is to create the essential traits of an indigenous Hispano-American culture." Vasconcelos's nationalism was a Hispano-Americanism. This Hispano-American vocation, in turn, was open to the world. In another passage of his speech, the Mexican writer indicates that the four figures and names that appear in the four corners of the main courtyard of the building possess a precise symbolism: Plato, Greece and the origin of our civilization; Quetz-alcóatl, ancient Mesoamerican civilization; Las Casas, Spain and apostolic Christianity; Buddha, the future synthesis between East and West that the "Indo-Iberian lineage" must bring about. This

doctrine was the one that inspired Muralism at its start. It was cast aside later by Calles and his administration, which adopted revolutionary nationalism. In the same speech Vasconcelos refers to Diego Rivera in terms that unmistakably reveal the accord between his own ideas and those of the painter: "For the decoration of the walls along the hallway of the building, our great artist Diego Rivera has already sketched figures of women dressed in costumes typical of each state of the republic, and for the staircase he has in mind a frieze rising upward that begins at sea level with its tropical vegetation, then turns into the landscape of the high central plain, and ends with the volcanoes."

Orozco's testimony is as clear as day: ". . . all the painters began with subjects derived from traditional Christian iconography . . . the Pantocrator, virgins, saints, burials, martyrs, and even the Virgin of Guadalupe." In the first part of this list Orozco is alluding to Siqueiros's murals in the lower school of the National Preparatory School (the *Christ*, the *Angel* and the *Burial of the Worker*); in the latter part he is referring to Leal, Revueltas, and Alva de la Canal. Orozco also points out (and mourns the fact) that painters have on occasion retouched his paintings to introduce certain changes. He is probably referring, among other changes, to the lid of the coffin in the burial scene painted by Siqueiros along the stairway of the lower school, which today shows a sickle. Orozco himself, moreover, also made substantial changes to several murals on the ground floor of San Ildefonso. In the Secretariat of Public Education, Jean Charlot and Amado de la Cueva painted frescoes inspired by daily labor and popular fiestas. . . .

I don't believe it necessary to mention more examples. This brief résumé shows that in its earliest days the Muralist movement was a plurality inspired by different tendencies. Only later, under the influence of Siqueiros and Rivera and backed by zealous disciples and fanatical critics, did it turn into an ideological art.

And once the misapprehensions that keep this painting from being seen are laid aside, what do you see?

My conviction that the work of art is always unfaithful to its creator is confirmed. The work of art says something different from what the artist intended. I shall give an example: the Ajanta murals in India are justly famous; no one thinks, however, that it is necessary to see those murals *from* the perspective of Buddhism rather than *through* the beliefs and ideas of that religion. It is not necessary to believe in bodhisattvas to love these paintings. Art is a world beyond art; it says something more than and, almost always, something different from what the artist tried to say. Thus, in its best and most intense moments, Mexican mural painting is something more than, and something different from, the ideology of those painters and their patron, the Mexican government. Rivera the painter, fortunately, frequently refuted Rivera the ideologue.

A History of Masks

You have spoken of Rivera in particular. Do you believe that his influence played the decisive role in the change of the Muralist movement toward more and more Marxist positions?

No. Diego was extremely astute and made haste to go along with the tide of opinion. To make this point clear, one need only recall that he returned to Mexico in July of 1921, after the Muralist movement had already begun, and that the subjects of his first murals, in the Bolívar Amphitheater and in the Secretariat of Public Education, were mythological allegories and representations of popular life.

And what about Siqueiros?

He too was in Europe. He came back to Mexico a year after Rivera, in September 1922. In Barcelona he drafted an appeal to

the artists of Latin America that was published in the only issue of the avant-garde review *Vida Americana* (May 1921). In this text he denounces Spanish academic painting, "the anemic art of Aubrey Beardsley, the archaism of Zuloaga," and, finally, art nouveau. He declares himself the heir of Cézanne, admires "three Spaniards of genius: Picasso, Gris, Sunyer [sic]," and enthusiastically welcomes the experiments of the Cubists and the Futurists. Following the example of modern European artists in their attitude toward "the admirable human content of Negro art and, in general, of primitive art," he recommends the return to the art of the Mayas, the Aztecs, and the Incas. He comes out, however, against the "lamentable archaeological reconstructions, such as Indianism and [Latin] Americanism, that are all the rage." (This is a criticism that, years later, in a more comprehensive and consistent way, he was to repeat in his opposition to Rivera and his followers.) The manifesto ends with an attack on "literary motifs" and a glorification of "pure fine art." It would be pointless to look for allusions to social art, collectivism, or ideological and political painting in this text. Siqueiros's position, in 1921, was no different from that of most European avant-garde artists, that of the Futurists in particular. The frontispiece of the review, in accordance with the aesthetic taste of its editors, reproduced a caricature of Ambroise Vollard by Marius de Zayas, Apollinaire's and Duchamp's friend.

The Futurist influence is present not only in Siqueiros's work but in many of his ideas and preoccupations concerning pictorial technique.

Yes. In Siqueiros's activity there is a Futurist facet and another that is Constructivist. On the other hand, his interest in the *metaphysical painting* of Chirico and Carrá is less well known. In a recent book devoted to Mexican mural painting, Serge Fauchereau, author of valuable studies of modern poetry, emphasizes the fact that

Siqueiros visited Carrá while passing through Milan.[5] A painting of Siqueiros's reproduced in *Vida Americana* shows the twofold influence of Chirico and Carrá. The mannequins and automatons of these painters frequently reappear in the Mexican painter's murals. But the trip to Italy was memorable for another reason: the frescoes of the great masters of the early Renaissance and the Ravenna mosaics. This experience had a profound effect on him, as it did on Rivera. On his return to Mexico in 1922, as I have already said, Siqueiros painted on the walls of the lower school of San Ildefonso several compositions that are noteworthy because of their religious emotion. Charlot's testimony dispels any doubt on the subject: "The roots of modern Mexican art were so deeply sunk in the colonial past that my new friends . . . can scarcely conceive of a nonreligious art. . . . Orozco, the good anarchist, painted a series of frescoes to glorify St. Francis. Siqueiros, in an allusion to Columbus, painted a St. Christopher."[6] Siqueiros himself referred to "the mystical tendencies and the Romantic subjectivism that appear in my works."[7] In another text he alludes to the subject once again: "The mystical aestheticism of our first mural painters, that is to say, those of the early period of the National Preparatory School." Siqueiros naturally included himself in this mysticism.

[5] *Les peintres révolutionnaires mexicains*, Paris: Messidor, 1985. In my opinion, Fauchereau's monograph is the best historical and critical synthesis of Mexican Muralism. Laurence E. Schmeckebier's *Modern Mexican Art* (Minneapolis: University of Minnesota Press, 1939), though more comprehensive and still indispensable on a number of points, has become somewhat dated.

[6] *An Artist on Art (I)*, Honolulu: University Press of Hawaii, 1972.

[7] "Synthèse du cours historique de la peinture mexicaine moderne," a lecture delivered by Siqueiros at the Palacio de Bellas Artes on December 10, 1947. Reprinted in *L'art et la révolution* (Paris: Editions Sociales, 1974), a selection of Siqueiros's texts by Raquel Tibol. I use the French translation because this lecture is not included in *Textos de David Alfaro Siqueiros* (selected, with an introduction, by Raquel Tibol, Mexico City: Fondo de Cultura Económica, 1974).

So the change . . .

The change can be pinned down, more or less precisely, to 1924. It was not all-embracing: Orozco took another path, Charlot left the country, others accentuated nationalism and folkloristic themes. The change was evident in two central figures: Rivera and Siqueiros. In them and in their disciples, followers, and imitators, who were numerous. It was preceded by the founding of the Union of Revolutionary Technicians, Painters, and Sculptors in 1923. The manifesto of the new organization was apparently written by David Alfaro Siqueiros and signed by Rivera, Orozco, Charlot, Mérida, Fermín Revueltas, and others. It is a revolutionary text, like many others that appeared in those years in various countries, but it is not a Marxist text. That is no doubt the reason why it was signed by Orozco, Charlot, Mérida, Montenegro, and several others. And for that same reason, the founding of the union was interpreted in different ways. Schmeckebier says in *Modern Mexican Art*: ". . . there were those who saw it as a Communist propaganda organization, others as a medieval guild under the aegis of the government and others still as a spontaneous manifestation of the rebirth of the age-old art and culture of Mexico."

What is your opinion?

It seems to me that all three interpretations are true. The precursor of the union, its origin, was the Centro Artístico, a group founded in 1910 by Dr. Atl (Geraldo Murillo) and a group of young artists. They were rebels, antiacademics, and nationalists. In Atl's ideas it was not hard to perceive vague anarchist and Socialist sarcasm. Thanks to Atl's provocation, Díaz's government commissioned the Centro Artístico to decorate the walls of the Bolívar Amphitheater. In point of fact, Justo Sierra had originally chosen the painter Saturnino Herrán, but for various reasons he was not able to execute the commission. Nor were the young painters of the Centro Artístico: when the scaffolding needed to begin the

work had already been put in place, the Revolution broke out. Twelve years later Diego Rivera painted those walls. Another example of an open secret: the breaks between Díaz's regime and the revolutionary government almost always end up being mended.

The 1923 union, garnering the heritage of the 1910 Centro Artístico, was first and foremost an association of artists, a guild. But the guild almost immediately became a political and ideological organization. With his usual opportunism, Rivera wanted to merge it with CROM (the Regional Confederation of Mexican Workers), which would have meant yoking it to the government's policy. The doctrinaire Siqueiros, for his part, conceived of the union as an organization more or less directly affiliated with the Mexican Communist Party. According to Schmeckebier, the artists did not trust Rivera, who thirsted for publicity and had no real relationship to the revolutionary movement in Mexico: his tendencies at the beginning had been historico-religious (*The Creation*, in the Bolívar Amphitheater) or post-Cubist (the early murals of the Secretariat of Public Education) and in both cases not in keeping with the revolutionary spirit. The worst of it was that, once Rivera had been left out in the cold, the union turned into Siqueiros's private club.

The year 1924 was a focal one, the year of the change. José Vasconcelos resigned from the Ministry of Public Education in January (General Calles had assumed power in September), and on March 15th the first issue of *El Machete*, edited and published by Rivera, Siqueiros, and Guerrero, appeared. The early issues were memorable for José Clemente Orozco's satirical engravings. Soon, however, *El Machete* ceased to be an artists' publication and increasingly became an organ for Communist propaganda. The first stage of Muralism was coming to an end. In that same year Siqueiros joined the Communist Party, to which he was to remain faithful until his dying day. Rivera too became a convert. With characteristic exuberance, he put out an abundance of declarations of principle,

laid down articles of faith and fulminated anathemas against what he had loved and thought only a few months before. On a wall of the Public Education building he painted a caricature of his benefactor, José Vasconcelos: *Cría cuervos* . . .[8] The union turned into a dogmatic, closed group. Abandoned by most of its founding members, it finally fell apart. It was a victim not of the hostility of the government but of its own internal dissensions.

But relations between the government and Communist painters soon deteriorated . . .

No. The process was slower and more complex. Calles's government was more radical than the one that had preceded it, especially during the early years of his term as president. It was a nationalist, revolutionary, and anticlerical regime. In that same year, 1924, diplomatic relations were established with the USSR. The first ambassador was the well-known and intelligent Alexandra Kollontay, who captivated Mexican intellectuals and the press. Her declaration "There are no two countries in today's world as similar to each other as Mexico and the USSR" gave rise to any number of commentaries. The conservative press in the United States and elsewhere began to speak of the "Bolshevization of Mexico." At the end of this period the situation changed: in 1929, during Portes Gil's administration, relations with the USSR were broken off and repressive measures against Communists began to be taken. But in 1934, when General Lázaro Cárdenas took over the presidency, the Communists regained their government posts and won others.

All these fluctuations had their effect on the attitude of the government toward the Communist painters, although its patronage did not cease altogether. Vasconcelos's policy was continued, and

[8] The title was taken from an old Spanish proverb: *Cría cuervos y te sacarán los ojos*: "Raise crows and they'll pluck out your eyes," i.e., "Mind you don't lavish your gifts on the ungrateful" or "Mind you don't raise a snake in your bosom." —TRANS.

the walls of government buildings were covered with frescoes. The painter who benefited most was Diego Rivera. There was a considerable share of opportunism in the government's policy, and the same must be said of the attitude of the painters. Both parties, the artists and their patrons, found this compromise advantageous. It is not beside the point at this juncture to note, in passing, that the relationships between the administrations of that era and the Muralists are a chapter—though not the main one—of a much vaster subject, which has left a deep mark on the modern history of Mexico. I am referring to the integration, within the political system by which we are ruled, of the intellectual class, particularly the so-called leftist sectors. This is a matter of a modus vivendi that has lasted for more than half a century, from 1920 to our own day. It is a tacit arrangement that has survived each and every crisis and divorce; whenever there is a break, it is followed, shortly thereafter, by a new alliance. This compromise has inflicted serious damage on Mexican political life, has hamstrung independent thought and has helped cause—not alone, however—the poverty of our intellectual and ethical criticism.

How do you explain the attitudes of the state and of the painters?

Our administrations see themselves as the heirs and perpetuators of the Mexican Revolution. Hence, from the beginning, it has been their aim, insofar as possible, to exploit the painting of the Muralists to close their eyes—or, rather, half-close them—to certain dogmatic and doctrinaire abuses. They have looked on mural painting as a public art that, beyond this or that ideological inclination, expressed the genius of our people and its revolution. To the painters—orthodox ones, heterodox ones such as Rivera the Trotskyite, and even mere "fellow travelers"—it was once again no longer beyond contempt to use the walls of public buildings, when possible, to disseminate their beliefs. Thus, the divergent interests of the government and of the painters coincided on an essential point.

Your explanation is above all a political one.

I would slightly rephrase your opinion: it is a functional expla-
nation. Your conclusion, without being mistaken, is incomplete. It
is necessary to consider other, no less decisive, circumstances: his-
torical, social, psychological, affective ones.

Vision and Ideology

Would you care to be more explicit?

I have referred to the subject on a number of occasions, so I
shall be brief. One of the distinctive traits of the Mexican Revo-
lution was the absence—relatively speaking, naturally—of an ide-
ology that was also a universal vision of the world and of society.
Comparison with the English Revolution of the seventeenth cen-
tury, with the American and French revolutions at the end of the
eighteenth, or with that of Russia in the twentieth will spare me
a long demonstration. The Mexican Revolution was a terrible pop-
ular uprising and that is why I have more than once called it a
revolt. The result of that revolt, as I have attempted to show in a
number of my writings, was a compromise between the different
factions that was not only political but ideological.[9] But revolutions,
which are the modern versions of old religions (and, more often
than not, their bloody caricatures), require total visions of human-
kind and of history. Those global ideologies are their justification,

[9] See, in particular, *El laberinto de la soledad*, Mexico City, 1950. (American ed.:
The Labyrinth of Solitude, trans. Lysander Kemp, New York: Grove Press, 1961.)
I need scarcely point out that my mere glancing reflections need to be amplified.
They lack, for example, an analysis of an essential theme of our history: the
influential role of intellectuals in the revolutions of the past century (independence
and liberalism), in contrast to their modest part in the great popular revolt of 1910.
Another subject worth thinking through carefully: the dominance of the intellec-
tual class during the regime of liberal despotism exemplified by Porfirio Díaz and
during the postrevolutionary regime, from 1920 to the present.

their reason for being; without them, they would not really be revolutions. Religions are almost always based on the revelation of a deity; revolutions, on the revelation of an Idea. Hence revolutions are disincarnate religions, the skeleton or the ghost of religion.

In Mexico, fortunately, we did not have a total ideology, an Idea transformed by revolutionary ecclesiastics into a universal catechism, the foundation of the state and of society. *We did not have a metahistory.* This spared us many horrors; for instance, we have had popular and governmental violence but no ideological terror. The absence of a revolutionary Idea, however, was resented by many, intellectuals in particular. It must not be forgotten that modern intellectuals are the descendants of the clerical and ecclesiastic orders of the past. Certain of them wanted to fill the vacuum, some, such as Vasconcelos, with philosophies of their own invention, others with imported philosophies and ideologies of global import. Among them, and in the first rank, Marxism, which in the twentieth century has been the ideology par excellence of the intellectual class.

In your first essay on the Muralists, in 1950, you stated that "the Marxism of Rivera and his comrades has no other meaning than that of replacing the absence of philosophy of the Mexican Revolution with an international revolutionary philosophy."

Precisely. In the same text I pointed out that "the nonexistence of a great proletariat or a meaningful Socialist movement—that is to say: the lack of relationship between social and historical reality and the painting that attempted to express it—gave the Muralism of Rivera, Siqueiros, and others an unavoidable inauthentic nature." This is still what I think.

What other path could the painters have taken?

It would have been very hard for them not to have chosen the one that they in fact chose. Mexican mural painting was above all the expression of a victorious revolution. That revolution, like all

the rest, saw itself as the beginning of a new age. Not only Díaz's dictatorship but nineteenth-century liberalism now lay in the past. Díaz's regime, after all, had been a deviation, an aberrant form of liberalism. The Revolution was something more than a rectification of the vices and errors of the dictatorship. On the one hand, it was a resurrection: the Mexican past, Indian civilization, popular art, the buried spiritual reality of a people; on the other, it was a renovation, or more exactly, a *novation*, in the juridical sense and in the figurative one of a thoroughgoing beginning. The first to translate this idea in aesthetic terms was Vasconcelos. He often spoke of an organic, total art inspired by that of the great periods in history and particularly by that of Christianity: Byzantium and the quattrocento. The painters immediately adopted this conception, developed it, and began to put it into practice. Why? Because it admirably suited their aspirations and the necessities of the moment. It was an answer, at once creative and their very own (national), to the modern art that they had known and practiced in Paris. An answer, not a rejection: they too were modern—as Orozco, Siqueiros, and Rivera said more than once—and they had incorporated into their art many of the techniques and forms of their European contemporaries.

Perhaps we should pause to consider this subject.

And to repeat certain things. . . . The ambition to create a public art requires at least two conditions for its fulfillment: first, a community of beliefs, feelings, and images; second, a vision of humanity and of its place and mission in the world. With respect to the first: it is evident that the painters believed that they were expressing the collective beliefs of Mexicans. If we consider the very start of their activity, they were not mistaken. In the beginning they took their inspiration from the images of tradition and celebrated Mexico's patriotic holidays, fiestas, and popular life. They also glorified the Mexican Revolution and its heroes and martyrs.

But there is no denying that during the second stage of the move-
ment, the ideological one, neither their images and themes nor
their beliefs and convictions could be those of the Mexican people.
In this second phase their art was not popular but didactic; it did
not lend expression to the people: its aim was to indoctrinate them.
Their interpretation of our history was motivated by self-interest,
intolerant, partial; their frescoes are the counterpart of the no less
unjust and ignorant opinions propounded by so many clerics in the
sixteenth century when confronted by the religion and the civili-
zation of the Indians. Orozco's painting was not an expression of
popular beliefs and feelings either: it was a personal, tragic vision
of the fate of humanity. Concerning this point: neither Vascon-
celos's philosophy—soon cast aside by the government—nor the
ideology of the revolutionary regime—haphazardly woven together
from various traditions and political and social tendencies—could
be transformed into that total vision of the world and of humankind
that is the inspiration of public art. I will repeat, yet again, that
such visions have always been religious, as is demonstrated by the
examples of Egyptian art and that of the Greek, Buddhist, Hindu,
Christian, and Islamic polis.

*How do you explain the fact that Rivera, Siqueiros, and their followers
saw in Communist ideology the modern equivalent of the vision that had
inspired Christian artists?*

It is yet another proof of the unfortunate modern confusion
between religion and politics, revolution and salvation. Orozco, by
contrast, distinguished between politics, clericalism, and religion.
His vision of the world and of history came from a symbolic and
esoteric tradition. But his art was not public either: it was a personal
vision.

And the others?

To understand the decision of those who adopted the *Bolshevik*
version of Marxism we must remember that in those years the image
of the Russian Revolution appeared on the historical horizon as an

event destined to change the fate of humanity. I have spoken of an *image* and an *apparition* because it was a matter of a genuine vision, in the psychological and in the religious senses of the word. It deeply moved intellectuals and artists all over the world. For the Mexican painters—let us not forget the religiosity of many of their first mural compositions—it had a special significance: it was the answer to their predicament. The Russian Dawn, as Waldo Frank called it, brought enlightenment to many consciences in 1924. In accordance with the logic of every millenarianism, a group of Mexican artists shared in those years a portentous experience: being witnesses to and actors in the Change of Times. Only the divinatory gaze of Orozco perceived, with terrifying clarity, the true reality of that awesome dawn; the other two, Siqueiros and Rivera, became converts to the new idolatry.

What do you think of the public art of Mexico?

Are you referring to the idea or to the reality, that is to say, the painting? On the latter I have already given you my opinion: as an overall phenomenon, it is impressive. It is impossible to close our eyes to so vast, so powerful, and so discordant a presence. On the other hand, the idea of public art strikes me as a sentimental nostalgia and a dangerous anachronism. Vasconcelos, and Rivera and Siqueiros as well, proposed, though for different purposes, to follow the example of the art of Byzantium, Egypt, Teotihuacán, the quattrocento. I emphasize again that this art was not only a religious but a governmental and even a dynastic phenomenon. It was the expression of collective beliefs and mythologies but, at the same time, the product of the will of states and churches in which there was a fusion between religion and power, that is, between a doctrine and an ecclesiastic and military bureaucracy. It was an art that took its inspiration from a community of collective sentiments and images; to an equal degree it was, and still is, a testimonial to the unanimity that religious and political orthodoxies impose when they hold power. Free art has destroyed that unanimity again and again.

In the West, free art first appears in Athens, as the offspring of political democracy. It is the art of tragedy and comedy in the classical era: Aeschylus, Sophocles, Euripides, Aristophanes. With them the criticism of religion, of social ethics, and of power makes its appearance. Its main theme is religious and political: the disasters brought on by hubris, the sin of gods and semigods, of heroes and princes. Rome was also familiar with free art, and I scarcely need mention Lucretius, Lucan, or the *Satyricon*. In the Renaissance, free art appears again, and since then there has been the art of modernity, which has manifested itself not only in literature but in music and the visual arts—Goya, Courbet, and any number of others.

The art of modernity has been, simultaneously, critical creation and creative criticism, an art that has made of criticism a creation and of creation a critical, subversive power. For this reason, despotic states and intolerant churches have always looked on it with horror and have persecuted it whenever they have been able to do so. In modern works, affirmation and negation are closely meshed; analysis, reflection, and doubt engage in dialogue with the old certitudes. The mission of public art was the celebration of an orthodoxy and the glorification of its heroes and those whom it had beatified—also the condemnation of all heterodoxies and the damnation of heretics, reprobates, and rebels. Modern art, precisely because it is not a public art, has devoted itself to the criticism of heaven above and the earth below, of reason and of the passions, of power and of submission, of sanctity and abjection, of myth and of utopias. This criticism has been creative, for it has invented worlds of living images, forms, and creatures. And there is something more: it has bent down to examine itself, has dismantled the creative process and reflected on forms and their secret structures. Its explorations have been creations and, in the twentieth century, go by the names of Impressionism, Expressionism, Cubism, Abstractionism. The subversion of forms has its parallel in the rebel-

lion of the passions and of images: Romanticism, Surrealism. The adventures of art have been the adventures of freedom.

For all the foregoing reasons it seems to me that the idea of returning to public art, or of inventing one for our time, was a reactionary nostalgia. Public art has invariably been the religious art of a state or of a church as powerful as a state. By definition, there is no such thing as public art made by isolated individuals or private groups. On the other hand, revolutionary art, which is simply a variation of free art, has been the work of independent, marginal, or clandestine individuals or groups. The phrase *revolutionary public art* not only contains a contradiction but is, in fact, meaningless. Likewise, only through an abuse of language—which is also a logical and moral abuse—is it possible to speak of a revolutionary art sponsored by the state.

Since we live in a horrible era of internal strife, chaotic passions, and unbridled acts of violence—a lawless, godless time—the idea of order has fascinated many of our contemporaries. That is natural and understandable. At one extreme, this illusion cast its spell over Eliot and Claudel; at the other, over Brecht and Neruda. But the nostalgia for orthodoxies and for order that they enjoin generally conceals the fear and the hatred of freedom. Order has very often been the mask of despotism, especially in periods of tremendous convulsions such as our own. In the twentieth century the old forms of oppression of humanity have been extended, renewed, and strengthened, but their new guise ought not to make us forget that, like those of the past, their essence lies in an alliance between the idea and the sword. The public art of Rivera and Siqueiros was frequently the painted apologia of the ideological dictatorship of an armed bureaucracy. In this sense, more than in its aesthetic, it is reminiscent of the art of the pharaohs and of Byzantium.

You spoke before of the lack of organic relationship between the ideas of the Muralists and Mexican social reality.

This is the strangest and most disturbing trait of Muralism as

a historical, political, and moral phenomenon. Neither the nation nor the Mexican government was Communist; nevertheless, the state adopted an art that expressed ideas that were different from and even contrary to its own. Demagogy, duplicity, lack of awareness? The paradox—let us call it that—was no less scandalous on the part of the painters: their painting was, simultaneously, official and revolutionary, state-sponsored and against the state and its ideology. Reflection on the relations between the state and the Muralists shows us what a mummery the modern history of Mexico is. Let me add that Muralism is but one of the episodes in this masquerade.

Is there nothing missing in your explanation, or rather, in the series of explanations that you have outlined?

The decisive circumstance, and the one on which all the others depend, is missing.

And what is that?

The nonexistence of an artistic market. In the past, the nobility of New Spain and the Church were artists' patrons. The Church in particular: the great art of New Spain was above all else religious. The civil wars of the nineteenth century, which impoverished the country; the triumph of the liberal faction, and, finally, the intellectual and artistic decadence of the Church itself put an end to the traditional sources of patronage. Unlike what happened in Europe, the middle class was able to replace the former patrons only in a tentative and partial way. At the end of Porfirio Díaz's regime, however, thanks to the years of peace and prosperity, a class existed that was beginning to be interested in the nation's artists and was acquiring their works. One example: Diego Rivera's exhibition in 1910, in which nearly all his paintings were sold. The revolution impoverished the oligarchy, and therefore in 1920 painters could find no other Maecenas except the state. A sponsor like Sergio Francisco de Iturbe, educated in Europe, was exceptional, and no

one similar appeared on the scene until years later. If a painter wanted to paint, he was obliged to rely on the government, the universal patron.

It was a curious form of paternalism.

Between 1920 and 1945, the Mexican state substituted for society both in the field of the arts—painting, sculpture, music, dance—and in that of literature. In the sphere of painting, the result was public art, an art that was simultaneously official and revolutionary. In the sphere of letters, the result was also paradoxical. There were no publishing houses and scarcely any readers, and the career of university professor—today so generously subsidized—was closed to most (apart from the fact that the salaries were ridiculously low). Writers had to become government functionaries to survive. Revolutionary administrations received them cordially and supported them: writers knew how to write and how to handle ideas, so they were very useful in this first period of national reconstruction. But they did not have readers, or, to put it more precisely, writers' readers were other writers. There thus came into being a refined, hermetic literature, at times exquisite to the point of preciosity and, at others, engrossed in its own abyss. Poetry flourished, a poetry that adopted as its masters the most demanding and difficult poets, such as Valéry and Rilke. We owe to this period some of the purest and most perfect works of modern poetry in Spanish, the poems, for instance, of Gorostiza and Villaurrutia. The two faces of the art of this period: public art and secret poetry, the city square and the boudoir, the multitude and the mirror. Reverse symmetry. Two extremes, both indispensable: which to choose? I know very well that our poets are often forgotten, whereas the painters are always present in the public's memory. Rather than a lack of taste or an aesthetic sin, this seems to me to be a spiritual mutilation.

The prose of that period does not have the same character as the poetry.

A part of it does. I am thinking of the essay and the short story in particular. But there were also authors who wrote for more of a mass public and who soon found readers, although such writers were rather few and far between in the beginning: Azuela, Vasconcelos, Martín Guzmán, and a handful of others. They were also read in Hispanic America, and—a modest prefiguration of the "Boom"—Azuela and Guzmán were translated, and highly thought of, in the United States, France, and other countries. As for painting: on the one hand, little by little a clientele took shape, composed of members of the new class that had sprung up from the Revolution; on the other, collectors made their appearance in the United States: this was the decisive factor. During those years the United States became the market for the revolutionary Mexican painters. Yet another paradox: that market was essentially capitalist but it was made up of affluent people and of institutions—museums and universities—created by private initiative. After the war, tastes changed in the United States, American Abstract Expressionism burst on the scene, and interest in the revolutionary painters of Mexico (with the exception of Tamayo) declined. But by that time a new class had appeared in Mexico and began to buy paintings and to read Mexican authors. The change began in 1945, when the war ended, or shortly before that. My generation was the first to benefit: we Mexican writers began to have Mexican readers. . . . But I have strayed a long way from our original subject: the circumstances that explain the change in orientation of Mexican mural painting between 1924 and 1925.

David Alfaro Siqueiros

I believe that we have already mentioned all the factors contributing to the change: political, social, economic, historical, intellectual, and personal.

Among these forces of change, you refer to the figure of Siqueiros. Is there anything else you would like to say?

Orozco neither influenced nor participated in the change. He was a born enemy of systems and speculations. A real loner. Diego was very intelligent, but apart from the fact that he never managed to win his comrades' confidence, his ideas soon turned into fantasies and his theories into fables. Charlot was the only one, outside of Siqueiros, who possessed a reflective turn of mind. A first-rate "brain," but he wasn't Mexican, nor did he propound a social philosophy that could serve the expressive and psychological needs of the movement.

Don't you attribute too much importance to ideas? We are speaking, after all, of an artistic movement.

It is my opinion that the art of an era is inseparable from the ideas of that same era. Furthermore, I have spoken not only of ideas but of the activity of this or that artist. The activity of certain artists is a focal point at various moments and in certain circumstances. Darío and Hispanic "Modernism," Pound and modern poetry in English, Breton and Surrealism. Siqueiros's activity was decisive. His ideas on the function of art in the modern world were at once messianic and revolutionary.

Messianic and revolutionary?

Yes; in his writings two extremes were merged: the public art of the past (Christianity, above all) and the collective art of the new Communist society. Siqueiros saw in the Russian Revolution something similar to primitive Christianity, though now at a higher historical stage. The superiority of our era was twofold: on the one hand, the revolution of the proletariat was the result not of a religious vision but of a scientific philosophy of history, Marxism, a science per se; on the other hand, the revolution was not only social but scientific and technological. The comparison with the Renaissance was inevitable; Siqueiros felt and described himself as a

"primitive" of a future Renaissance. Unlike the earlier Renaissance, which led to the bourgeois revolution and to liberal capitalist society, the twentieth-century one would be that of the new collectivism: worldwide Communist society. Communism would be the synthesis of embryonic Christian collectivism and Renaissance humanism. Siqueiros's beliefs were simplistic and unrealistic; nonetheless, they move us. They are the offspring of faith—something more than a run-of-the-mill aesthetic.

A great tribute. I had the idea that you were an enemy of Siqueiros's.

It is base to disparage our adversaries. Siqueiros was a painter of great talent, the possessor of a logical mind and a gift for polemical argument that is rare among artists. His logical turn of mind led him to idolize systems, and this intellectual perversion turned him into a fanatical sectarian. In the depths of his fanaticism—although buried beneath all sorts of superstitions and pseudoscientific and falsely rational beliefs—a vein of religiosity remained alive. A thirst for communion with others, compassion for the forsaken and the helpless; in other words, the age-old Christian charity that today goes by a name that is half secular and half religious: revolutionary fraternity. I understand Siqueiros's admiration for Cimabue and Giotto.

And for El Greco too?

Here the crucial factor was aesthetic affinity. I say this because in Siqueiros there is a Mannerist and even Baroque tendency: the love of dynamic forms, movement, contrasts, chiaroscuro. Another note: a certain Romanticism. His painting is reminiscent at times of Delacroix and, above all, of Géricault. Eloquence, yes, but passion as well. His most notable defect: high-flown rhetoric. Yards and yards of grandiloquent harangues, gesticulations, melodramatic commonplaces! But how can one forget the moments of formal invention and the compositions, at once vast and intense, sober and passionate?

Do you admire him?

I admire him, I disapprove of him, and I find him boring, all at the same time. I spoke of his religious depth, but I must remind my listeners and readers that it had much to do with the pride of the theologian. Arrogance and intolerance: vices of an ideologue who regards himself as the possessor of the truth. A truth that comes down to two or three formulas. What did he lack? Doubt, a willingness to examine his conscience, the humility to submit his ideas and beliefs to rigorous criticism. Humility and wisdom: ideology is the enemy of true discernment. He was a descendant of the Spanish theologians, of the Renaissance utopians, and of the medieval doctors of divinity. He was possessed by the demon of systems. He was not the only one among our contemporaries: there are any number of others in our century who have adored this fierce, abstract divinity. I need scarcely mention the best known of them: Pound, Sartre, Neruda. For this reason, the figure of Marcel Duchamp takes on greater and greater stature in my eyes: he was not only a great artist but an authentic wise man as well. Our Diogenes, our Chuang-Tsu.

Siqueiros's life was not exemplary . . .

He was a man of action, an adventurer, like Malraux. Like all adventurers, he was also an actor, a figure out of commedia dell'arte, a sort of swaggering braggart, the character in *L'illusion comique*, capable, however, of carrying out his swashbuckling boasts. He was courageous; he took part in the Mexican Revolution and the Spanish Civil War. Nonetheless, it is impossible to forget, or forgive him for, certain acts, such as the unsuccessful attempt on the lives of Trotsky and his family, which ended in the cold-blooded murder of a secretary of the revolutionary leader. That corpse casts a shadow over the memory of Siqueiros. Can a painter have bloodstained hands? An awesome question that I don't know

how to answer. But *I know* that it is a question that all of us must ask ourselves. Have our critics done so?

There are very few today who defend Siqueiros. But the figures of Diego Rivera and, even more, Frida Kahlo, are praised to the skies.

The attempt to beatify these two artists, who did not scruple to betray and basely defame their old friend and guide, Leon Trotsky, seems to me to be one more symptom of a very grave moral infection. Yet again, the alliance between nationalism and ideology, the two passions that have perverted and desiccated people's souls. Apparently, many Mexican intellectuals of the left have been incapable of carrying out a thorough radical criticism of their attitudes. For it is not enough to denounce the vices, errors, and perversions of Stalinism: we must get to the root causes—psychological, moral, historical—of the Stalinist aberration and subject them to close scrutiny. Diego and Frida ought not to be subjects of beatification but objects of study—and of repentance.

Let us get back to Siqueiros the artist.

Yes. But first I must tell you that it has been difficult for me to speak of certain aspects of his life. I met him in Spain, during the Civil War. He was a colonel in the Spanish Republican Army and the commander of a regiment on the southern front. We were friends in those days, but we broke with each other when Siqueiros directed the attack on Trotsky's life. It was an event that affected me deeply. Nor can I forget that Siqueiros was a Stalinist throughout his life: he was one of the very few who applauded the entry of Russian tanks into Prague. It would not be honest to hide the other side of the coin: he was a militant who served jail sentences and persecution for his beliefs. He was a passionate man and a narcissist; in his life and his painting, flashes of truth and flashes of stage lighting abound. A temperament more Mediterranean than Mexican, a sort of Italo-Spaniard. Three persons in one: a painter endowed with plentiful gray matter (a rara avis), managed by a

Neapolitan impresario, and the two of them under the direction of an obtuse theologian.

But the artist . . .

It is impossible to ignore him. Or the critic either, who almost always hit the nail square on the head, both as regards the archaism of Rivera and his followers and the fateful influence of galleries and financial speculation where art is concerned. Time has finally proved him right—although his recommended remedy, art sponsored by the state, continues to be worse than the disease. . . . As a painter, Siqueiros did not have the savoir faire or the color, the line and the sensuality of Rivera; neither did he have Orozco's dramatic vision. On the other hand, he was more inventive and daring. In his first manifesto, in 1921, he extolled "pure plastic art"; well, certain of his murals and his canvases deserve to be called that: they are admirable compositions in which forms in movement constitute a triumph and in which the physical material possesses an extraordinary vivacity. What more can I say?

And the inventor?

His ideas on the use of photography and of new tools and materials, on the integration of architecture, painting, and sculpture, on perspective in motion, and on other kindred subjects were original and influenced a number of contemporary painters. Among his disciples, apart from Pollock and others from the United States, there are several South Americans and an East Indian of great talent, Satish Gujral, who besides being a painter and sculptor, has also proved himself an architect.

One of Siqueiros's discoveries especially interests me: the "use of happenstance." The first to speak of this was Leonardo, if I am not mistaken. At almost the same time as Siqueiros, the Surrealists—Masson, Ernst—carried out similar explorations and experiments. Siqueiros pursued his path independently and—something that seems more important to me—with different purposes in mind.

There is a marvelous moment in which the artist, guided by what we call chance, but which no doubt is something older and more mysterious, suddenly finds himself face to face with a conjunction between the external and the internal, that is to say, between what belongs to the outside world and what comes from his own innermost depths. His will and the will of the world intersect. At that moment the mind doubles back on itself: the artist is witness to his own creation, or more exactly, the artist realizes that he himself is only one of the elements of the creative process, the transmission channel of universal energy. It is an experience that is comparable to discovery in the sphere of science or to mystical experience. Siqueiros had it one day in April 1936, in New York, when he was not yet completely possessed by the demon of systems. The result was one of his best paintings, *The Birth of Fascism*, which hangs today in the Museum of Modern Art in New York. As always happens, the work goes beyond the title and the intentions of the artist. The painting could also be called *The Birth of Painting*.

Siqueiros was fully aware of the experience he had had, and he recounted it with wonderment in an impressive letter to his friend María Asúnsolo. It is an extraordinary testimonial because of both its human emotion and its psychological and artistic interest. I reproduce herewith a long fragment:

> I worked all Saturday night and all of Sunday, stopping only to eat the sandwiches they have here, which hardly even taste like food. But the result was marvelous. I swear to you with enthusiasm and without exaggeration: it confirms all my theories. . . . It's a matter of using happenstance in painting, or, in other words, of using a special method of absorption of two or more superposed colors, which blend with one another and produce the most fantastic and won-

drous forms the human mind can imagine; something that resembles nothing so much as the geological formation of the earth, the polychrome and polyform streaks of mountains; the integration of cells and all those phenomena that cannot be seen by the human eye except with special equipment. In a word, the synthesis, the equivalence of the entire creation of life, that organized thing which emerges from the depths of mystery because of who-knows-what terrible laws. In these absorptions (that is what we call them in our plastic jargon) there are the most perfect forms you can imagine. Shells of an infinite number of forms shaped with incredible perfection, forms of fish and of monsters that no one could create directly by using the traditional media of painting. And above all: the tumultuous dynamism of a tempest, of a psychic and social revolution that frightens you.[10]

An impressive avowal, impossible to read without being moved. Matter is alive and creative. Materialism? I would say, rather, animism. But the philosophical definition of the phenomenon is of no importance: what counts is to see the intersection of human will and the will of the material (we are obliged to use such an expression in speaking of those creative movements of forms and figures). What does the artist do? He provides the impetus for the movement of substances and colors, allows himself to be guided by their surprising alliances, and in turn guides them. . . . Passivity is activity and activity is passivity. Excitement and lucidity as well: Siqueiros is present at the birth of his painting as though he were present at the very birth of life and of the universe. And what is more, he

[10] David Alfaro Siqueiros, *L'art et la révolution.* Again, this letter does not appear in the Spanish *Textos de David Alfaro Siqueiros.*

was the witness of his own birth as an artist. He was his creator and his creature.

Conclusion

Rivera and Siqueiros were rivals. Was this because of a clash of personalities or of ideologies?

Their differences in temperament were no less decisive than their intellectual and political ones. Rivera *used* revolutionary ideas: not art in the service of the revolution, though that is what he very often said, but the revolutionary idea in the service of his art; Siqueiros, on the other hand, *believed* in what he said and what he painted. This psychological difference was also a moral difference, whatever Siqueiros's grave and reprehensible misdeeds may have been. But these differences should not conceal from us certain equally evident similarities. For example, even though Rivera was a Trotskyist for a long period and Siqueiros never abandoned Stalinism, their Marxism was similar, belonging to that simplistic and simplifying variety which was popular forty years ago. It is obvious that that schematic ideology, in conjunction with their backing of and by the state, played an influential part in the progressive stylistic and emotional degeneration revealed by the works of their late years. In general, great artists—Titian, Rubens, Goya, Cézanne, Renoir, Matisse—reached the height of their creative powers at the end of their lives. Good painting is like good wine: it gets better and better as time goes by. Not so for Rivera and Siqueiros. Rivera in his last years turned into a mass producer, a hand that painted endlessly, mechanically guided not by inspiration but by habit. Siqueiros's case would be laughable were it not pathetic; his last murals are a tangle of inflated forms.

Do you believe, along with many critics, that Rivera's and Siqueiros's painting exemplifies "Socialist realism"?

Nobody knows what "Socialist realism" means. The truth is that, as with almost all the works of that tendency, their painting is not realistic, and still less Socialist. It is allegorical painting, and this is one of the least modern traits of Muralism. Allegory was the favorite means of expression of the Middle Ages. Today it has fallen into disuse. The last artists to practice this genre were the so-called *pompiers*—the tedious traditional painters of the nineteenth century, who turned out allegories on Progress, Science, Commerce, Industry. But allegory ought not to be looked down on: at its apogee it gave us works such as *The Divine Comedy*. The painting of our Muralists—the observation applies to Orozco as well—is very far removed from that complexity and subtlety: it is a dualistic vision of history. In Rivera and Siqueiros, this allegorical Manichaeism has its source in an elementary version of Marxism, in which each visual image represents either the forces of progress or those of reaction. The good guys and the bad guys.

How would you characterize this attitude?

I have called it Manichaean, but in doing so I have been unfair to Manichaeism, which was a very comprehensive dualism, one capable of expressing the many diverse shadings of reality. Authentic Marxism, moreover, results in the same phenomenon. I will cite an example of this narrow, dogmatic dualism. The murals by Rivera and Siqueiros present the Conquest of Mexico as a genuine curse, as the triumph of reaction, that is to say, of evil. Hence, they idealize pre-Columbian society—Rivera even extols human sacrifices and cannibalism—while at the same time they emphasize to the point of caricature the gloomy and negative characteristics of the conquistadors. For Marx and Engels, however, the Conquest, despite its cruelty and the fact that it reduced the Indians to slavery, was a positive phenomenon, as was the British domi-

nation of India. The imperialist expansion of the West was positive because it imposed on backward and static societies the new and dynamic economic and cultural rationality of capitalism. The triumph of the West was the triumph of a mode of production superior to the Aztec or Hindu one. For the same reason they were supporters of the United States in its war against Mexico: the Americans from the north represented progress, technology, and democracy. For Marx and Engels, the "bad" side, since it was an expression of the forward movement of history, was really the "good" side. They thought that in the long run history does not make mistakes and that its disasters are transformed into progress in the end. The "bad guys"—the Spanish conquistadors—were "good guys" because their action was the result of new historical forces. The gunpowder of their muskets was superior to the bows and arrows of the Indians, just as the European science of the Renaissance was superior to Aztec magic. One can disapprove of this way of thinking but not ignore it, especially if one calls oneself a Marxist. To reduce Marxism to the black-and-white dualism of our Muralists (and also of many poets, such as Neruda) is not only to impoverish it but to misrepresent it.

The idea of the good qualities hidden in the apparently bad side of history, that is to say, its positive nature in the end, was taken over by Marx and Engels from Hegel (the real is rational), who in turn was following a philosophical tradition that goes back to Plato: being is necessarily good, because it *is*. In Proclus, the Neoplatonist, very much admired by Hegel, the answer that would one day be given by the "dialectic of history" was already evident. Proclus emphasized the positive powers of negation, asserted that progression comes about in a continuous relationship with regression, and that progression even necessarily presupposes regression. For that reason, he said, Chaos is no less divine than Order. But we had to arrive at our own era before we encountered that somber

caricature of the "dialectic" that makes us label the bureaucratic dictatorships of the East "popular democracies."

Apart from these ideological similarities, don't the personalities of Rivera and Siqueiros strike you as diametrically opposed?

Yes, but many of these differences come from a common source: theatricality. Rivera and Siqueiros were born actors, and, for both, the borderline between representation and reality was rather tenuous; imperceptibly, as is always the way this phenomenon occurs, they ceased being persons and became characters. Their painting turned into empty gesture. The difference between them lies in the fact that Siqueiros's personality belongs to melodrama and Rivera's to farce. Rivera had something of the clown about him, and this is one of his most likable traits of character. He was a marvelous inventor of tall tales and fantasies. His fondness for inventing fictions could lead him, however, to outright lying and even to things with weightier consequences. It is a healthy practice to take neither other people nor oneself seriously; it is not healthy to lose one's respect for oneself and for other people. Siqueiros's political career was reprehensible, at least to a man of my convictions, but it was not incoherent; Rivera's was lamentable and inconsistent. Rivera participated in the Trotskyite movement and was a close friend of Trotsky and his wife, Natalia Sedova, during the first years of his exile in Mexico. How could Rivera, at the end of his life, forsake Trotsky, renounce Trotsky's ideas, embrace Stalinism, and smother the murderer of his old friend with praise? The text in which he applies for readmission into the Mexican Communist Party is a pathetic document, an abject mea culpa and not a request. Frida Kahlo's retraction, doubtless drawn up under Rivera's influence, was no less shameful.

I remember all this because in the official publications devoted to these painters the truth is concealed. The biographies of all of them have been expurgated and doctored with the aim of

canonizing and mummifying them. The catalogue of the retro-spective exhibition of Frida Kahlo's works in the Palacio de Bellas Artes was particularly grotesque: not only did she appear as a piously devoted militant of irreproachable orthodoxy, but her multiform erotic life had been carefully concealed. An example of the artistic, political, and moral insensitivity of our authorities is the Museo Frida Kahlo in Coyoacán. But on this subject it is best to yield the floor to Jean van Heijenoort, Trotsky's former male secretary, who lived with Frida Kahlo and Diego Rivera during the Russian rev-olutionary's years of exile in Mexico:

> The house where Trotsky and Natalia lived in Coyoacán has been turned into the Museo Frida Kahlo. Through false inscriptions ("Frida and Diego lived in this house 1929–1954"), every effort has been made to erase the traces of Trotsky's stay there. The sessions of the Dewey Commis-sion were held there but nothing reminds the visitor of this historic fact. In the bedroom where Trotsky and Natalia slept for more than two years, someone has left, like a little pile of excrement, a small bust of Stalin.[11]

In 1983 Hayden Herrera published her biography of Frida Kahlo, a book in which the real Frida—a fascinating artist and a complex and complicated woman, haunted by hostile phantoms—finally appears.[12] An attractive work, more the product of admi-ration than of clear-mindedness, replete with curious episodes and little-known bits of information, but whose one object, tailored to appeal to the current tastes of readers in the United States, eager

[11] *With Trotsky in Exile: From Prinkipo to Coyoacán*, Cambridge: Harvard University Press, 1978.

[12] *A Biography of Frida Kahlo*, New York: Harper & Row, 1983.

to hear the intimate details of others' lives, is to *tell a story*, not get to the bottom of an enigma or re-create a character. Frida's bisexuality, for example, deserves at least a pause and thoughtful reflection, but the author confines herself to telling us about one crush after another. The lack of psychological curiosity on the part of the author turns into moral insensitivity and historical myopia when she touches on political and social topics. The passage of Diego and Frida from Trotskyism to Stalinism, which Trotsky characterized, not without reason, as a "moral death," provokes neither a shudder nor a comment. It strikes her as just one incident among others. The same is true of Frida's ignoble declarations in the daily *Excelsior* a few years after the death of Trotsky, who had loved her, in which she calls him a "crazy old man" and accuses him of having stolen various objects from her house, among them fourteen rifles and a lamp! Confronted with these moral contortions, I repeat to myself the question that Breton asked himself with regard to certain attitudes of Aragon and Eluard: can a person be, at one and the same time, an artist and a despicable cur? Yes, that is possible. But not with impunity; art cannot be suborned, and it is implacable: the weaknesses, taints, and defects that show up in the works of Diego and Frida are moral in origin. The two of them betrayed their great gifts, and this *can be seen* in their painting. An artist may commit political errors and even common crimes, but the truly great artists—Villon or Pound, Caravaggio or Goya—pay for their mistakes and thereby redeem their art and their honor.

What can you tell us about Orozco?

Orozco was the freest and the most profound of the three. By temperament he was an intense person. He did not know how to laugh or to smile. Another limitation, a serious one for a painter: he was not sensual. In Goya there is a fascination for and a horror of the flesh; in Daumier and in Toulouse-Lautrec, sex is a devil, and the devil, as is well known, is the inventor of laughter. In

Orozco everything is serious, everything is somber. Caresses are something unknown to Orozco's bodies: they are the bodies of executioners and of victims. A contracted, tortured, and occasionally monotonous art: in the end the violence becomes boring. But there are moments of terrifying intensity, moments in which the artist impresses us and jolts us. Orozco moves us, moreover, by another admirable quality: he is a free spirit. A true rebel. Because of his ideas as well as because of his temperament Orozco bears more than one similarity to Vasconcelos. They both began as revolutionaries and both ended up as admirers of Cortés, the bogeyman of liberals and revolutionaries. The Mexican Reaction (written as it should be, with a capital *R*) has in Vasconcelos and in Orozco its two loftiest and most authentic expressions in this century. Both were deeply religious, although Orozco never fell into Vasconcelos's bigotry or his political aberrations. On the contrary, Orozco was one of the first to see the similarities between Hitlerism and Stalinism. He was a passionate spirit and yet strangely perceptive and clearsighted. A really free man and artist who—something almost unheard of in Mexico—had no fear of using his freedom, no matter what the consequences.

Other affinities of Muralism with foreign movements?

Muralism not only absorbed influences and stimuli from outside but also made its influence felt elsewhere. The history of the influence of Mexican painting in Latin America has yet to be written. Something similar occurs with regard to the influence of the Muralists on Abstract Expressionism in the United States. I am thinking not only of the case of Pollock, which is well known, but of that of others less often cited, such as Tobey and Noguchi, the sculptor. I discussed this subject in *Puertas al campo* [*Gates to the Countryside*] and do not care to repeat today what I wrote there.[13] I shall confine myself to pointing out a few things. It has often

[13] See, in this volume, the essay "Price and Meaning."

been said that Abstract Expressionism is an automatism that comes
directly from Surrealism, from Masson and Matta in particular. This
is true. The example of Siqueiros, however, has been overlooked.
The Mexican painter was one of the first to use *happenstance* in a
systematic way. An aesthetic close to automatism: flinging a shower
of paint against the wall and then painting with that stain of color
as the basis. But the Mexican influence is not limited only to this.
In *Abstract Expressionism*, as its very name indicates, there was an
explicit contradiction (I will remark in passing that the reason for
its extraordinary vitality lies in that very contradiction): on the one
hand, abstraction; on the other, expression. European Abstraction-
ism was intellectual and metaphysical: it sought to reduce forms
to a geometry, sensations to archetypes, and life itself to rhythms.
Although painters in the United States, like the European Abstrac-
tionists, rejected the representation of reality, they wanted to paint
not archetypes but emotions, immediate and concrete sensations.
This brought them closer to Expressionism and, naturally, to Mex-
ican painting (Siqueiros and Orozco), which had had an influence
on almost all of them in the thirties. The Abstractionism of painters
in the United States came from Europe; their Expressionism came
from Mexico. In a word: Surrealist Automatism plus European
Abstractionism plus Mexican Expressionism. All this confirms what
I said at the beginning of this conversation: the Mexican Muralist
movement has a place that is at once unique and powerful in the
history of twentieth-century painting. It has it, first of all, in and
of itself, by which I mean because of the notable works, many of
them admirable, left by Rivera, Orozco, Siqueiros, and several
other artists who, although minor, are not to be disdained; and,
second, because of its influence on painting in the United States
and elsewhere. Muralism was not a copy of the European painting
of its time nor was it a provincial art: it was and is a presence in
the world.

One last reflection: the influence of Muralism illustrates a

phenomenon that has been repeated again and again in the history of the arts. In Mexico the influence of Muralism was harmful inasmuch as, instead of opening doors, it closed them. Muralism engendered a sect of vociferous academic disciples. In the United States the influence was beneficial: it opened the minds, the sensibilities, and the eyes of painters. In one case, the influence paralyzed artists; in the other, it liberated them. It is altogether natural that the protagonists of the following chapter in the history of Mexican painting were heterodox and marginal figures, who dared say no to the academicism and the ideologism into which Muralism had degenerated. This new chapter—begun by Tamayo, Mérida, Gerzso, and others—has not yet ended. It does not seem to me to be inferior to Muralism: it is something very different, with a life of its own, something that it is now time to see with rigor and generosity. The same rigor and the same generosity with which we ought to see and judge the Muralists.

MEXICO CITY, *August 1978*
Sábado 43, MEXICO CITY, *September 9, 1978*

The Concealment

and Discovery

of Orozco

The most fraudulent and treacherous words in art criticism are Morality, Ideology, Social Message, Revolution, and still more Revolution . . . and others of the same sort.
—José Clemente Orozco

1

Glory is always equivocal. It is an exaltation and, at the same time, a disfiguration. When we glorify this or that work, we almost always diminish it and reduce it. Mexican mural painting is an impressive illustration of the fate suffered by all great artistic and spiritual movements: beatification is attained by way of simplification. Muralism was a complex, contradictory movement, irreducible to a single orientation, in which many different personalities participated, each of them the possessor of a particular vision of the world. It was a polemical movement, not only as it confronted the art of the immediate past but also inwardly; in other words, Mexican muralism was always fighting against itself. Hence its vitality. In

On July 12, 1983, Salvador Elizondo, Miguel Léon Portilla, and I participated in a colloquium, held in the Hospital de Jesús under the auspices of the Colegio Nacional, on the person and the work of José Clemente Orozco. The following pages are the expanded and emended version of my contributions to the colloquium.

the last thirty years, however, its history has been reduced to the linear development of a single idea, a single aesthetic, and a single objective.

Those responsible for this simplification have been, on the one hand, the critics and historians who represent the aesthetic and political points of view of a tendency that claims to be Marxist; on the other hand, the official ideology. All the works and personalities that do not fit within this schema have been eliminated or placed under wraps. This historical revisionism affects, in particular, painters such as José Clemente Orozco, Jean Charlot, and Roberto Montenegro. Since it is impossible to deny the artistic importance of Orozco's work, a successful attempt has been made to hide its significance. Certain aspects of his painting are highly praised, but others, the ones that are most polemical, are made to disappear by a sort of conjuring trick. All that is needed to justify such sleight of hand is this phrase or that. For example, declaring that Orozco is a great artist but that he is anarchic and contradictory. The hint is that Orozco's violence must be accepted, provided that it is purged of its subversive and demonic elements. To deplore Orozco's contradictions is to forget that contradiction is the very heart of almost all the great artistic and literary creations of the modern era. Michelangelo is contradictory, as is Caravaggio, as is Rembrandt, as is Goya, and as are almost every one of the great poets and painters of the nineteenth and twentieth centuries. In Mexico, Vasconcelos and José Clemente Orozco were contradictory. I wish to be properly understood on this point: I am not trying to repudiate the painting of Diego Rivera or that of Alfaro Siqueiros. That would be to perpetrate another oversimplification and another mutilation. It is a matter, rather, of restoring to Muralism its original richness, its complexity, and in short, its historical and aesthetic ambiguity.

For all the foregoing reasons, I made up my mind to write these pages. Not to render homage to a great painter but to discover in

his work that which distinguishes it and makes it unique. Orozco's powers of subversion remain intact in his work, unlike that of other of his contemporaries, who have been assimilated and canonized. It is a subversive body of work because, both in the realm of aesthetics and in his vision of human reality, he dared to say *no* to the great modern simplifications: *no* to the official version of our history, *no* to clericalism, *no* to the bourgeoisie, *no* to sects. Orozco's great, violent, contradictory *no* turns at certain moments into a tragic affirmation: the human being who appears in his painting is a victimizer and a victim as well. In both these aspects he arouses our wrath and our pity. Painting that moves us and, moreover, causes us to reflect on the enigma that human beings are, each and every one.

José Clemente Orozco's first works are drawings, engravings, caricatures, and watercolors. They were done between 1910 and 1918. Their subjects are those of everyday reality in the lower depths of the city; they are not realistic works: they are grotesque, satirical, frequently terrifying visions. Black visions. The series of watercolors is impressive. Brothel scenes: shabby parlors, dingy rooms with cots and enormous armoires, purgatories of half-naked women with flaccid flesh and bones that stick out, covered with faded gaudy rags and tatters, coupling or having secret rendezvous with skinny johns with little hairline mustaches, in their underwear but with their socks on. Around 1920, the first, unforgettable oils and drawings, showing scenes of the Mexican Revolution, make their appearance. The vigor of the draftsmanship—violent, cruel, sarcastic, at times pathetic and at others compassionate, but unfailingly intense—takes the viewer by surprise. Almost entirely free of ideology, these works are genuine *testimony*, in a way that the photographs of the era are not. Yet another confirmation of the falseness of a modern idea: photos and reportage, save for exceptional instances, are documents but not testimony. Genuine

testimony combines understanding with truthfulness, what is seen with what is lived and relived by the imagination of the artist. Understanding is born of moral sympathy and is expressed in many ways: pity, irony, indignation. Understanding is participation.

From his early years until his death, Orozco never stopped painting. His body of work is abundant and varied: drawings, oils, murals, engravings, gouaches, watercolors. Over the years, his subjects broadened in scope, and he went from satire of everyday life to great mural compositions in which the prophetic vision of history is conjoined with vast religious allegories. Despite all these changes, his inspiration always remained the same: the Orozco of the early drawings and watercolors (*Scenes of Women*, 1910–1916) is not essentially different from the Orozco of the murals of the Hospital de Jesús (*Allegory of the Apocalypse*, 1942–1944). How to define a work so vast and yet, throughout its changes, so faithful to itself? The works that really count are unique; by that I mean to say, although they belong to this or that style, they always represent a break with what has gone before, which frees the artist and impels him to go beyond that style. There are two ways of conceiving of the history of art: as a succession of styles and as a succession of breaks with the past. Both are valid. And what is more, they are complementary. One lives as a function of the other: because there is style, there is transgression of style. In other words: styles live thanks to transgressions; they are perpetuated through them and in them. A never-ending starting all over again: each transgression is the end of a style and the birth of another. Orozco confirms the contradictory relationship between a style, which is always collective, and a break, which is an individual act. His work takes its place within the Expressionist current of our century, but it is impossible to understand it if one does not realize that it defines itself by being nothing less than a transgression of Expressionism. Orozco's painting hallows the very thing that it denies: his transgression of Expressionism is an Expressionist act.

Expressionism was born in the early years of the century, and its favorite haunt was the Germanic and Scandinavian countries. However, as is true of other great artistic movements, it is impossible to limit it to any one era and any one region. Goya in his last years was a great Expressionist, *avant la lettre*; so was the latter-day Picasso, *après la lettre*. The two of them were Southern Europeans. In Orozco's first works, one notes the presence of an Expressionist who was neither a German nor a Norwegian and who surely never realized that he was an Expressionist: José Guadalupe Posada. Later on, it is not hard to make out the lesson that Orozco learned from two other artists who came before (and after) Expressionism: El Greco and Goya. There are also traces of a painter whom critics, except for Antonio Rodríguez, usually do not mention: the awesome Grünewald. The affinities between this German painter of the sixteenth century and the Mexican artist of the twentieth century are the result of a spiritual kinship: across the centuries and across cultures, both shared a belief in the supernatural value of blood and sacrifice. Both succumbed to the fascination of the dual figure of the executioner and the victim, united not by psychological but by magico-religious ties.

I mentioned El Greco, a constant presence in Orozco's work. In Orozco's *Prometheus*, at Pomona College, critics note traces of El Greco's *The Burial of Count Orgaz*, and in the figures of the witches who were Quetzalcóatl's adversaries, at Dartmouth College, they find reminders of his *Christ Driving the Money Changers from the Temple*. These examples are not the only ones, but they suffice for my purpose, to show how Orozco takes up a tradition, uses it for his own ends, and, by so doing, transforms it. The way in which he uses El Greco is repeated with Michelangelo, both on the subject, once again, of the driving of the money changers from the temple and, in a closely related work, on that of the expulsion from paradise. Both subjects are found often in the painting of the Renaissance. It is impossible not to be reminded of another

predecessor, with whom Orozco was doubtless familiar: Masaccio. The wonderful fresco *The Gravedigger*, in San Ildefonso, showing a figure lying stretched out, brings Piero della Francesca's *The Dream of Constantine* to mind because of the pose and the pictorial treatment. But Piero's classicism is far from Orozco and closer to the dynamic, convulsive art of Michelangelo and El Greco. Hence it is not surprising that the famous *Man of Fire* of the Hospicio Cabañas is unquestionably closely akin to a celebrated and daring composition by Correggio, *The Ascension of Christ*, in the cupola of San Giovanni Evangelista in Parma.[1] Finally, I scarcely need call to your minds other frequent presences in Orozco: Giotto, who inspired in part the paintings of Franciscans along the stairway of San Ildefonso, and Byzantine art. The latter was a stimulus and a guide that opened up perspectives for all the Muralists—Rivera, Siqueiros, Orozco, and Charlot. In my opinion, Orozco and Siqueiros arrived at a more profound understanding of the lesson of the Byzantines than the others did. The dramatic economy that appears in a number of compositions by Orozco and in certain portraits by Siqueiros reveals a deeply felt understanding of this great tradition.

Orozco began as a draftsman and a graphic artist. It is altogether natural, then, that he should have seen in Goya a master whose example he could use not only in his graphic works but also in the series of oils on the Mexican Revolution. In like manner, it is altogether natural that he should have benefited from the lesson of Daumier. In a quite different direction, he also assimilated that of Toulouse-Lautrec. All these names define his spiritual family and his artistic lineage. These antecedents explain his having accepted so naturally and spontaneously and assimilated so success-

[1] See Laurence E. Schmeckebier, *Modern Mexican Art*, Minneapolis: University of Minnesota Press, 1939. Justino Fernández also dealt with the relationships between Orozco and Renaissance painting in his book *Orozco, forma e idea*, Mexico City: Universidad Nacional Autónoma de México, 1942.

fully the influence of Expressionism. This tendency gave him a vocabulary of forms that, possessed of genius and a sense of freedom, he transformed and re-created. He was neither a disciple nor a follower, but without the great Expressionists he probably would not have been what he was and is: a universal painter. I am speaking not only of his debts to particular painters but also of the significance to him of the example of a number of artists of whom he, in far-off Mexico, had a less than thoroughgoing knowledge, acquired through mediocre reproductions. No matter: they opened up a path for him. I am thinking of Rouault, Munch, Ensor, Kokoschka, Grosz, Max Beckmann. The resemblance to Beckmann is noticeable and constant. Even though the similarities are extraordinary, it is impossible to speak of influences without committing a crude simplification, as is noted by Hans Heufe, a critic who has written with discernment on the subject. Orozco is more vigorous and vast, but it is impossible to say that Beckmann is a follower of Orozco's or vice versa. It is a question, rather, of artistic and spiritual kinship.

Salvador Elizondo has pointed out the presence of another current in Orozco's art, which he calls idealistic. It might also be labeled hermetic or symbolic. Elizondo finds a relationship between this tendency and the ideas of Matila G. Ghyka, the author of several books, famous in his time, on rhythm, the golden section, the aesthetics of proportions, and other related subjects. Our painter probably became acquainted with these ideas during the years he frequented the Delphic Circle, a group made up of the Greek poet Angelos Sikelianos, his wife, Eva, and other artists and intellectuals who were more or less close to the Neo-Hellenic movement. In the book that Alma Reed wrote on Orozco's life and work, she dwells at length on this episode (1928–1931).[2] The Delphic movement upheld certain aesthetic and philosophical principles—

[2] *José Clemente Orozco*, New York: Oxford University Press, 1956.

universal rhythm, the dynamics of proportions, and other funda-
mental beliefs inherited from Neoplatonism and occultism—in-
termeshed with the new physics and commingled with political
ideals such as nationalism and universal peace. Naturally, Orien-
talism was not missing from the list. Angelos Sikelianos and Alma
Reed shared a huge apartment, known as the Ashram. It was a
meeting place for artists and writers interested in hermetic and
esoteric doctrines. In politics they were fervent supporters of the
movement for Indian independence. There was talk of aesthetics,
Alma Reed says, and of the doctrines of the great masters: Jesus,
the Buddha, Lao Tse, Zoroaster, Emerson, Gandhi. There were
also disciples of Blake and Nietzsche. One of the most attentive
and most frequent participants was the Mexican poet José Juan
Tablada, who was among the first of Orozco's defenders.

It is not easy to imagine this taciturn painter in that world. Not
only did he paint a portrait of Eva Sikelianos, however, but that
moment and that circle were also the source of some of his aesthetic
ideas. Elizondo has quite properly stressed the influence of "dy-
namic symmetry," an aesthetic doctrine of the Canadian mathe-
matician and artist Jay Hambidge. Although Orozco did not know
Hambidge, who died young, he was a friend of Hambidge's widow,
Mary, who disseminated her husband's ideas within the Delphic
Circle and wrote a book about them. Orozco followed the precepts
of Dynamic Symmetry in the *Prometheus* fresco at Pomona College
(1930), and in the frescoes at the New School for Social Research
(1930–1931). In these compositions of visionary symbolic spiritu-
alism, it is not difficult to perceive the traces of the philosophical,
aesthetic, and political speculations of the Delphic Circle. A Neo-
platonic and Renaissance heritage: geometry conceived as an aes-
thetic, that is to say, as a system of proportions that reflect or
symbolize the rational form of the universe and of the creative
mind. It should also be said that Orozco was already prepared to
receive and assimilate these ideas: before a trip to New York he

had painted, in the Casa de los Azulejos, in 1925, the mural *Omniscience*, of a decided symbolic and spiritual cast. The influence of Vasconcelos, and his theory of universal rhythm, or of the preoccupations of Sergio Francisco de Iturbe, the great Mexican Maecenas who commissioned those paintings?[3]

In certain late compositions Orozco, faithful to these metaphysical and aesthetic concerns, parted company with Expressionism even more radically than in the era of the Delphic Circle. I am referring to the portable mural *Dive Bomber and Tank* (New York, 1940),[4] to the *National Allegory* (Normal School, 1947–1948), and to an unfinished work, *Spring* (Miguel Alemán Housing

[3] In the latter half of 1983, after these pages had been written, a book appeared entitled *Orozco: una relectura* (Mexico City: Universidad Nacional de México). It contains essays gathered together by the critic Xavier Moyssén. Among them, one by Fausto Ramírez on esotericism in the work of Orozco and another, by Jacqueline Barnitz, about his Delphic years, impressed me. Fausto Ramírez points out the highly likely influence on Orozco of Antonio Caso's aesthetic ideas and, above all, those of José Vasconcelos. The latter's influence is unquestionable; he was the author of two books that were widely read in his day, *Pitágoras, una teoría del ritmo* (1917) and *El monismo estético* (1918). Ramírez emphasizes the affinities between the Mexican painters influenced by Symbolism and Vasconcelos's ideas. He also alludes to the esotericism of several poets—among them, Tablada—who were friends of the painters. He perhaps neglects the general and generalized influence of Darío and the other great Hispano-American Modernists, all of them believers in the theories of universal rhythm and of correspondences. (See chapter IV of my *Los hijos del limo* [*Children of the Mire*], Barcelona: Seix Barral, 1974.) The parallel established by Ramírez between the theosophical ideas of Schuré and Orozco's painting is convincing. Jacqueline Barnitz's essay contains a wealth of information concerning the Delphic period. It also includes an excellent analysis of the gestation of the *Prometheus* at Pomona College; the subject was probably suggested to Orozco by Alma Reed, for whom he made several advertising posters announcing the performance, at Delphi, of Aeschylus's *Prometheus Bound*, directed by the poet Sikelianos.

[4] It was commissioned by the Museum of Modern Art in New York, where it was prominently exhibited. Today it has been relegated to the vaults of this museum. Also imprisoned in that purgatory are a number of canvases, some of them admirable, by Tamayo, Siqueiros, and Rivera.

Development, Mexico City, 1949). Since I intend to return to this subject at the end of this essay, I shall merely point out here that in these works Orozco is inclined toward abstraction, but only to further accentuate its symbolic nature. There is an intimate relationship, as Worringer saw before anyone else, between abstraction and symbolic vision. These compositions are veritable icons, not of gods but of ideas. They are idea-forms. I stress the fact that Orozco uses abstraction to express and symbolize: in other words, he preserves the relationship between form and meaning; this approach is the diametrical opposite of abstract painting, which tends to cancel out the differences between form and idea, signifier and signified.

This extremely brief examination of the compositions in which Orozco deviates from Expressionism confirms the fact that even in his transgressions he did not cease to be an Expressionist. More exactly: his heterodoxy is an exacerbated Expressionism, except that it is an Expressionism that is critical of itself and that goes beyond the traditional limits of the movement. By way of negation—Expressionism is satire, blasphemy, sarcasm, a powerful and passionate negation—Orozco arrives at the great religious symbols. I need scarcely add that those symbols are not abstractions but living forms, anguished and anxious. Expressionism is a negation of all symbols: it has a horror of abstractions, types, and archetypes; it is an art of the singular and the unique, of that which violates the norm and the mean. Negation always places the characteristic in opposition to the universal, the *this* or the *that* to the idea. By the *via negativa* of Expressionism, Orozco arrives at results that are the exact opposite of those that European Expressionist artists aimed at. It is for that reason that I think of his unwitting resemblance to Grünewald.

His attitude toward Expressionism is echoed in the attitude that he adopted toward the other two tendencies that attracted him:

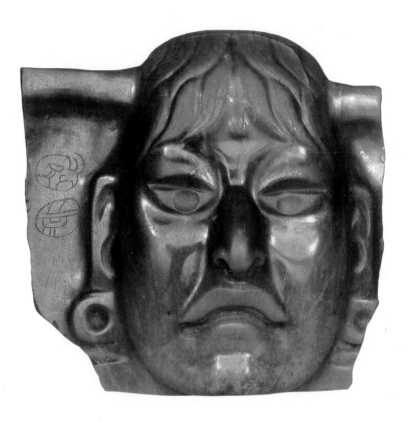

Olmec head. 1000–600 B.C. Engraved in green jade.
Copyright British Museum.

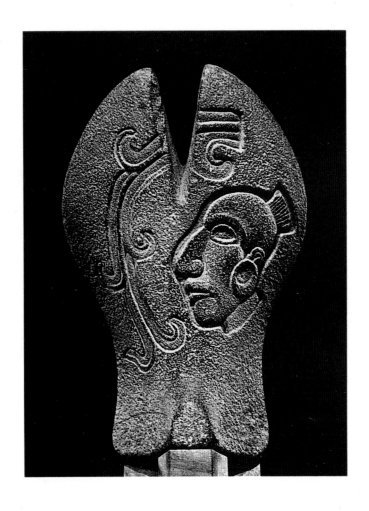

Profile of human head with ear. Veracruz. 500–800 A.D. Stone.
Museo Nacional de Antropologia, Mexico City. Photograph: Carlos Franco, courtesy of FCE.

Smiling faces. Veracruz. 500–800 A.D.

Museo Nacional de Antropologia, Mexico City. Photographs: Michel Zabé.

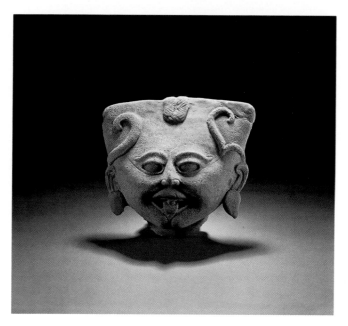

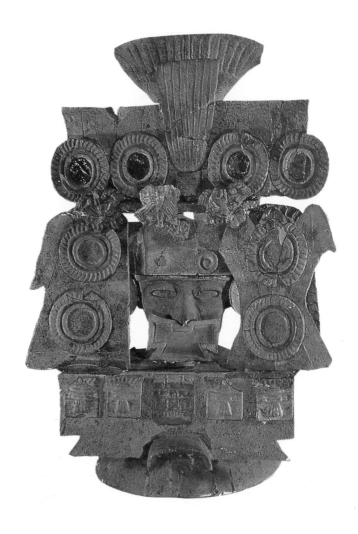

Teotihuacan brazier in the form of a temple, mask of deity
in center. 200–600 A.D. Clay.
Museo Nacional de Antropologia, Mexico City. Photograph: Carlos Franco, courtesy of FCE.

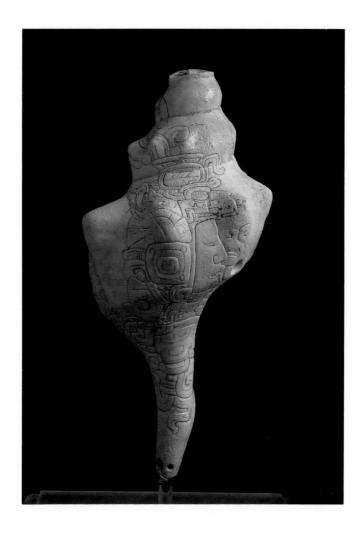

Maya marine shell with cinnabar incisions, ritual trumpet.
250–400 A.D.
Kimbell Art Museum, Fort Worth, Texas.

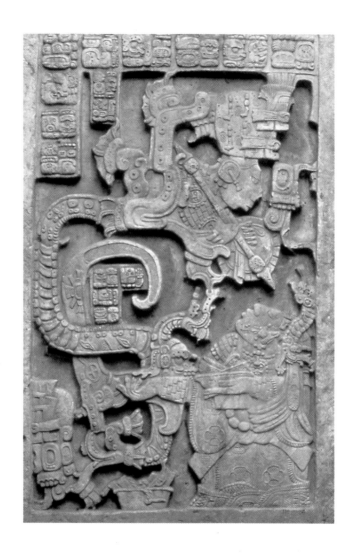

Vision of Queen Xoc, Maya. 725 A.D. Limestone.
Copyright British Museum.

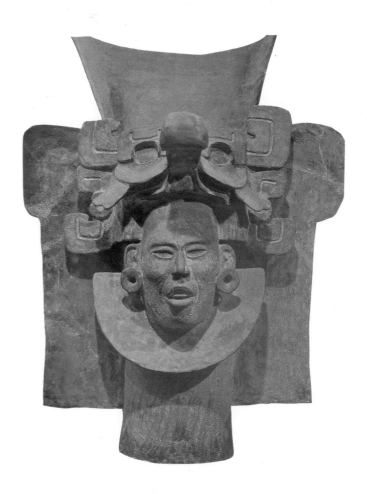

Zapotec funerary urn. 100–200 A.D. Polychrome pottery.
Museo Nacional de Antropología, Mexico City. Photograph: Carlos Franco, courtesy of FCE.

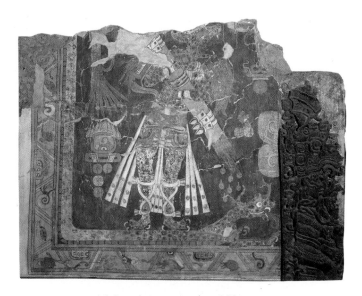

Maya jaguar warrior. 900 A.D.
Photograph: Rafael Doniz, courtesy of Rafael Doniz.

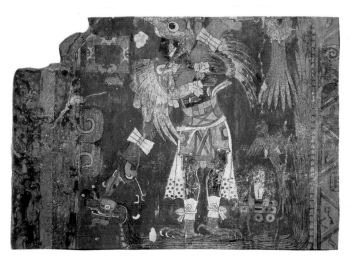

Maya eagle warrior. 900 A.D.
Photograph: Rafael Doniz, courtesy of Citicorp Citibank, Mexico City.

Hermenegildo Bustos, self-portrait, 1891. Oil on canvas.
Museo de la Alhóndiga de Granaditas. Photograph: Salvador Lutteroth and
Jesús Sánchez Uribe, courtesy of CNCA/INBA, Mexico City.

José Clemente Orozco, *Bandaged Indian*. 1947. Mural,
pyroxylin on masonite.

Instituto Cultural Cabañas, Guadalajara, Jalisco. Photograph courtesy of FCE.

Diego Rivera, *The Fecund Earth*. Mural, fresco.
Universidad Autónoma de Chapingo, Chapingo, Mexico. Photograph:
Bob Schalkwy, courtesy of CNCA/INBA, Mexico City.

David Alfaro Siqueiros, *Woman with Grinding Stone.*
1931. Oil and pyroxylin on burlap.
Private collection, courtesy of CNCA/INBA, Mexico City.

Rufino Tamayo, *Woman Weeping*, 1941. Oil on canvas.
Lee A. Ault collection, New York. Photograph courtesy of FCE.

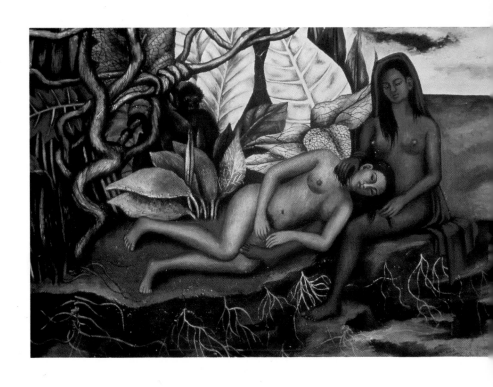

Frida Kahlo, *Two Nudes in the Jungle*, 1939. Oil on metal.
Mary Anne Martin collection/Fine Art, New York. Photograph courtesy of Mary Anne Martin/
Fine Art/Centro Cultural de Arte Contemporáneo de México.

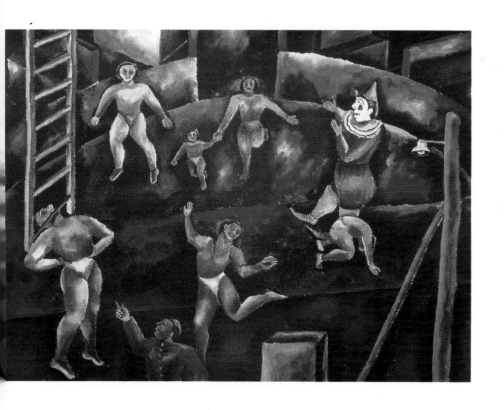

Maria Izquierdo, *The Circus*, 1939. Gouache on paper.
Banco Nacional de México collection. Photograph: Michael Calderwood,
courtesy of Centro Cultural de Arte Contemporáneo de México.

Manuel Alvarez Bravo, *Portrait of the Eternal*, 1935. Photograph.
Collection of the artist.

the symbolic esotericism of his early years and, at the end of his life, abstract painting. His attraction to abstract art is not surprising: in the earliest and greatest Abstractionists, such as Kandinsky and Mondrian, occultist and theosophic ideas are clearly visible. For Orozco, by contrast, form is expression, and this separates him from all formalisms, from the modern version, abstract art, in particular; at the same time, by way of a series of more and more radical self-negations, expression reaches the point of denying itself. It ceases to express, so to speak, so as to become an icon. But it is an icon that we cannot adore and one that, when it moves us, opens our eyes to an abysmal reality. It is an icon that contains its own negation. Orozco's icon is not a god or an idea but a reality at once present here and now and eternal, universal, and concrete, a reality in perpetual struggle against itself. The icon is doubly threatened, by abstraction and by expression, by universality and by singularity. In order to escape, it denies expression through the symbol, and the symbol through expression. The icon denies itself in a ceaseless and cruel ceremony of self-purification. Christ breaks his cross to pieces, Quetzalcóatl sins and flees, the sky falls in on Prometheus, fire consumes humankind. Expressionism, the aesthetic of modern negation, is used by Orozco to paint icons in constant combustion. The flame turns into sculpture, and each of his creations ends in a conflagration that destroys his creatures.

2

The differences between Orozco and the other Mexican Muralists are no less profound than those that separate him from the European Expressionists. His subjects are, admittedly, the same as theirs: the history of Mexico, the Revolution, the great social conflicts of the twentieth century. His attitude, however, is almost

always different from that of Rivera and Siqueiros. Many times, it is even precisely the opposite. His real subject is not the history of Mexico but what lies behind or underneath, what the historical event conceals. The past, the present, and the future are a temporal current that flows past and then flows back in the other direction, a deceptive and enigmatic succession that the eye of the artist or the prophet penetrates: another reality appears therein. For him, history is not an epic with individual heroes and villains, a temporal process possessed of a direction and a meaning; history is a mystery, in the religious sense of the word. The mystery is that of the transfiguration of men into heroes; almost always the elect are voluntary victims who, through blood and sacrifice, are transformed into living emblems of the human condition. Orozco neither recounts nor relates; nor does he interpret: he confronts the facts, questions them, searches for a revelation in them.

Not only his attitude toward history is different, so are his ideas and opinions regarding historical facts and their protagonists. Miguel León Portilla has recalled Orozco's position in the old debate between the indigenists and the Hispanists, the supporters of Cuauhtémoc and those of Cortés. In his *Autobiography* he is scandalized by this idle debate and says: "It seems as though the Conquest of Mexico by Hernán Cortés and his hosts happened yesterday; it is more topical than Pancho Villa's outrages; the assault on the Gran Teocalli, the Noche Triste, and the destruction of Tenochtitlán appear to have happened not at the beginning of the sixteenth century but last year, or just yesterday. The subject is spoken of with the same animosity with which it was no doubt spoken of in the days of Don Antonio de Mendoza, the first viceroy." And he concludes: "This antagonism is deadly." As León Portilla has pointed out, this attitude is even more explicit in Orozco's murals: Orozco does not idealize the indigenous world, nor does the Conquest strike him as an abomination.

Orozco views the ancient civilization of Mexico with a mixture

of horror and admiration. He admires the grandeur of its temples and pyramids, and its arts and monuments amaze him; its myths and its rites repel him. Certain of its features seem despicable to him: the worship of chieftains and the servility of those societies, the militarism and the divinization of perpetual war, the mindless and superstitious reverence toward priests and shamans, the innate clericalism of that civilization—the natural complement of the preeminent function of war—and finally, human sacrifices and ritual cannibalism. He feels a fascination and a repugnance for that world, at once barbarous and decadent. He sees it as a dark age. But his condemnation is not a total one: the horrible traits of pre-Hispanic civilization are horrible not because they are Indian but because they are human. Cruel sacrifices reappear in the modern era: on the walls of Dartmouth College (in 1932–1934) he paints, alongside an ancient human sacrifice, one that is modern. In the first, the victim naked on a stone, the aromatic fumes of copal, the awesome figure of the idol, the masked priest and his acolytes, the obsidian knife; in the other, a man who has fallen with his boots on, the murderous machine gun, the civic wreath, the votive lamp of patriotism, the monument to the Unknown Soldier, the waving of flags. Religion and nationalism, Aztec ritual death and anonymous modern death: two idolatries and an identical cruelty.

There is a figure who sheds light on the shadows of the Indian world: Quetzalcóatl. On the walls of Dartmouth College, as legend tells of him: a bearded white man, come from across the sea, patron of the arts, inventor of the calendar and the system of writing of the codices. Orozco's Quetzalcóatl is not a god: he is a hero who brings civilization, a superhuman figure. According to myth, after governing Tula, teaching the arts of civilization, and forbidding human sacrifice, Quetzalcóatl is the victim of the evil spells of his sorcerers and his rival, Tezcatlipoca. He flees from the city in defeat but prophesies that on a memorable day like that one (*Ce Acatl*), he will return to win back his kingdom. Moctezuma believed that

Cortés was Quetzalcóatl, or at least an envoy of his. Cortés cleverly took advantage of this belief. Very soon the missionaries, the chroniclers, and the historians of New Spain adopted and transformed the myth. The bearded white god who arrives by sea and disappears by way of the "place where the water joins the sky" was turned into a European, perhaps St. Thomas, who teaches the natives the arts and sciences but is betrayed by two idolatrous priests, who reestablish human sacrifice and dark rites. The prophecy regarding Quetzalcóatl's return was also transformed: his return meant the arrival of the Spaniards and the Conquest of Mexico. This interpretation, revised and secularized in the nineteenth century, was the one that Orozco adopted, following Vasconcelos and other intellectuals of that era.

In the frescoes at Dartmouth College several of his favorite subjects appear, in highly dramatic form: the advent of a reformer, the betrayal by the priests, the prophecy of the betrayed hero, and finally the arrival of the conquistadors. Thus Orozco sees the Conquest as a punishment for the betrayal of Quetzalcóatl, the bringer of civilization. The hero of the pre-Hispanic world, Quetzalcóatl is also its victim; the victim in turn becomes the righteous interpreter who prophesies the punishment of his people. The instrument of justice, the avenger of the hero, is named Cortés. In Orozco's mythology—yet another great difference from Rivera and Siqueiros—Cuauhtémoc is not a hero. Nor is Cortés. They are not reformers or victims transfigured by their sacrifice: they are tools, instruments of cosmic justice.

There is nothing more different from Rivera's Cortés than Orozco's. Rivera's is a sickly and deformed being; confronted by that grotesque figure, one wonders how such a hideously maimed man could fight, ride horseback, command men, traverse jungles and deserts, raze villages, make women fall in love with him. Rivera's Cortés is a portrait of the petty passions of that great painter, the confession of a touch of resentment. Orozco's is an ironclad warrior,

a terrifying prophecy of the mechanical age. In the fresco of the
Hospicio Cabañas (Guadalajara, 1938–1939), Cortés cleaves an In-
dian warrior in two with his sword, as the angel of victory kisses
him. Orozco was not at all fond of conquerors, but he does not
conceal his admiration for the Spanish conquistador: his Cortés is
formidable but neither inhuman nor ignoble. Driven by the hur-
ricane of his time, he is the agent of destiny. He is not the Cortés
of the history books: he is an emblem of the grandeur and the great
loneliness of victors. . . . There is another Cortés, not clad in armor
but naked and without a sword, locked in embrace with an Indian
woman who is also naked, Malinche. The two figures embrace in
a moment outside of time, and their quietness inspires fear and
veneration. They are two pillars on which the centuries rest. Their
immobility is that of myth before history. With them Mexico be-
gins; a terrible beginning: at the feet of Cortés lies a dead Indian.
Orozco shows us an image of the myth that devours Mexico and
devours us: the father is the murderer, the bed where love is made
is the scaffold, the pillow the body of the victim. But we must not
close our eyes as we stand before this dreadful image: the ghosts
vanish if we are able to face them squarely.

The Conquest and its consequences—the conversion to Chris-
tianity, the Indians' slavery, and the slow gestation of another
society—were a twofold phenomenon, like almost everything that
happens on this earth. Unlike his comrades and rivals Rivera and
Siqueiros, who were possessed by the spirit of system and Party
dogmatism, Orozco was sensitive to the ambiguity inherent in his-
tory. In the face of Cortés and his implacable warriors, a tempest
of iron and blood (*The Teules*, Mexico City, 1947), the missionary
friars make their appearance. In the frescoes of San Ildefonso, a
series of paintings in tempera and pyroxylin on Masonite (Mexico
City, 1926–1927), the Franciscans raise the Indians from the dust
and give them the magic liquid, the water that slakes thirst and
the water of baptism. In the frescoes at the Hospicio Cabañas, a

Franciscan armed with a cross stands before the figure of Cortés the warrior. In the background, the same angel of victory that kisses Cortés in the opposite mural unfolds a parchment with the letters of the alphabet. The cross liberates because it teaches how to read and opens the mind to new wisdom. It also enslaves, hoodwinks, steals, and kills. Orozco painted, on those same walls of San Ildefonso, a caricature of the Eternal Father that Lautréamont would have been jealous of, as well as other images that show the complicity of the Church with the rich and with oppressors. There are, to be sure, scenes of modern Mexican life, but in other frescoes (for instance, those at Dartmouth College) the cross emerges from the pile of ruins to which the Conquest reduced the Indian world, though there is no way of telling whether it represents refuge or a moment in celebration of oppression. I am inclined to believe that it is the latter: it is a severe, pitiless cross.

The same duality is seen with respect to the fate of the vanquished during the viceroyalty: in the San Ildefonso frescoes they are seen crawling along the ground, covered with sores and parched with thirst, aided only by the friars; but in that same building there is a fresco that represents two energetic figures, an image of the will to construct, the title of which is *The Conquistador as Builder and the Indian Worker.* All the foregoing confirms what I said before: although history is the raw material for his art, Orozco does not conceive of it as a temporal succession but as a *proving ground.* It is a place of perdition but also, through creative sacrifice, a place of transfiguration.

It is only natural that so vehement a temperament would not linger for long over the three centuries in which Mexico was called New Spain, a period not marked by an abundance of dramatic episodes. The history of the nineteenth century did not inspire him either. The allegories of Hidalgo (Governor's Palace, Guadalajara, 1937) and of Juárez (Chapultepec Castle, Mexico City, 1948) are vast, pompous compositions. The painter's violence in

the former is surprising: Hidalgo clutches the torch for lighting the fire while, below, a swarming mass of enraged men stab one another. History seen yet again as punishment and vengeance. Another wall has as its subject *The Great Revolutionary Mexican Legislation*, yet another title more appropriate for a legal work than for a painting. Public art, empty and grandiloquent, as is the Júarez allegory in Chapultepec Castle. Although the fresco of Jiquilpan (1930) is marred by the same more or less official rhetoric, the violence does not dissolve into mere gesture: the ferocity of those figures is real, especially that of the animals emblematic of Mexico—the jaguar, the eagle, the serpent. There is also grandeur in the woman—the nation?—mounted on a jaguar. I wonder whether there is not in this image an unconscious memory of Durga and her tiger, a Hindu representation that he must have seen in the Reed-Sikelianos Ashram.

In these frescoes—there are others, such as those in the New School for Social Research in New York—Orozco confused power with eloquence, passion with gesture. Two temptations threaten mural painting: that of rhetoric and that of intimacy. Mural painting is a public art that tends to supplant the personal vision and manner of the artist with stereotypes and clichés; at the same time it barely tolerates the intrusion of the painter's innermost emotions and ideas. Orozco committed the latter transgression on occasion, but at other times, as in these paintings, he fell into the former vice, that of commonplaces and high-flown oratory.

Two periods in the life of Mexico aroused his passionate enthusiasm: the Conquest and the Revolution. In the first he saw, quite rightly, the decisive event in our history, the great break and the great fusion. The second is the contradictory complement of the first, the reply that, by denying it, consummates it. Orozco participated in the Revolution only from the sidelines, like most Mexicans of his age and class. In his *Autobiography* he says: "I took no part whatsoever in the Revolution, for me the Revolution was

the most joyous and amusing of carnivals." He should have written: "the gloomiest of carnivals." At a very young age he took part in the rebellion—half aesthetic and half political—headed by Gerardo Murillo, also known as Dr. Atl. Later, when the Revolution triumphed, he proved himself an adversary of the movement and created cruel caricatures in which he ridiculed Madero and other revolutionary leaders, such as Zapata and Gustavo Madero, the president's brother.

Victoriano Huerta's coup d'état made him change sides. He was in Orizaba with Dr. Atl; in the newspaper *La Vanguardia* he published caricatures of the dictator, the Church, and the ambassador of the United States. But in that same revolutionary period other caricatures appeared which give evidence of his early disillusionment with, and horror at the atrocities of, the civil war. Among them there is one that reveals the ambiguity of his feelings: it shows the face of a girl—smiling and vivacious, with big eyes—wearing a headdress topped by an ax and a dagger, with this caption: "I am the revolution, the destroyer!" The same ambivalence—less polemical, and tempered by admiration and pity—appears in the dual series *Mexico in Revolution* (oils, watercolors, gouaches, drawings and lithographs, 1913–1917 and 1920–1930). These works represent one of Orozco's high points as an easel painter, both on account of their pictorial excellence and on account of their vision. He sees the Revolution with the eyes of an artist, not of an ideologue: it is not a movement of a particular party but the eruption of our people from the very depths of their history and psychology. In these paintings there is grandeur and horror, executions by firing squad and pillaging, rapes and clumsy dances amid mud and blood, heroism and pity, sadness and anger. There are maguey cacti growing on parched land, a green presence as tenacious as life.

Despite the echoes and repetition of the worst habits of the Renaissance painters, the disparity between the various parts of

the whole, and the confusion between satirical engravings and mural paintings, the frescoes of San Ildefonso are one of his most successful works. They were a glorious beginning. Although a number of these paintings are illustrations—a common defect among our Muralists, and perhaps of the genre itself—others seem to me masterpieces, *The Destruction of the Old Order*, *The Strike*, and *The Trench*, for instance. This last still has all its powers intact, despite the flood of cheap reproductions. In these three frescoes there is passion without pathos, vigor without brutality, supreme strength, nobility in the draftsmanship, and restraint even in the violent color. Others of them are enlarged caricatures of the bourgeoisie, of institutions, and of justice. Orozco's scale is wrong, but I confess that those huge colored satires impress me as much today as they did fifty years ago, when I saw them for the first time on enrolling in the National Preparatory School. Some frescoes move me more deeply still: those in which he expresses his bitterness, his pity, and his wrath toward revolutionary folly, which is to say, toward human folly. One of them foreshadows the great Guadalajara compositions: three workers, one of them missing an arm, another who is covering his ears, and a third blinded by a red cloak and clutching a rifle. The fresco is entitled *The Revolutionary Trinity*: a double knife thrust, against religious dogma and against revolutionary dogma.[5]

In 1924 Orozco collaborated with the Communist painters work-

[5] In the sumptuous book *La pintura mural de la Revolución Mexicana*, published in Holland in 1960 by an official institution, the National Bank of Foreign Commerce, the title given this fresco is more reserved and respectable: *Trilogy*. This book is an example of the concealment of Orozco to which I referred at the beginning of this essay. For instance, in the reproduction of the fresco called *The Carnival of the Ideologies*, the fragment showing the hammer and sickle alongside the swastika has been suppressed in its entirety. Nor do the works of Jean Charlot and of Roberto Montenegro figure in this book.

ing for the newspaper *El Machete*. He soon abandoned this leaning and a year later painted the fresco *Omniscience* in the Casa de los Azulejos. But neither political ideas nor philosophical systems define him. He was, above all else, an artist; secondly, and no less totally, he was a religious spirit. His religion lacked dogmas, churches, and visible gods, though it showed no lack of revelations and mysteries. A religion of righteous wrath and vengeful pity. Anticlerical, antischolastic, antipharisaical, solitary, taciturn, and sarcastic, he loved and hated his fellows with the same exasperation with which he loved and detested himself. The Revolution fascinated him because he saw in it an explosion of what is best and of what is worst in human beings, the great trial from which some of us emerge condemned and others transfigured. He made mock of the Revolution as an idea and found it repellent as a system and horrifying as a power. With the same passion with which he glorified, and expressed his compassion for, its martyrs—whether the victim was a betrayed revolutionary such as Carrillo Puerto or a poor executed bourgeois—he vented his cruelty on leaders, political bosses, ideologues, generals, and demagogues. What did the Revolution mean to him then? As an institution and a form of government it seemed to him no less abominable than the Roman Church, the international bank, the Communist or the Fascist Party. As a social system it was magnificent and cruel, abject and generous: it was the roulette ball, the great confusion, the return to original chaos, the big rumpus. The Revolution, the womb where time begets its prodigies and its monsters: the hero, the executioner, the thief, the whore, the martyr, the sister of charity, the woman warrior, the lion, the snake, the crowned ass.

His vision of the human animal is no less tragic. The people are the clay and the gunpowder out of which revolutions, wars, and tyrannies are fashioned. But the people degenerate into a mass, the succession of blurred faces we see in religious processions, in

patriotic parades, at political demonstrations. Hoodwinked, robbed, beaten, and tortured by the military and the priesthood, by revolutionary leaders and ideologues, the people are cruel and meek, tough and stupid, victim and victimizer. The people create revolution, and revolutionaries in power destroy the people.

There is a disturbing analogy between Orozco's black vision and that of Mariano Azuela, Martín Luis Guzmán, and José Vasconcelos, Mexico's three great writers. His image of the Revolution as the great roulette ball that rolls at random, a flooding river that, having overflowed its banks, destroys everything that is opposed to it, makes me think of Azuela; his denunciation of the crimes of the military and the lies of demagogues, of Martín Luis Guzmán; his wrathfully judgmental and ultimately religious vision of history, of Vasconcelos, with whom he has perhaps the greatest affinity. But something distinguishes the painter from the three writers, and in particular from Vasconcelos: in Orozco's eyes the Revolution in power is no different from religion petrified into a Church. Here there appears a central and archetypal image of Orozco's: Rome/Babylon. It is an image that comes from the Bible and from the great religious texts: Babylon was Rome for St. John; for Orozco, Babylon is the Revolution triumphant, and it is the great modern cities—New York, London, Paris, Berlin—as well. . . . Babylon is Cosmopolis, the Great Whore. Orozco was an assiduous reader of the Book of the Apocalypse, and it is impossible to understand his visions if one forgets this sacred text. It goes without saying that his interpretation was not an orthodox one and was influenced by his ideas and by the opinions and excogitations of his friends from the New York Ashram. The subject of the Apocalypse brings me to another phase of his painting.

3

The Conquest of Mexico is inexplicable without the horse. Apart from the military superiority of the Spanish cavalry over the Indian infantry, there was the mythical fascination: to the Indians the horse was a supernatural creature. They believed that the horseman and his mount were a dual being capable of uniting and separating at will: for this reason, during the siege of Tenochtitlán, the Aztecs sacrificed in the Gran Teocalli not only the cavalrymen taken prisoner but their horses as well. The obsessive abundance of equestrian images on the walls of the Hospicio Cabañas is not, however, due to historical reasons alone: for Orozco, the horse was a symbolic animal. Once the day comes when his symbols and forms are studied with a modicum of attention, it will be seen that his most intense visions are resurrections of ancestral images buried in his soul. His religious and philosophical preoccupations constituted another source naturally manifested as visual images; for him, thinking was seeing. I have already pointed out the similarity of the figure of the woman mounted on a jaguar to the traditional image of Durga and her tiger. It is one example among many. Orozco's iconography and his bestiary are symbolic, and they belong to a traditional store of images. Some of them are pre-Columbian, most of them are Christian, and some come from Gnosticism and the pre-Christian religions and from the Orient. We are in need of a good iconographic study of his painting.[6]

Among the many horses of the Hospicio Cabañas there are two that are outstanding. One is a two-headed horse ridden by an iron

[6] Justino Fernández diffidently began such a study in his *José Clemente Orozco, forma e idea.* He examines the *Prometheus* at Pomona College superficially and refers to Panofsky's iconographic studies. Unfortunately, he failed to pursue the subject and delve more deeply. It is regrettable, for Justino Fernández was the first to emphasize the philosophico-religious meaning of Orozco's symbolism.

horseman representing martial Spain. Why is the beast bicephalous? The first answer that came to me was this: the Conquest was the dual work of the sword and the cross. It is probable that this obvious symbolism conceals one that is more subtle and profound. On the adjoining wall, facing the two-headed horse, appears another, no less fantastic and even more terrifying beast, a mechanical horse ridden by a robot who is brandishing a flag with the imperial arms of Spain. A juxtaposition of eras: the horse and his rider belong to the twentieth century, the flag to the Renaissance. In the theater of images that history signifies for Orozco, the meaning can only be the following: the Conquest, the work of the cavalryman and his mount, opens the gates to the modern era, the mechanical age. In Orozco's eschatology, the mechanical age corresponds to the dehumanization of human beings. The four horsemen of St. John's Revelation, the white, the blood-red, the black, and the yellow one—are fused in this steel-gray horse whose limbs are pistons and cylinders, whose tail is an iron chain, and whose rider is a killing machine. The passage from the Renaissance world to the modern one is expressed through the symbolism that transforms the two-headed horse of the Conquest into a mechanical beast. The symbolic series reveals to us a process consisting of leaps and falls: Quetzalcóatl→treason→escape→the Conquest→the two-headed horse: sword and cross→the mechanical age→dehumanization.

History is nothing but the turning of the wheel of cosmic justice.

Dehumanization was a leitmotiv of Orozco's generation. For Ortega y Gasset it was a sort of mental hygiene against Romantic excess; for others it was a confirmation of the concept of alienation as put forth by Hegel and Marx; for others still, such as Orozco, a sin, a fall: the loss of being. The human soul turned into a mechanism. In the Hospicio Cabañas, the painter represents the devil as a hideous idol, Huitzilopochtli, smeared with blood and surrounded by cannibal priests. In another mural, opposite the idol,

the symbol of the modern age: the mechanical horse and its rider. The modern devil is not an idol: he is a machine whose sole movement is the repetition of the same deadly gesture. The soul is breath, creative and life-giving movement; evil is its caricature: the barren movement of the machine, doomed to repeat itself endlessly. But mechanization is only one aspect of the universal dehumanization. The other is ideology: the mechanical age is also the century of ideologies. Ideology dehumanizes us because it makes us believe that its shadows are realities and that realities, including the reality of our own being, are nothing but shadows. It is a series of mirrors that hides reality from us, that steals our faces and our free will from us so as to turn us into reflections. Repetition is the mode of being that typifies the devil: the robot repeats the same gestures, the ideologue the same formulas.

If the machine is the caricature of life, ideology is the caricature of religion. In 1937, Orozco painted two frescoes, *The Phantoms of Religion in Alliance with Militarism* and *The Carnival of the Ideologies*, side by side in the Governor's Palace in Guadalajara. The first represents the old conservative sin that, in the history of Christianity, began with Constantine: the confusion between power and religion, the throne and the altar. This clerical and political corruption of faith has been the cancer of Latin America, from Independence down to our own day. The sacrilegious alliance between the sword and the cross is the equivalent of Huitzilopochtli and his bloodthirsty warriors. The other fresco shows us the political and spiritual reality of the modern world, divided into ferocious sects, each the possessor of a book in which the adept finds an answer to all the enigmas of history. In *The Carnival of the Ideologies*, there is a band of grotesque beings—cruel clowns, clever and stubborn madmen, sadistic men of learning—each armed with a sign —the crucifix, the hammer and sickle, the swastika, the fasces, the keys of this world or those of the world to come. It is not

difficult to recognize in these rag dolls the faces of many of the doctrinaires and masters of our century, all of them possessed by *theological hatred.* Each sect believes itself the possessor of the total truth and is ready to impose it on the other sects by force and extermination. The twentieth century has been an ideological century, as the twelfth century was a religious century. The phantoms of religion brought on the persecutions of heretics, the religious wars of the sixteenth century, and other disasters; the ideologies of the twentieth century have brought war to every nation, murdered millions of people, and enslaved countries as vast as continents.

The subject of Revolution corrupted by power leads to two images of modern society: mechanization and ideological alienation. Through the Revolution, our country made its way into the modern world, but that world is not the one—the world of endless progress and universal fraternity—that liberals and revolutionaries dreamed of. Years ago, touching on this subject, I wrote: "For the first time we are contemporaries of all men."[7] This sentence has not always been read correctly. I was referring to the collapse of beliefs and utopias; I was pointing out that today we are alone and that, like all the rest of humankind, we are living in the open, without shelter: "There are no longer either old or new intellectual systems capable of providing us refuge from our anxiety . . . Before us there is nothing." In fact, the distinctive feature of these last years of the century has been the failure of revolutions that kindled the hopes of immense multitudes and of many intellectuals barely fifty years ago. At the same time, the countries that have not been frozen by revolutionary totalitarian dictatorships and that have es-

[7] *El laberinto de la soledad*, Mexico City, 1950. (English ed.: *The Labyrinth of Solitude.* Trans. Lysander Kemp, Yara Milos, and Rachel Phillips Belash. New York: Grove Press, 1985 [an expanded edition, containing other works]). The translations above are mine.—TRANS.

caped military tyrannies, in other words, the liberal nations of the West, have been incapable of putting a stop to the process of dehumanization. The evils have been less grave than in the totalitarian regimes; nonetheless, the degradation of human existence has been immense. A society of consumers is not even a hedonistic society. It is a world impelled by a circular process: producing to consume and consuming to produce. Orozco's vision was profound and clear: we are already modern because we are citizens of the mechanical and ideological age. We are the maimed of being.

After *The Carnival of the Ideologies*, Orozco painted in various frescoes his vision of postrevolutionary Mexican society and of the modern world. In 1941, in the National Palace of Justice in Mexico City, he dared to reveal the venality of our justice. He hit the bull's-eye: without judicial reform, Mexico will never be able to put itself in order. In the elegant *Turf Club*, he painted in 1945 a satire on the affluent society that antedated Fellini's *La Dolce Vita*. But the work that is characteristic of this period, both because of its violence and because of its subject, is slightly earlier: *Catharsis* (Palace of Fine Arts, 1934), a veritable purging not only of his feelings but of his obsessions. A multitude of bestial figures, mixed up helter-skelter and all jammed together, fight among themselves and stab one another. They are members of splinter groups, fanatics, merchants, thieves, demagogues, doctrinaire hypocrites, transformed into a feral, greedy mass: here and there, immense, fleshy, and long past their prime, their legs parted, wallowing in the blood and excrement, are the courtesans. Their great bursts of boisterous laughter drown out the drumming of machine-gun fire. This image of modern society is nothing more or less than the updating of the centuries-old biblical image of Babylon, the Great Whore.

The vision reveals itself with even greater clarity in one of his last (unfinished) frescoes, *The Allegory of the Apocalypse* (Hospital de

Jesús, 1942–1944). The allusions to St. John's text are even more direct and explicit. The whore dresses and drinks in the modern mode, but she is astride an obscene creature: "And I saw a woman sitting on a scarlet-colored beast, full of names of blasphemy, having seven heads and ten horns. . . . And upon her forehead a name written—a mystery—Babylon the great, the mother of the harlotries, and of the abominations of the earth." The Great Whore is none other than imperial Rome, mistress of all vices and tyrannies: "And the woman whom thou sawest is the great city which has kingship over the kings of the earth." Alongside Rome/Babylon appear other images taken from the holy text. We see the angel bind Satan and, later, unbind him. "And when the thousand years are finished, Satan will be released from his prison, and will go forth and deceive the nations which are in the four corners of the earth, Gog and Magog, and will gather them together for the battle; the number of whom is as of the sand of the sea." The liberation of Satan unleashes universal war: our time.

Esoteric interpretation of history is very far from the Marxism of Rivera and Siqueiros, and from the ideas of most modern artists and intellectuals as well. To understand what have been called Orozco's contradictions—or rather, to understand that they are not contradictions—we must accept, however, that his painting is a symbolic vision of history and of human reality. His symbols are inherited from tradition but are freely linked together and interpreted. Orozco sees with the eyes in his head and with those of his mind; he subjects what he has seen and thought to geometry, proportion, color, and rhythm; his painting is a symbolic bridge that leads us to other realities. The art of painting what we see is transformed into the art of showing us the transfiguration of human reality into form and idea and, finally, into geometry become light and rhythm. Hence it was only natural that, particularly at the end of his life, he should feel attracted to abstract painting, that is to

, to the play of colors and forms that have ceased to have a meaning and simply *are*. In the Hospicio Cabañas and in the Hospital de Jesús, divinity is represented by abstract forms. But it was also only natural, by the very logic of his artistic endeavor, that he should resist Abstractionism; painting for him was a polemical, even tragic act, by means of which human beings signify themselves through form and thus transfigure themselves. To paint is to express our thirst, never sated, for absolute meanings. Orozco did not paint timeless certainties: he painted the longing for certainty.

The symbols carry on a dialogue among themselves; Quetzal-cóatl summons Cortés, who convokes the mechanical age, which leads to an apocalypse. The logic of the symbols is consistent, but what is their meaning? History has no meaning: history is the search for meaning. That is its meaning. For this reason it is the locus of purification and transfiguration. The hero and the martyr are emblems of the human condition transcended or transfigured. Each of us, on our own small scale, can be a hero, that is, a living proof of the possibility of going beyond ourselves. Where is that beyond located? Orozco does not know, or rather, as he once confessed to Justino Fernández, *he knows that it is the unknown*. An answer not lacking in grandeur. There is a word that defines both art and the person that Orozco was: authenticity.

It is impossible in a work such as this to examine at length the evolution and the changes in his style. I am writing an essay, not a monograph. I will therefore confine myself to pointing out, in passing, that the terms *evolution* and *change* designate paths that ceaselessly intersect: on the one hand, the gradual mastery of forms and techniques; on the other, the discovery of the world that is his own. For a true artist, learning to paint entails, above all else, appropriating means to express him- or herself; *evolution* is the gradual ascending movement that leads him or her to the possession of such means. *Change*, in turn, is a mutation possessed of a meaning

and a direction: authentic artists search for themselves, and their changes are the different moments of that search. For Orozco the search ended early on: once he had made his first dramatic sketches and watercolors he found himself. Although he later explored other paths and tried out different techniques and manners, he changed not to find himself but to broaden his outlook and annex new territories of reality. His changes did not make of him another person, as Picasso's did; they served to help him explore himself in greater depth and express himself better. All his variations reveal an extraordinary continuity. His experiments and his adventures, as I tried to show in the first part of this essay, were motivated not by a keen desire for novelty but by intimate needs for expression.

In the first third of our century, painting went through radical transformations, from Fauvism and Cubism to Surrealism and Abstractionism. Everything that has been done since has been nothing but variations and combinations of what was painted and invented during those years. The Mexican Muralist movement was a part —albeit an eccentric part—of those great changes. None of our painters closed their eyes to the successive aesthetic revolutions of the century; likewise, none of them surrendered unconditionally to those movements. The most conservative of them all, Diego Rivera, was the one who, in his youth, had participated most fully in the pictorial adventures of the twentieth century, Fauvism and Cubism. At the other extreme is David Alfaro Siqueiros, the most daring, the most inventive and imaginative of them all; I have always regretted that his obsessions and political fanaticism proved detrimental to his great powers as an innovator. Even so, it is undeniable that his conceptions concerning the dynamism of matter and the use of the blotch of color are forerunners of Abstract Expressionism in the United States. Plastic invention interested Orozco less than it did Siqueiros: Orozco's genius was not speculative. Nonetheless, as I have already said, he too explored and used the

resources of abstraction and geometrism, though always in the service of his peculiar vision of the world. Let me point out, moreover, that his geometric and nonfigurative experiments belong to his late period. Salvador Elizondo has made the discerning observation that Orozco died while still earnestly pursuing his search and exploring different paths: what would he have done had he lived a few more years?

Orozco and fidelity: in the watercolors of his early years there is already everything that there would be later on. While his draftsmanship is admirable for its tense economy, the composition announces his future mastery of large surfaces: in those paintings of much smaller dimensions, the space is vast and it breathes. The colors are acid and muddy, but this, which might be a defect in another type of painting, helps accentuate the exhaustion and suffering that inhabit the urban purgatories that Orozco's brothels represent. A little later he abandons those closed and suffocating worlds, comes out into the open air, and proceeds from anguish to anger, from mockery to imprecation, from oblique comment to great prophetic poetry. Other changes in his paintings correspond to these psychological and moral ones: his line becomes more full and energetic, his colors more brilliant and violent. It is true that he was not a great colorist, especially by comparison with two masters of color such as Tamayo and Matta. But neither can his art be reduced to black and white, as some have maintained. This confusion became widespread at one time, and I myself shared it for a while. It is not difficult to discern the reason: Orozco began as a graphic artist and never entirely ceased being one. Even some of his first murals—I am referring to *Social Untruths* (1924) at the Colegio de San Ildefonso—look like giant enlargements of satirical engravings. But in the same building other frescoes of his reveal a remarkable sense of color, almost always impassioned and on occasion radiant.

The limitation imposed by black and white is transformed into richness of chiaroscuro, their monotony into intensity. It is not surprising that Orozco left so many superb examples of a genre that particularly suited his temperament, at once obsessive and vehement. Many of his engravings and lithographs hold their own next to the very greatest, from Goya to Munch. Some of his black-and-white frescoes are also memorable. But this method of expression is only a facet, though a major one, of his painting. His genius consisted of *translating* the concentrated fury of black and white to the entire spectrum. He was not always successful. Enamored of violence and quite frequently a victim of himself, he paid no attention to gradations, shadings, phosphorescences, transparencies. On occasion his color is unpleasant; more often, however, his reds and greens flash, his yellows sparkle, his blues are iridescent, his grays are knife thrusts. Detonations, stormy colors, anguish, fire. Line—his great gift—supports these flaming constructions with no damage to itself. It is a pure, precise, firm line. Neither arabesques nor sinuous curves as in Matisse nor the serpentine line of Picasso, which coils with a certain lasciviousness around the Tree of Life. A line thrusting directly forward, a hand-to-hand skirmish with space, a line that invents bodies and architectures. Draftsmanship as mainstay.

It would be useless to search in Orozco's painting for the paradisiacal nature of Diego Rivera, a great painter of trees, creeping vines, flowers, mosses, water, men and women with coppery bodies. The world of the first day, infused with an all-powerful sexuality, a paradise more animal than human and more plantlike than animal. Diego Rivera the painter thereby pays the debt incurred by Diego Rivera the ideologue. Contemplating those frescoes, which show us the prodigious and colorful height of his generative powers at the very beginning, is generous compensation for the tedium of mile after mile of didactic painting and simplistic

ideology. Orozco's landscape is arid, rent apart, harsh; stormy skies, immense dry plains, stubbornly silent crags, twisted trees, petrified hamlets. Human bodies—men fallen in battle, women dressed in mourning—are the suffering part of the landscape. And also the fierce part: the bodies are talons, they are fangs, they are hoofs that crush what they tread on. Orozco's landscape is something more than a *paysage moralisé*; it is a dual emblem of the ferocity of nature and of the fierce nature of humankind. However, in those desolate environs, the very image of drought, the maguey cactus sprouts. It is not a cheery plant; a fount belonging to the vegetable kingdom, it is an obstinate green, a stubborn will to be born, to grow, to survive. Maguey: Mexico, or tenacity.

The urban landscape is the replica of the natural one. The physical and moral replica. In Orozco's works, industrial panoramas and perspectives abound: factories, skyscrapers, trains, iron bridges, machines and still more machines, ghostly men and women walking along endless streets between tall gray buildings. Orozco lived for many years in New York and in San Francisco, visited Paris and London, stayed for a time in Rome, and witnessed the transformation of Mexico City into a modern metropolis. Unlike painters and poets of our century such as Léger, Boccioni, Apollinaire, Joyce, he looked on the modern city not with amazement but with horror. For him the city was not the cosmos that Whitman had celebrated or the great factory of the marvelous that fascinated Breton. Closer to Eliot, he looked on it with biblical eyes: a place of condemnation, the native land of the Great Whore, as vast as the desert and as suffocating as the cell in which prisoners live crowded one on top of the other. In his visions of Mexico there sometimes appear white, gray, ocher cubes: they are houses from which sorrowing women, funeral processions, emerge. At other times he paints panoramas of cupolas, churches, towers, forts, walls, terraces: what remains of the Mexico of long ago. These backgrounds, painted with nostalgia, are like a farewell to a world that

has disappeared. I should add that all these urban landscapes are *constructed*, by which I mean, Orozco's eye and hand are architects. He was a great painter of volumes and solids. He was a man inspired but he was also a geometer.

In an essay famous in its time, Villaurrutia called Orozco a "painter of horror." I have already expressed my disagreement elsewhere and explained my reasons. Because of its intensity and its violence, Orozco's painting deserves to be called terrifying. Horror immobilizes us, fascinates us; the terrifying is threatening, and it arouses fear, panic in us.[8] It seems more accurate to me to say that Orozco is a colossal painter and a limited one. Colossal because his painting sinks its roots in the two mysteries that no one has unveiled, that of the beginning and that of the end. Limited because I miss many things in his painting: the sun, the sea, trees and their fruits, smiles, caresses, embraces. The polar opposite of Matisse, he is unaware of happiness, the solar plenitude of the female body lying at our side like a beach or a valley; in woman he sees the mother, the harlot, or the sister of charity; he does not see in her the fatal pomegranate that, split apart, gives us the sacred food that makes us sing, laugh, and become delirious. He is also unaware of the contemplation of the stars in the sky of the mind, the reach not of the hand but of thought, the rotation of forms and colors, the image of the perfection of the universe that made Kandinsky marvel: a spellbound play of atoms and suns. He is unaware, finally, of Duchamp's smile, which reveals to us at one and the same time the unfathomable abyss of the universe and the highest and most difficult art: dancing on the precipice.

Our painter compensates for all these limitations by the inten-

[8] See my *Xavier Villaurrutia, en persona y obra*, Mexico City: Fondo de Cultura Económica, 1978. I have written about horror, in an attempt to distinguish it from the terrible, in *El arco y la lira* (in the chapter entitled "La otra orilla") and in the collection *Puertas al campo* (in the essay "Risa y Penitencia," translated in this volume as "Laughter and Penitence").

sity of his vision and the tragic energy of his creations. He did not know how to laugh, to contemplate, or to embrace, but he was thoroughly acquainted with mockery, sarcasm, outcry, silence, loneliness, fraternity, the martyr's gasping breath in martyrdom, the divine vision atop the arid crag or in the darkness of the cave. What did he leave us? Forms set afire that outline a question: Prometheus the Titan punished for his love of humankind, Quetzalcóatl preaching in the desert, Philip II embracing a stone cross, Christ destroying his, Carrillo Puerto falling drenched in blood. Icons of the human question, icons of transfiguration. All of them dissolve and turn into another: humankind in flames.

MEXICO CITY, *March 1, 1986*
Vuelta 119, MEXICO CITY, *October, 1986*

Loners and Independents

From Criticism

to Offering

Reduced to its most immediate form, aesthetic experience is a pleasure, a particular type of relationship with a real or imaginary object that suspends, even if only momentarily, our rational faculty. The object seduces us, and the fascination it exercises over us goes from blissful rapture to repulsion, from delight to pain. Although the range of sensations is practically infinite, all of them have in common the fact that they paralyze our reason; pleasure transforms it and from our sovereign faculty converts it into an accomplice or a scandalized and powerless censor of our sensations. Judgment participates in our folly. Its light illuminates the representation of a senseless act, guides the footsteps of passion, or places illusory obstacles in its way. It is one element more, spice in the strange concoction, the spur that speeds or slows the race. How to write

about art and artists without abdicating our reason, without turning it into the servant of our most destructive tastes and our least premeditated inclinations? Our tastes cannot be justified; or rather, satisfying themselves, finding the object that they desire, is their sole justification. It is not my reason that justifies my tastes but rather those works that satisfy them. It is in them, and not in my conscious awareness, that I find the reason for my pleasure. But I can say little or nothing about those works, except that they captivate me in such a way that they prevent me from judging them and judging myself. They are beyond judgment; they make me lose my judgment. And if I decide to pronounce judgment, I fool neither myself nor anyone else as to the real meaning of my act: I do so only to give my pleasure added pleasure.

Such is, or ought to be, the point of departure of all criticism. And such is the first place where it is brought to a halt. For what if, in the light of reflection, my pleasure vanishes? I would have no other recourse than to confess that my senses were deceived and deceived me. They made me believe that a fleeting sensation was an enduring passion. My judgment teaches me to mistrust my senses and emotions. But the senses are irreplaceable. Judgment cannot substitute for them, because feeling is not its function. I shall have to train my senses, make them at once stronger and more delicate, at one moment tough, at another fragile; in a word, more lucid. I shall hear with my sense of sight and with my skin; I shall cover myself with eyes. Everything, even judgment, will be touch and hearing. Everything must be felt. I shall also think with my eyes and my hands: everything must think. Although criticism does not dethrone feeling, a change has taken place: judgment is no longer a servant but a comrade. An ally at times, an adversary at others, and always a demanding witness who cannot be suborned. It enters the closed world of works with me, and even though my eyes, my ears, and my sense of touch, emotion, and instinct go on

ahead, it (blind, deaf, and impassive) lights their footsteps. If I move closer to the painting so as to listen to its secret palpitation (the ebb and flow of the tide of red, the slow ascent of the green toward the cold surfaces), it takes the pulse of my fever. It tears down and rebuilds the object that I am contemplating and discovers that what seemed to me a living organism is merely an ingenious artifact. Little by little it teaches me to distinguish between living works and mechanisms. It thereby reveals to me the secrets of clever constructions and draws the borderline between art and the artistic industry. In the end, when I savor works, I judge them; when I judge them, I take pleasure. I live a total experience, in which my entire being participates.

Criticism not only makes my pleasure more intense and more lucid but obliges me to change my attitude toward the work. It is no longer an object, a thing, something that I accept or reject and on which, with no risk to myself, I pass sentence. The work now forms part of me, and to judge it is to judge myself. My contemplation has ceased to be passive: I repeat, in the reverse direction, the artist's gestures; I walk backwards, toward the origin of the work, and clumsily feeling my way along; I traverse the same path as the creator. Pleasure becomes creation. Criticism is creative imitation, reproduction of the work. The painting I contemplate is not, of course, identical to that of the painter. It tells me things that it didn't tell the painter. It could not be otherwise, since it is seen by two different pairs of eyes. It doesn't matter: thanks to criticism the painting is also a work of mine. The aesthetic experience is untranslatable, not incommunicable or unrepeatable. We can say nothing about a painting, except to bring it closer to its viewers and guide them so that they may repeat the test. Criticism is not so much the translation into words of a work as it is the description of an experience. The account of certain facts, a memorable feat, that turned an act into a work.

These reflections came to mind, almost despite myself, when I was preparing to write about the Rufino Tamayo exhibition at the Galerie de France. Perhaps they are not entirely beside the point, if one is of the opinion that, contrary to what a good many people believe, Tamayo's work is the offspring not only of instinct but of criticism as well. Moreover, an unusual phenomenon, which has not received sufficient attention: for this artist, painting is as much criticism as it is the discovery of realities. Tamayo confirms, yet again, that creation implies a critical activity on a number of different levels: the artist is at odds with the world, and at one moment or another of his life he must question the reality, the truth or the value of this world; he is at odds with the works of art that surround him, whether contemporary or from the past; and before and above all else, he is at odds with himself and with his own works.

Mexican mural painting had reached its zenith when Tamayo began to paint. It does not seem legitimate to me to disdain the Muralist movement, as is customary today. It was of capital importance not only for Mexico but for all the Americas. Its influence was particularly profound in the United States during the decade from 1929 to 1939, that is to say, in the period immediately prior to the almost explosive appearance of the great painters of that country. Many of the Abstract Expressionists had a hand in the WPA art projects of the Roosevelt era, undertakings inspired, at least in part, by the Mexican movement. By Tamayo's time, mural painting had already been converted from a spontaneous search into a school. It soon degenerated into a formula. The danger lay not only in the exhaustion of pictorial language but in the ideological intentions of the movement. In those days artists spoke, almost always in a tone that admitted of no appeal, of "national art," a notion already confused by then with notions no less vague, such as that of "proletarian art." (The mixture of the two, years

later, would serve as leavening for Socialist realism.) Abject obedience or heterodoxy were the roads open to artists. Tamayo chose heterodoxy and, along with it, isolation and criticism. In the first place, he refused to reduce his art to just another form of political rhetoric. Immediately thereafter, he decided to develop a personal painterly language in opposition to the so-called national style of painting; in other words, he resolved to create, to search for himself, instead of repeating others.

An invention of German Romanticism, the idea of a national style or national artist reappears more or less periodically and wins, in places remote from one another, the support of the most antagonistic and dissimilar spirits. It is beyond question that the arts express (among other things perhaps more profound) the temperament of every nation. But there is nothing less stable than a temperament constantly subject to change, to the combined action of the elements and of time. Temperament has a common border with temperature. Even more decisive than the ungraspable national character is the individual accent of every artist, often at odds with his compatriots and with his milieu. Moreover, the borderlines of styles almost never coincide with those of nations. Styles are vaster, encompassing many countries; they are international. Is the Gothic style (the name itself is already a trap) French or German? Is the Baroque Italian, Spanish, German? Italian lyric poetry stems from the Provençal style (imported, perhaps, from Moslem Spain, which in turn . . .). Curtius has shown that our literatures have all been one since the twelfth century: European literature. Without Petrarch, there would not have been Garcilaso de la Vega, nor Corneille without Alarcón, nor modern poetry in English, Russian, or Japanese without Baudelaire and the French Symbolists. From the sixteenth century on, European literature gradually wins over America, Russia, and, today, the entire world. And as it spreads and triumphs, it ceases to be European.

Styles are temporal; they belong neither to soils nor to centuries.

They are manifestations of historical time, the form of embodiment of the spirit and the tendencies of an era. Styles are vagabonds and move about from one place to another. They travel via the means of locomotion of their time: with knights and pilgrims in the Middle Ages, with soldiers and ambassadors in the Renaissance. The nearly instantaneous speed with which styles are transported in our own day is not a proof of fertility. The time of communication and of information is not the time of spiritual germination. Head colds depopulated whole regions of indigenous America; a certain sort of abstract painting can be fatal for many Latin American painters. A style turns into a contagious disease if those who embrace it do not put up any resistance. But if they oppose it too strongly, the style becomes exhausted and dies. The fecundity of a style depends on the originality of the artist who adopts it. A struggle between the two begins, which ends only with the death of one of the contenders. A true artist is the survivor of a style. Determined to live, Tamayo had no choice but to stand up to the "Mexican school of painting." He abandoned the stereotyped vision of reality (the freezing point of styles) and set out to see the world with different eyes. What his gaze revealed to him was, naturally, something incredible. Is that not one of the missions of the painter: to teach us to see what we had failed to see, to teach us to believe in what he sees?

Certain artists aspire to see what has never been seen before; others, to see in a way that no one has ever seen before. Tamayo belongs to the second lineage. To see the world with different eyes, in his case, means to see it as if his gaze were the primordial gaze. A pitiless and immediate vision, an almost inhuman clear-sightedness, rarely attained save by a very few artists. Between our gaze and the world, images previously produced by habit, culture, museums, or ideologies interpose themselves. The first thing a painter must do is to brush away from his eyes the spiderwebs of

styles and schools. The experience is dizzying and blinding: the world leaps to our eyes with the innocent ferocity of what is too alive. Seeing without intermediaries: a painful apprenticeship that never ends. Perhaps that is why painters, unlike poets, create their freshest works at the end of their days: once they have grown old they manage to see like children. Asceticism of vision: the hand learning to obey the eye and not the head, until the head stops thinking and begins to see, until the hand conceives and the eye thinks. To see the world in this way is to see it with one's whole body and mind, to regain the original unity in order to win back the original gaze. The primordial gaze: the gaze that is neither before nor after thought, the gaze that thinks. The thinking of that gaze tears off the rind and the crust of the world, opens it like a fruit. Reality is not what we see but what we discover.

To paint, for Tamayo, was (and is) to learn to see, to sharpen his gaze so as to penetrate reality and discover its innermost recesses. As he started out on his path, he had to discard the stylized idea of reality offered him by the Mexican painters of the previous generation. Almost from the first moment that he began to see it with clear eyes, reality ceased to be a stable and docile presence. It bristled, began to change, became a fount of enigmas. To see it was to strip it bare and, more than that, to skin it; to paint it was to fight it, take it prisoner. In one leap, Tamayo went from criticism of styles to criticism of the object. Without moving from where he was, he found himself in the very middle of modern painting, that is to say, in another world. His real travels (Paris, New York, Rome) would soon follow this first spiritual leap. But none of that came about by thinking but by painting. Rufino Tamayo is a man not of ideas but of pictorial acts.

Throughout the years, despite changes, ruptures, variations, and searches in every direction, Tamayo has remained faithful to the attitude he adopted in the very beginning. At first glance his

endeavor may appear contradictory. To see the world with other eyes means two different things: to see it with new eyes and to see it with eyes that are not ours. In Tamayo these alien eyes are those of universal painting and, above all, those of modern art. Universal vision may appear to be opposed to, or rather, to be superimposed on personal vision. The contradiction is resolved if we remember that for all real artists modern art is not so much a school as an adventure. An experience rather than a lesson, a goad to inventing and not a model that we must repeat. A path that each one must break for him- or herself and walk alone. What modern painting taught Tamayo was the shortest path toward himself. Thanks to universal painting he was able to see with other eyes— his *own*—the universe of forms and images of Mexico's past and of its popular art. He regained the eyes of long-ago ages and noted that those eyes were new and that they were his. Modern and pre-Columbian art revealed to him the possibility of seeing himself. An artist as richly endowed as he, a possessor in his own right of a world of forms and colors at once monumental and soaring, sober and delirious, could not be harmed by contact with great works of the present and of the past. The contrary is true: such contacts produce sparks, illuminations.

Tamayo's work develops in two directions: on the one hand, guided by his powerful instinct, it is a constant search for the primordial gaze; on the other, it is a critique of the object, that is, an equally constant search for essential reality. There is no dispersion, because the two paths cross. Criticism, intellectual painting, is a sort of *via negativa*. It is an ascetic practice whose goal is to channel instinct rather than to conquer it, like the sluice gate that lifts at the precise moment when the pressure of the waters is most intense. Thanks to criticism, not in spite of it, Tamayo continues to be an instinctive painter (since this is what he really is). But one runs the risk of distorting him if the word *instinct* is

taken too literally. Mexican popular art is instinctive in the sense that it is a tradition, a gesture that has been repeating itself for centuries. The mastery of popular artists evokes not the idea of effort but rather that of spontaneity. But Olmec and Totonac art, no less spontaneous than popular art and perhaps even more, is not a legacy, an inherited mastery: both are a beginning, the foundation of a tradition. And for that reason they are a geometry and a vision of the world. Each line is an analogy, a response or a question to a line, an image that is other. Unlike popular contemporary art, the great plastic works of the era before Cortés are a treatise, a discourse, or a hymn. The variety and the wealth of elements become a unity thanks to a geometrical rigor that is an intellectual rigor as well. Each object is a constellation of allusions. All these works, including the minor ones, are *compositions*. And the word *composition* and its counterpart, *instinct*, are keys to Tamayo's painting.

Instinct leads our painter to a direct art, at times Expressionist, at others poetic (popular or mythical: hence his exact correspondences with Miró and with certain Surrealists). At the same time, a certain predisposition of his mind, not without precedent in pre-Cortesian art, brings him closer to what I would call reflective painting. The two tendencies carry on a dialogue within his work: the fixed gaze that takes the object apart and then reassembles it, a gaze that I do not hesitate to call inquisitive, because there is an implacable and inhuman love in its fixity; and, confronting it, the splendor of a carnal star, a fruit, a form of black mud and green stone, a night sky, ocher, red, the dance of colors wailing around the white bone, the bone of death and resurrection. A dual painting that achieves unity only to rend itself apart and then put itself back together again. The vitality of Tamayo's art depends on the coexistence of these two tendencies. Once one of them prevails over the other to an excessive degree, the artist hesitates. If criticism

wins out, the painting dries up or languishes; if instinct dominates, it falls into a crude Expressionism. Equilibrium is not attained, however, through a truce between the contraries. To live, this painting needs to do battle with itself, to nourish itself on its contradictions. Neither immobility nor movement but instead the vibration of the fixed point. The center, the most sensitive point.

The first thing that impresses the visitor to Tamayo's recent exhibition, if he resists the attraction of the colors for an instant, is the rigor of the works. Pictorial reflection here reaches an extreme refinement, a daring and a delicacy that at times are reminiscent of a sort of renewed Cubism and at others of the boldest experiments of abstract painting. Cubism because many of the paintings on exhibition, besides being solid plastic constructions, are a pitiless investigation of the object in its triple function: as a thing in the world; as a form isolated in space, a model for the eye; and, finally, as an archetype or essence, an idea. Pure abstract painting (by contrast to informal or Expressionistic abstraction) because each of these paintings is an investigation, an analysis, and a re-creation of matter as matter, that is, as matter flung, so to speak, into its "materiality," matter that sees itself and aims at extracting its meaning from itself.

In both instances, Tamayo proposes to achieve something that he fully attains only at his peak moments. Something that is neither a critique of the object nor immersion in the density of matter: a sort of transfiguration of the world that I dare not call poetic, although it is, since the word has become outworn through overuse. Some of his most recent paintings show us the best Tamayo, the most secret one. A Tamayo almost faceless, just barely personal, very old and very young, recently awakened from a centuries-long sleep. Those paintings are not a critique of the object. No, this painting is not metaphysics or surgery. I said that his gaze was inquisitorial; I ought to have written *sacrificial*. A flint-gaze that

pierces the object-offering. Between death and life, sacrifice lays a bridge: humankind. Hence his painting at times seems to us one of those Aztec sculptures dressed in the skin of a human being. Sacrifice is transfiguration.

PARIS, *December 29, 1960*

Puertas al campo

Transfigurations

1

There are many ways of approaching a painting: in a straight line, until one is standing in front of the picture and contemplating it face to face in a questioning, defiant, or admiring posture; obliquely, like someone exchanging a furtive, knowing look with a passerby; taking a zigzag course, advancing and retreating in strategic moves reminiscent of both the game of chess and military maneuvers; measuring and taking things in with one's sense of sight, like the gluttonous guest surveying a table laid out before him; circling about like the sparrow hawk before swooping down or like an airplane in a holding pattern before landing. The straight-forward way, the complicitous way, the reflective one, the wary approach of the hunter, that of the mesmerized gaze. . . .

For more than twenty years now I have been circling about Rufino Tamayo's painting. I tried first of all to pin down my impressions in an essay aimed at situating him in his most immediate context, modern Mexican painting; later I wrote a poem; after that, a piece of art criticism properly speaking: Tamayo's painting, his vision of space, the relationships between color and line, geometry and sensation, volumes and empty surfaces. Today, with greater caution, I am writing these notes, not a summing-up but yet another beginning.

How to define my attitude toward Tamayo's work? Rotation, gravitation: it attracts me, and at the same time, it keeps me at a distance—like a sun. I might also say that it arouses in me a sort of visual appetite: I see his painting as being like an incandescent and untouchable fruit. But there is another, more precise word: *fascination*. The painting is there in front of me, hanging on a wall. I look at it and little by little, with slow, stubborn self-assurance, it unfolds and becomes a fan of sensations, a vibration of colors and of forms that spread in waves: living space, space happy to be space. Later, with the same slowness, the colors fold up again and the painting closes in on itself. There is nothing intellectual about this experience: I am simply describing the act of seeing and the strange, though natural, fascination that takes hold of us when we contemplate the daily opening and closing of flowers, fruits, women, the day, the night. Nothing is farther from metaphysical or speculative painting than Tamayo's art. When we contemplate his paintings we are not witnesses to the revelation of a secret: we participate in the secret that every revelation is.

2

I have said that Tamayo's art is not speculative. Perhaps I should have written: it is not ideological. In that first essay, written in

1950, I pointed out that Tamayo's *historical* importance in Mexican painting lies in his having interdicted, with exemplary radicalism, the ideological and didactic art of the Muralists and their followers. It must be added that Tamayo's true originality—his *pictorial* originality—lies not in his critical attitude toward the confusion between painting and political literature against which Mexican artists were struggling in those years but in his critical attitude toward the object. In this sense one can indeed speak of speculative painting. Painting that subjects the object to an intense questioning concerning its plastic properties and one that is an investigation of the relations between colors, lines, and volumes. Critical painting: reduction of the object to its essential plastic elements. The object seen not as an idea or representation but as a field of magnetic forces. Each painting is a system of lines and colors, not of signs: the painting may refer to this or that reality, but its plastic meaning is independent.

Tamayo's first period, once the years of hesitation and apprenticeship were over, includes a number of compositions, such as the *Homage to Juárez* and several murals, that reveal an affinity, both inevitable and natural, with Mexican painting in this period. It is his debt to the Muralists and, in particular, to Orozco. He soon parts company (permanently) with that highly rhetorical manner. His adventure was destined to be entirely different. Between 1926 and 1938 he paints many oils and gouaches—I am thinking above all of the still lifes and of various urban landscapes: arches, cubes, terraces—that place him in Cézanne's lineage. Following that path, he will arrive, a little later, at Braque. Tamayo's painting is not Cubist: it is one of the consequences of the Cubist movement, one of the paths that painting was enabled to take after Cubism. In other canvases of those same years, there appears an inspiration, freer and more lyrical, that can be defined as the excitement generated by the color of daily life. Sensuality rather than eroticism:

Matisse. In Tamayo, of course, there is an exasperation and a fierceness that are absent in the work of the great French master. Other aspects of those paintings—and certain others painted in those years—place him in close proximity to another focal point of radiation, Picasso. Except that here the lesson learned is not that of rigor or sensual equilibrium, but rather that of the violence of passion, humor, and rage, the revelations of dreams and of eroticism. Painting not as an investigation of the object or as a plastic construction: painting as an operation that acts as a total destruction of reality and, at the same time, as its metamorphosis. At the end of this period, Tamayo begins to paint a series of violent canvases that are plunged in melancholy at times, are almost manic at others, and are always intense and concentrated: dogs howling at the moon, birds, horses, lions, lovers in the dark, women bathing or dancing, lone figures contemplating an enigmatic firmament. Not at all theatrical or dramatic: delirium has never been more lucid or more self-controlled. A tragic joy. Tamayo discovers in the course of those years the metaphorical capability of colors and forms, the gift of language that painting represents. The painted work turns into the plastic counterpart of the poetic image. Not the visual translation of the poem in words, a technique practiced by several Surrealists, but a plastic metaphor—something closer to Klee and Miró than to Max Ernst. And so, through a continuous process of experimentation, assimilation, and change, Tamayo turns his painting into an art of transfiguration: the power of imagination that converts a sun into a mammee tree, a half-moon into a guitar, a bit of wildwood into the body of a woman.

I believe the names that I have mentioned form a constellation that does not so much define as situate Tamayo's endeavor in his initiatory period. I shall remind my reader that at the dawn of our language the word *sino*, a cognate of *signo*, meant, literally, a

constellation.[1] Destiny: sign: constellation: Tamayo's place and likewise his signs as he begins his exploration of the world of painting and that other, more secret world, that is, his being as a man and as a painter. Points of departure toward oneself.

3

To define an artist by his predecessors is as pointless as to try to describe a mature man by the marks of identity of his parents, his grandparents, his uncles. The works of other artists—what existed before, after, or alongside—situate an individual work, but they do not define it. Each work is a self-sufficient totality: it begins and ends in itself. The style of an era is a syntax, a set of conscious and unconscious rules whereby the artist can say everything that occurs to him, with the exception of commonplaces. What counts is not the regularity whereby syntax functions but its variations: violations, deviations, exceptions—everything that makes the work unique. From the very beginning, Tamayo's painting differed from all others in the preeminence of certain elements and in the unique form in which they were combined. I shall try to describe them, if only in a very general way; immediately thereafter, I shall do my best to show how the combination of those elements is the equivalent of the transformation of an impersonal and historical syntax into an inimitable language.

Tamayo is rigorous, and he has imposed on himself a strict limitation: painting is, first and foremost, a visual phenomenon. The subject is a pretext; the painter's real objective is to allow

[1] *Sino*, meaning in Spanish *destiny*, *fortune*, *lot*, *fate*, and the like, is still a recognizable cognate of *signo*, sign. Cf., even in modern English, the belief that one's astrological sign determines both one's ultimate fate and its daily manifestations —TRANS.

painting its freedom: it is forms that speak, not the intentions or the ideas of the artist. It is form that is the source of meanings. Within this aesthetic, which is that of our time, Tamayo's attitude is distinguished by his intransigence toward the ease with which literary fantasy is brought into play in painting. Not because painting is antiliterary—it never has been and never can be—but because he maintains that the language of painting—its writing and its literature—is not verbal but plastic. The ideas and the myths, the passions and the imaginary figures, the forms that we see and those we dream are realities that the painter must find *within* the painting, something that must spring forth from the painting and not something that the artist introduces into the painting. Hence his zealousness as regards pictorial purity: the canvas or the wall is a two-dimensional surface, closed to the verbal world and open to its own reality. Painting is an original language, as rich in resources as that of music or literature. Everything can be said and done in painting—within the painting. Tamayo, of course, would not frame his intentions in that way. By stating them in a concise verbal form, I fear that I am betraying him: his is not an orthodoxy but an orthopraxy.

These concerns have led him to carry on slow, continual, and stubbornly persistent pictorial experimentation. Investigation of the secret of textures, colors and their vibrations, the weight and density of materials and paint mixtures, the laws and the exceptions that rule the relationships between light and shade, touch and sight, lines and their structures. A passion for materials, a materialist painting in the proper sense of the word. Imperceptibly, guided by the logic of his investigation, Tamayo proceeds from the critique of the object to the critique of painting itself. Exploration of color: "as we use a smaller number of colors," he once said to Paul Westheim, "the abundance of possibilities increases. It is more valuable, pictorially speaking, to exhaust the possibilities of a single

color than to use an unlimited variety of pigments." It is said repeatedly that Tamayo is a great colorist; it should be added that the richness is the fruit of sobriety. For Baudelaire, color was harmony: an antagonistic and complementary relationship between a hot color and a cold one. Tamayo carries the search to its ultimate extreme: he creates this harmony within a single color. He thereby obtains a luminous vibration of resonances with less amplitude but more intensity: the extreme point of a note or tone of color, very nearly immobile by dint of its tension. Limitation becomes abundance: blue and green universes in a handful of pollen, suns and earths in a yellow atom, dispersions and conjunctions of hot and cold in a patch of ocher, sharp-pointed castle spires of gray, precipices of whites, gulfs of violet. This abundance is not a collection of clashing colors: Tamayo's palette is pure, he is fond of straightforward colors, and he refuses, with a sort of instinctive wholesomeness, any and every dubious refinement. Delicacy and vitality, sensuality and energy. If color is music, certain passages of Tamayo's make me think of Bartók, the way Anton Webern's music makes me think of Kandinsky.

The same severity toward lines and volumes. Tamayo's line is that of a sculptor, and it is regrettable that he has given us only a very few sculptures. A sculptor's line because of the vigor and the economy of the draftsmanship but, above all, because of its essentiality: he designates the points of convergence, the lines of force that govern an anatomy or a form. A synthetic line, not at all calligraphic: the real skeleton of the painting. Full, compact volumes: living monuments. The monumental nature of a work has nothing to do with the work's size: it is the product of a relationship between space and the figures that inhabit it. Tamayo's murals are the least successful part of his work. But it is not the dimensions but the attitude toward space—be it great or small—that counts. What distinguishes an illustrator from a painter is space: for the

former, it is a frame, an abstract limit; for the latter, a series of internal relationships, a territory governed by its own laws. In Tamayo's painting, the forms and figures are not in space: they are space. They form it and shape it, just as rocks, hills, the riverbed, and the grove of trees are not in the landscape: they construct, or to put it more exactly, they *constitute* the landscape. Tamayo's space is an animated extension: weight and movement, forms on the earth, universal obedience to the laws of gravitation or to the other, more subtle ones, of magnetism. Space is a field of attraction and repulsion, a theater in which the same forces that move nature twine and untwine, oppose and embrace each other. Painting as a double of the universe: not its symbol but its projection on the canvas. To repeat: the painting is not a representation or a set of signs: it is a constellation of forces.

The reflective element is half of Tamayo: the other half is passion. A contained passion, absorbed in thought, that never is rent apart and never degenerates into mere rhetoric. This violence kept on a tight leash, or rather, unleashed on itself, both takes him farther away from and brings him closer to the two aspects of Expressionism: the German one of the first quarter of this century and the one that later was called Abstract Expressionism, something of an abuse of the terms. Tamayo: the passion that distends forms; the violence of the contrasts; the petrified energy that animates certain figures, a dynamism that turns into a threatening immobility; the crude glorification of color, the rage of certain brush strokes and the bloody eroticism of others; the categorical oppositions and the strange alliances. . . . All this brings to mind the verse of our Baroque poet "the beautifully ugly face." This phrase is a definition of Expressionism: beauty is not an ideal proportion or symmetry but character, energy, rupture: expression. The union of Baroque style and Expressionism is more natural than it is ordinarily thought to be: both are exaggerations of form; both are styles that underline

with red ink. In Tamayo's painting, Baroque style and Expressionism have been taken as a proof of plastic asceticism: the former has lost its curves and its ornaments, the latter its vulgarity and its exaggeration. In Tamayo there is no passionate outcry: there is an almost mineral silence.

I am not proposing definitions: I am risking approximations. Expressionism, pictorial purity, criticism of the object, passion for materials, sovereignty of color: names, arrows pointing the way. The reality is something different: Tamayo's paintings. Criticism is not even a translation despite the fact that this is its ideal: it is a guide. And the best criticism is something less: an invitation to carry out the one act that truly counts, seeing.

4

Tamayo's great creative period, his maturity as a painter, begins around 1940, in New York. He lived there for about twenty hard and fruitful years. In 1949 he travels to Europe for the first time and has shows in Paris, London, Rome, and other cities of that continent. He lives in Paris for a time and in 1960 returns to Mexico, where he settles permanently. The last years in New York and the first in Paris coincide with the appearance and the apogee, in the United States, of Abstract Expressionism, a movement that has produced three or four great painters. At almost the same time, powerful isolated figures such as Fautrier and Dubuffet, not to mention other, younger ones such as Nicolas de Stael, Bacon, and that loner among loners named Balthus, burst upon the scene in Europe. In short, in the forties a new group of painters comes to the fore, real contemporaries of Tamayo and some of them his equals. It is a generation that has never ceased to surprise us in these last twenty-five years and one whose work has not yet come

to an end, even though other groups and other tendencies have, of course, made their appearances by now. A cosmopolitan art— as all modern art has been since its birth, as Baudelaire was the very first to note. This cosmopolitanism has become accentuated since World War II, and not only because of the international nature of the styles but also because its protagonists belong to every nation and culture, including those of the Far East, from the Chinese Zao Wu-ki to the Japanese Sugai. It is tempting to situate Tamayo within this context as I earlier did his predecessors.

If we think of the two Latin American contemporaries of Tamayo, the Cuban Wifredo Lam and the Chilean Roberto Matta, we soon discover that there are very few points of contact between them. The same thing does not occur if we look toward the United States and Europe. What I have called, with many reservations, Tamayo's Expressionism shows definite affinities with that of Willem de Kooning and, from another angle, with the painting of Jean Dubuffet. He shares with the former, moreover, both de Kooning's obsession with the female body in its mythical dimension and as a great mother goddess as well as the generous violence of his color. The affinity with Dubuffet is also twofold: the fierceness of his outlining, the glutting of his fury on and against the human figure no less than the predilection and concern for textures and their physical properties, whether tactile or visual. All three are terrestrial, material painters. The three of them have painted some of the masterworks of what might be called contemporary pictorial savagery. The three have humiliated and glorified the human figure. The three have created a work apart that is unmistakable.

The similarities between Tamayo and Dubuffet are as revealing as the differences. I have mentioned their common love for textures and materials. Dubuffet's investigation is methodical and delirious. The implacable rigor of reason applied to objects and realities that traditionally escape quantitative measurement: the overall topog-

raphy of a millimeter of soil, the orographic map of a female belly, the morphology of beards. Tamayo's approach is more empirical and instinctive. A show by Dubuffet is a demonstration that is simultaneously convincing and overwhelming: he hangs on the walls every possible variation on a plastic invention. Tamayo seeks out unique specimens. The Ariadne's thread of his explorations is not analysis but the logic of correspondences: he lays a bridge between his eyes, his hand, and the spirals of crystal, wood, skin, and the galaxy. One of them uses the razor of the syllogism, the other the bow of analogy.

In Dubuffet there is a rational radicalism, even (or to put it more precisely, especially) when he presents his apologia for irrationalism and *art brut*. He is so intelligent that he paints with the totalitarian logic of madmen, but clearsightedness, which is both his gift and his punishment, never abandons him; madmen sometimes know that they are mad and also know that they are unable to stop being so; Dubuffet knows that he is not mad and never will be. His childish paintings are the impressive work of a child who is a thousand years old, a visionary and demoniacal one, who knows and has not forgotten the syntax of all styles. Dubuffet's creation is critical and his ferocity is mental. His work is not a celebration of reality but a confronting of it, an act of vengeance rather than of love. His cannibalism is authentic and socially and morally justified. Nonetheless, he would horrify real cannibals: it is not a ritual but the macabre play of irony and desperation. Not a communion: a gluttonous feast on an operating table. Deliriums of reason. A world that calls to mind, not only because of its violence but because of its systematic nature, the name of Sade rather than that of Goya.

Dubuffet's genius is encyclopedic; Tamayo's is less extensive but no less rich. Tamayo's paintings too are peopled with monsters, and his brush too skins human beings alive. This artist, at times

so joyous and tender, knows how to be cruel: humor occupies a
central place in his work. But the roots of his cruelty are neither
irony nor system but satire and the sense of the grotesque. The
love of monsters, freaks of nature, and ogres: an Indian and Spanish
heritage. Pre-Columbian art abounds in deformed beings, and the
same phenomenon occurs in great Spanish painting. Moctezuma
and his hunchbacks, Philip IV and his simpletons. Tamayo's paint-
ing is rich in people who are out of the ordinary, the dregs of
society, or buffoons: the glutton, the man-who-laughs, the society
matron, the maniac, the idiot, and other targets of derision. Among
his terrifying images is one that has the value of being an emblem
without forfeiting the other, more immediate value of being a daily
reality: the bone, the pile of bones that we are. Dog bones, a bone
moon, bone bread, human bones, landscapes of bones: an ossuary
planet. The obsession with bone, a satirical one in the beginning,
is transformed into a cosmic image. Tamayo's ferocity is not in-
tellectual; it is satire and rite, popular mockery and magic cere-
mony. His madmen are pathetic and grotesque, not contemptible;
his monsters are vital, the miscarriages and abortions of nature, not
metaphysical caricatures. His deformations of the human figure are
the recording of the devastation and the victories of passion, time
and the inhuman forces of money and machines. The physical world
is his world. Rain, blood, muscles, semen, sun, drought, stone,
bread, vagina, laughter, hunger: words that for Tamayo have not
only a meaning but also a flavor, an odor, taste, weight, color.

The contrasts and similarities with de Kooning are of another
order. With Dubuffet, the danger is system; with Tamayo, im-
mobility; with de Kooning, the empty gesture. At the same time,
in de Kooning there is a vital and not at all systematic abundance,
which moves us and wins us over. A cordiality, in the best sense
of the word: courage in the face of life and harmony with the forces
that inhabit us. The other side of concord is discord: two words

that form the axis of his work. All this brings him close to Tamayo, a painter who also obeys his heart and his impulses. Dore Ashton discovers two elements in de Kooning's painting: a passionate drive, alternately demoniacal and orgiastic, and a tendency toward Baroque style.[2] The female body, the center of his art even in his nonfigurative compositions, embodies the duality of these elements and their final conjunction: it is the sphere that encompasses all forms and the eroticism that tears them to pieces. The paradox of eroticism: in the act of love we possess the woman's body as a totality that becomes fragmented: simultaneously, each fragment —an eye, a patch of cheek, an earlobe, the splendor of a thigh, the shadow of her hair falling across a shoulder, her lips—alludes to the others and in a certain way, contains the totality. Bodies are the theater where the play of universal correspondence is, in fact, represented, the endlessly destroyed and reborn relationship between unity and plurality. If eroticism unites these two painters, Baroque style separates them. I have already pointed out wherein Tamayo's Baroque aspect lies and the severe limits he places on it. A severity missing in de Kooning. In the American, there is a lack of restraint; in the Mexican, concentration. Different versions of the orgiastic: the Flemish kermis and the Mexican fiesta.

The passionate and demoniacal element corresponds in Tamayo to what I have called *transfiguration*, analogical imagination. For Tamayo the world is still a system of summonses and answers, and humans are still part of the earth; they are the earth. Tamayo's attitude is more *ancient*: it is closer to the origins. It is one of the privileges, amid so many disadvantages, of having been born in an underdeveloped country. In de Kooning, Romantic vitalism: humankind is alone in the world; in Tamayo, naturalism: a vision of the unity between the world and humankind. De Kooning has said,

[2] *The Unknown Shore*, 1962.

"When I think of painting today, I find myself always thinking of that part which is connected with the Renaissance. It is the vulgarity and fleshy part of it which seems to make it particularly Western." There is nothing less *fleshy* than Tamayo's painting: on the one hand, his figures and even his landscapes and abstract compositions are bony; on the other, the same asceticism that keeps him from falling into the Baroque temptation of the curve prevents him from flinging himself into carnal flabbiness. Death is a constant presence in Tamayo's painting, as it is in the work of all great artists, including de Kooning. That presence is severe and absorbed in thought: it is not the vertigo of the fall or the pomp and the splendors of putrefaction but, as I have already said, the geometry of bones, their whiteness, their hardness, and the extremely fine dust particles that they become.

5

In the previous notes my aim was to describe Tamayo's attitude toward painting and the place of his own work in contemporary painting: the relationship between the painter and his work and the relationship of his work with that of other painters. There is another relationship that is no less decisive: Tamayo and Mexico.

The critics have pointed out the importance of popular art in his creative endeavors. The influence is undeniable, but it is worth the trouble to investigate what it consists of. First of all, what is meant by popular art? Traditional art or the art of the people? Pop Art, for instance, is popular but it is not traditional. It does not continue a tradition but instead, with popular elements, tries and occasionally manages to create works that are new and explosive: the opposite of a tradition. On the other hand, popular art is always traditional: it is a manner, a style that is perpetuated through

repetition and that permits only slight variations. There are no aesthetic revolutions in the sphere of popular art. Furthermore, both repetition and variation are anonymous, or to put it more appropriately, impersonal and collective. So then, if it is true that the notions of art and style are inseparable, it is also true that works of art are the violations, the exceptions to or the exaggerations of, artistic styles. Baroque or Impressionist style constitutes a repertory of plastic terms, a syntax that becomes meaningful only when a unique work violates that style. What Impressionism really represents is not a style but the violations of that style: a series of unique and unrepeatable works. Because it constitutes a traditional style with no creative interruptions or changes, popular art is not art, if this word is used in the strict sense. Moreover, it does not seek to be art: it is an extension of the utensils and ornaments of everyday life and aspires only to blend in with our day-to-day existence. It lives in the realm of fiesta, ceremony, and work: it is social life crystallized into a magic object. I say *magic* because it is quite likely that the origin of popular art is the magic that accompanies all religions and beliefs: offering, talisman, reliquary, fertility rattle, little clay figure, family fetish. The relationship between Tamayo and popular art must therefore be sought on the deepest level: not only in the forms but in the subterranean beliefs that breathe life into them.

I do not deny that Tamayo has been sensitive to the spell cast by popular plastic inventions: my point is that they do not appear in his painting because they are beautiful, even though they are. Nor because of a wildly excessive nationalist or populist zeal. Their significance lies elsewhere: they are transmission channels, establishing communication between Tamayo and the world of his childhood. Their value is affective and existential: the artist is the person who has not entirely buried his or her childhood. Apart from this psychic function and in an even deeper stratum, these popular

forms are something like underground irrigation conduits: ancestral sap, original beliefs, the unconscious though not incoherent thought that animates the world of magic rise through them. Magic, Cassirer says, affirms the fraternity of all living beings because it is founded on the belief in a universal fluid or energy. Two consequences of magical thought: metamorphosis and analogy. Metamorphosis: forms and their changes are mere transmutations of the original fluid; analogy: everything corresponds to everything else if a single principle governs the transformations of beings and things. Irrigation, circulation of the primordial breath: a single energy runs through everything, from the insect to the human being, from the human being to the ghost, from the ghost to the plant, from the plant to the star. If magic is universal animation, popular art is the survivor of it: in its captivating and fragile forms is engraved the secret of metamorphosis. Tamayo has drunk from this spring and knows the secret. Not with his head, which is the only way in which we moderns can know it, but with his eyes and his hands, with his body and the unconscious logic of what, inaccurately, we call instinct.

Tamayo's relationships with pre-Columbian art do not manifest themselves in the unconscious area of beliefs but on the conscious level of aesthetics. Before I touch on this subject it is absolutely necessary to lay certain errors to rest. I am referring to those frequent confusions between the nationality of the artist and that of art. It is not hard to note, at first glance, the "Mexicanism" of Tamayo's painting; nor is it difficult, if one reflects a bit, to discover that this is a trait that defines his art only in a very superficial way. No work, moreover, is defined by its nationality, and it is even less by that of its author: to say that Cervantes is Spanish and that Racine is French is to say little or nothing about Cervantes and Racine. Let us forget Tamayo's nationality, then, and consider the circumstances that determined his encounter with the ancient art

of Mexico. The first thing that should be emphasized is the distance that separates us from the Mesoamerican world. The Spanish Conquest was something more than a conquest: the destruction through violence of the civilization (or civilizations) of Mesoamerica and the beginning of a different society. Between the pre-Hispanic past and ourselves there is not the continuity that exists between the China of the Han and that of Mao, between the Japan of Heian-Kio and the contemporary one. Hence it is necessary to outline, even in a very general way, our peculiar position with regard to the Mesoamerican past.

The reconquest of pre-Hispanic art is an undertaking that would have been impossible had it not been for the intervention of two critical factors: the Mexican Revolution and the cosmopolitan aesthetic of the West. A great deal has been written about the former, so that I shall touch only on what appears to me to be essential. Thanks to the revolutionary movement, our country has felt itself and seen itself as what it is: a mestizo country, racially closer to being Indian than to being European, although the same is not true of its culture and its political institutions. The discovery of ourselves led us to look with passionate interest on the remains of the civilization of antiquity as well as on survivals of it in popular beliefs and customs. Thus modern Mexico has tried to reconquer that grandiose past. The essence of Mexico is Indian, and the social, cultural, and psychic vestiges of pre-Hispanic societies are numerous. Even the word *vestiges* is inaccurate, and it would be better to say mental and social structures. These half-buried structures give shape and form to our myths, our aesthetics, our ethics, and our politics. But as a *civilization* the indigenous world has died. More precisely: it was dealt a death blow. We venerate and collect in museums the remains of Mesoamerica but we have not tried, nor would we be able, to bring the murder victim to life again. Here the other factor, the European vision of civilizations and traditions, different from the Greco-Roman, intervenes.

The discovery of the "other," in the domain of societies and cultures, is recent. Its beginning goes back to almost the same time as the imperialist expansion of Europe, and its first testimonials are the accounts, chronicles, and descriptions of the Portuguese and Spanish navigators and conquistadors. It is the other side of the coin of discovery and conquest: an affective and intellectual *conversion*, which, on revealing the humanity and the wisdom of non-European societies, simultaneously revealed the remorse and the horror felt by a few consciences in the face of the destruction of peoples and civilizations. The eighteenth century, with its curiosity about and respect for Chinese civilization and its glorification of the innocent savage, went a step further and opened people's minds to a less ethnocentric conception of the human species. And so, little by little, like a critical counterpoint to the atrocities committed in Asia, Africa, and the American continent, the European vision of other peoples changed. The final disaster: at the very moment that anthropology comes into being, the inexorable end of the last primitive societies begins. Today, at its moment of victory, when all other civilizations have been destroyed or petrified, the West discovers itself in its racial persecutions, imperialism, war, and totalitarianism. The civilization of historical awareness, the great European invention, is arriving in our day at another awareness, that of the self-destructive forces that inhabit it. The twentieth century teaches us that our place in history is not far from that of the Assyrians of Sargon II, the Mongols of Genghis Khan, and the Aztecs of Itzcóatl.

The change in the European aesthetic vision was even slower. Although Dürer did not conceal his admiration for the work of the Mixtec goldsmiths, we had to wait until the twentieth century for this isolated judgment to be transformed into an aesthetic doctrine. The German Romantics discovered Sanskrit literature and Gothic art; their successors all over Europe became interested in the Islamic world and the civilizations of the Far East; finally, at the

beginning of this century, the arts of Africa, Latin America, and Oceania appeared on the aesthetic horizon. Without the modern artists of the West, who made this immense entirety of styles and visions of reality their own and transformed it into living, contemporary works, we would not have been able to understand and love pre-Columbian art. Mexican artistic nationalism is a consequence both of the change in social consciousness that the Mexican Revolution represented and of the change in the artistic awareness that European aesthetic cosmopolitanism represented.

After this digression it can be seen more clearly where the error lies when nationalism and pre-Columbian civilization are confused. In the first place, it cannot be said that pre-Columbian civilization is, strictly speaking, Mexican: Mexico did not exist when it was created, nor did its creators have any awareness of that modern political concept which we call a nation. In the second place, and in an even stricter sense, it is debatable whether arts have a nationality. What they have is a *style*: what is the nationality of Gothic art? But even if it had a nationality, what meaning would that have? There are no national property rights in art. The great contemporary critic of French medieval art is named Panofsky, and Bernard Berenson is the great authority on Italian Renaissance painting. The best studies on Lope de Vega are probably Vossler's. It was not the mediocre Spanish painters of the nineteenth century who carried on the Spanish pictorial tradition but Manet. Why go on? No, the understanding of pre-Columbian art is not an innate privilege of Mexicans. It is the fruit of an act of love and reflection, as in the case of the German critic Paul Westheim. Or of an act of creation, as proved by the example of the English sculptor Henry Moore. In art there are no legacies: there are discoveries, conquests, affinities, appropriations: re-creations that are really creations. Tamayo is not an exception. Modern aesthetics opened his eyes and made him see the modernity of pre-Hispanic sculpture. Later, with

the violence and the simplicity of every creator, he appropriated those forms and transformed them. Using them as a basis, he painted new and original forms. Popular art, to be sure, had already fertilized his imagination and prepared it to accept and assimilate that of ancient Mexico. Nonetheless, without modern aesthetics that initial impulse would have dissipated or would have degenerated into mere folklore and decoration.

If we think of the two poles that define Tamayo's painting— his plastic rigor and the imagination that transfigures the object— we note immediately that his encounter with pre-Columbian art was a true union. I will begin with the first of the two poles: the purely plastic relationship. The most immediate and surprising qualities of pre-Columbian sculpture are the rigorous geometry of the conception, the solidity of the volumes, and the admirable fidelity to the material. These were the qualities that from the beginning impressed modern artists and European critics. Tamayo's attitude faithfully follows the same line of reasoning: Mesoamerican sculpture, like modern painting, is above all a logic of forms, lines, and volumes. This plastic logic, unlike that in the Greco-Roman and Renaissance tradition, is based not on the imitation of the proportions of the human body but on a radically different conception of space. A conception that, for the Mesoamericans, was religious; for us, intellectual. In either case, it is a question of a *non*human vision of space and the world. Modern thought maintains that man is no longer the center of the universe or the measure of all things. This idea is not very far removed from the vision that the ancients had of man and the cosmos. Artistic correspondences of these diametrically opposed conceptions: in the Renaissance tradition, the human figure is so central that there is an attempt to subject landscape to its rule (for instance, the humanization of landscape in the poetry of the sixteenth and seventeenth century or the subjectivism of the Romantics); in

pre-Columbian and modern art, by contrast, the human figure is subjected to the geometry of a nonhuman space. In the first case, the cosmos is a reflection of man; in the second, man is simply a sign among other signs of the cosmos. On the one hand, humanism and realistic illusionism; on the other, abstraction and a symbolic vision of reality. The symbolism of ancient art is transformed into *transfiguration* in Tamayo's painting. The Mesoamerican tradition revealed to him something more than a logic and a grammar of forms: it showed him, with a vivacity that surpasses even Klee and the Surrealists, that the plastic object is a high-frequency transmitter that beams forth plural meanings and images. The dual lesson of pre-Hispanic art: first of all, fidelity to the material and the form—for the Aztec, stone sculpture is sculptured stone; and then after that, that sculptured stone is a metaphor. Geometry and transfiguration.

I wonder: didn't Tamayo already know all this? Like Henri Michaux's experience with mescaline, Tamayo's encounter with pre-Columbian art was not so much a discovery as a confirmation. Perhaps the real name of creation is *recognition.*

6

In the course of these reflections I have repeated two words, tradition and criticism. I have pointed out several times, and I am not the only one, that criticism is the substance, the lifeblood, of modern tradition. Criticism conceived of as an instrument of creation and not only as judgment or analysis. Hence each new work assumes a polemical stance toward the ones that precede it. Our tradition is perpetuated as the result of the successive negations and breaks that it gives rise to. The only dead art is that which does not merit the supreme homage of creative negation.

The difference from the past is significant. The artists of old imitated the masterworks of their predecessors; modern ones reject them or at least endeavor to create others that bear no resemblance to them. Within this tradition in constant crisis (and perhaps coming to an end), it is still possible to make another distinction: there are artists who make of criticism an absolute and who, in a certain way, make of negation a creation—a Mallarmé, a Duchamp; there are others who use criticism as a trampoline to make the leap into other territories, other affirmations—a Yeats, a Matisse. The former bring on a state of crisis in language, be it that of poetry, music, or painting; that is to say, they subject language to criticism without an appeal to silence. The latter make that same silence into a resource of language. This is what I have called, within the modern tradition of breaking with the past, the family of the No and that of the Yes. Tamayo belongs to the second of these.

A painter of painting, not of its metaphysics or of its criticism. At precisely the opposite pole from a Mondrian or, to speak of his contemporaries, a Barnett Newman. On the side of a Braque or a Bonnard. For Tamayo, reality is corporeal, visual. Yes, the world exists: red and royal purple, the iridescence of gray, the black stain of charcoal say it; the smooth surface of this stone, the knots of wood, the coldness of the water snake say it; the triangle and the octagon, the dog and the coleopteran say it. Sensations say it. The relationships between sensations and the forms that create as they intertwine and separate go by the name of painting. Painting is the translation of the world into the language of the senses. To translate the world in painting is to perpetuate it, to prolong it. Such is the origin of Tamayo's rigor toward painting. His attitude is not so much an aesthetic as it is a profession of faith: painting is not a self-sufficient reality, it is a way of touching reality. He gives us the sensation of reality; he brings us face to face with the reality of sensations. The most immediate and direct ones: colors, forms,

touch. A material world that, without losing its materiality, is also mental; those colors are painted colors. Tamayo's entire critical inquiry tends to be the salvation of painting, the preservation of its purity and the perpetuation of its mission as translator of the world. Against literature no less than against abstraction, against the geometry that makes a skeleton of it, and against the realism that debases it into an illusion that is a swindle and a delusion.

The translation of the world into the language of the senses is a transmutation. In Tamayo's case the transmutation is never abstract: his world is everyday life, as André Breton pointed out. This observation would be of little interest had Breton himself not immediately added that Tamayo's art lay in placing everyday life within the realm of poetry and ritual. In other words, transfiguration.

The fabric of pictorial sensations that a painting of Tamayo's represents is also a metaphor. What does that metaphor say? The world exists, life is life, death is death: *everything is*. This affirmation, from which neither misfortune nor chance are excluded, is an act of the imagination rather than of the will or of the understanding. The world exists through the work of the imagination, which, on transfiguring it, reveals it to us.

7

If it were possible to say in just one word what it is that distinguishes Tamayo from the other painters of our time, I would say without hesitating: *sun*. It is in all his paintings, be it visible or invisible; night itself for Tamayo is nothing save charred sun.

DELHI, *April 11, 1968*

El signo y el garabato

Loners and
Independents

Between 1930 and 1940, as I have pointed out several times, a reaction toward Muralism takes place. The name of Tamayo is a focal point, but it is not the only one. A group of painters, each on his own account and without the least intention of constituting a school, explore other paths: Carlos Mérida, Julio Castellanos, Jesús Reyes Ferreira, Agustín Lazo, Alfonso Michel, and others as

In "Repaso en forma de preámbulo" ("Review in the Form of a Preamble," in this volume), which opens the series entitled *Los privilegios de la vista* (*The Privileges of Sight*), I regretted certain omissions and lacunae. I have tried my best to remedy these gaps, if only partially, with this brief account and an essay in the form of a dialogue on María Izquierdo. I realize the inadequacies of this text, but recently I have had neither the occasion nor the time to write anything else of the length that certain of these artists deserve. I am thinking of Frida Kahlo in particular.

well, among whom we find two remarkable women, Frida Kahlo and María Izquierdo. Mexican painting is alive thanks to those heterodox artists. Another tradition begins with them. It could not be otherwise: art is adventure, exploration, and sometimes discovery. The only artistic heritage that I can conceive of is the one that is a point of departure, not a rest home for the worn out. Didn't the Muralists have disciples? They had something better: objectors.

From the beginning, Carlos Mérida proved to have an attitude of intelligent artistic independence toward the ideological art of Rivera and Siqueiros, as well as toward Orozco's Expressionism. Mérida had a very different conception of mural painting, as was evident from the walls of the Benito Juárez Public Housing Development, destroyed in the 1985 earthquake, but also in the Municipal Palace of Guatemala and the San Antonio Civic Center in Texas. In these works he tried, successfully, to fuse mural painting with abstract and geometric painting. The result was convincing although now and again, to my taste, it bordered on the decorative. One of the risks of geometrical painting. He was a great connoisseur of the avant-garde movements in Europe as well as of pre-Columbian art—that of the Mayas in particular (Mérida was of Guatemalan origin)—and we witness in his work the union, almost always a felicitous one, of these two traditions, that of the universal art of the twentieth century and the pre-Hispanic. His sense of plastic order was conjoined with his profound and genuine affinity with pre-Columbian and popular forms. He did not fall into either nationalism or archaism, as did Diego Rivera, but instead found in Mesoamerican art a source of unusual modernity. Two words define this excellent painter: intelligence and sensitivity, expressed through precise draftsmanship and clear, sharp colors. The combination of these two gifts gave Mérida's painting a limpid solidity that is often admirable.

At the opposite pole from Mérida, a resolutely avant-garde artist, we find the classical temperament of Julio Castellanos. In a

short essay devoted to him, Villaurrutia hit the mark precisely in pointing out the traces of two great European painters in Castellanos's work, Picasso and Ingres. I must add that the Picasso that interested Castellanos was the painter of the so-called neoclassical period, that is to say, the Picasso influenced directly by Ingres. "Every artist," Gide said, "has the influences that he deserves." Castellanos fully deserved the ones he had. Apart from being an excellent draftsman, like Ingres and Picasso, he also painted murals and, above all, a number of oils whose composition is refined and complex, possessing a balance that it is not an exaggeration to call classical. Among these paintings is a little masterpiece, *St. John's Day*. Julio Castellanos was a limited painter whose work, through its very limitation and in comparison to the hyperactive and muddled panorama of Mexican painting, gives us a lesson in perfection and sobriety. One of our best painters.

The poets of *Contemporáneos* defined themselves as a "group without a group," that is, as a group of loners. The same can be said of the painters of this period, and Agustín Lazo in particular. A painter, an engraver, and a stage designer, Lazo represents the most European tendency of painting in this period. His collages call Max Ernst to mind, and his oils Chirico. In a recent study of Lazo, Miguel Cervantes points out that Chirico's influence has been exaggerated. He may well be right; however, quite apart from the horses, the arcades, and the public squares, motifs characteristic of Chirico, almost all the paintings and engravings of Lazo are suffused with an indefinable oneiric atmosphere—or, more precisely, a somnabulistic one—that inevitably brings the Italian painter to mind. Lazo's work is scant, but it does not lack character and a certain lyricism. His friend Villaurrutia defined him in three lines: "Lazo paints without a model even though he has one right in front of him. He paints from memory, with the closed and open eyes that we use when we're asleep and dreaming."

Manuel Rodríguez Lozano was the possessor of a powerful

temperament and a clear mind. He was not a loner who found himself out of the mainstream but a person who deliberately chose to isolate himself. Yet he had followers, some of whom were remarkable, Abraham Ángel for instance, who died at a very early age. Rodríguez Lozano was, first and foremost, an excellent draftsman, both in his drawings and in his oils. As is true of certain painters of those years—María Izquierdo, Lazo, and at times even Tamayo— there are traces of the horses and the architectural structures of Chirico and of the fantastic zoology of Chagall; in others, such as Rodríguez Lozano, the monumental Picasso of the neoclassical period is noticeably present. Alongside Picasso are other, more tenuous, reminiscences of Renaissance painters, of Mantegna in particular. The pure colors—blues, greens, crimsons—call to mind certain Florentines of the early Renaissance, especially Filippo Lippi. But what is best about these oils is the draftsmanship. Some of them, the ones that I prefer, appear to be studies of sculptures.

A real loner: Alfonso Michel. He is yet to be recognized. He left us a number of still lifes that rival Tamayo's. Although we find in them traces of Cézanne and Derain, we realize that they could have been painted only by him. They are a modern and very personal continuation of the venerable tradition of Mexican still lifes. Carlos Orozco Romero was another loner. In his best painting, melancholy and brilliant color are conjoined. An alliance that is not unusual: it is the feeling of loss and of elation aroused by a puppet dressed in gaudy colors, abandoned in a corner of memory.

Jesús Reyes Ferreira, Chucho Reyes, was an artist from the state of Jalisco who had a great influence on two remarkable talents, the architect Luis Barragán and the painter Juan Soriano. In 1946, the writer Rodolfo Usigli and I visited Picasso in his studio on the Quai des Grands-Augustins. Chucho Reyes had asked Usigli to give Picasso, as the least of homages, a gouache he had painted. If memory serves me, it was one of his fantastic "little horses."

Picasso was pleased with the gouache and said to us, "This young man has talent." Whereupon I explained to him, "He's not young; he's your age." Quick as a flash, Picasso replied, "Well then, he's a very young old man." Lofty praise.

This period is memorable because of the appearance of two women who were great artists: Frida Kahlo and María Izquierdo. We are dealing here with a phenomenon unique in the history of Mexican painting. Although they were contemporaries, their personalities were very different and their works develop in opposite directions. Both of them are indebted to Surrealism; at the same time, the two of them demonstrate a marked preference for Mexican subjects. Elsewhere in this book I deal with María. As for Frida, she was an artist at once limited and intense; almost always, her form was perfect, and that perfection made the inflammable materials that it encompassed—dreams, sex, death—burn with a sort of sumptuous violence. In her training as an artist, the academic tradition was decisive. Her draftsmanship, her composition, and the mastery with which she painted in oils reveal the educated artist who has gone through the Academy. Frida Kahlo, to be sure, was something more than a strict academic painter: she was an intense visual poet, and her visions were often *incorrect*, as are almost all the revelations that well up from our inner abysses.

In Frida's paintings, a verbal element appears more or less regularly, usually a popular expression or a cliché, which she turns into a poetic image that, in turn, she transforms into a visual image. One example among many: *"The Apple of My Eye."*[1] The poetic spark kindles the colloquial phrase, and, in a second step, the artist turns the verbal metaphor into a visual representation. Three levels: the popular, the poetic, and the pictorial. Certain critics have seen

[1] The Spanish title is *La niña de mis ojos*, literally, "The Little Girl in My Eyes."—TRANS.

in these games above all, or exclusively, the intelligent and inventive familiarity with which Frida handled popular forms and traditions; in other words, they emphasize the popularism and the nationalism of the painter. But there is something more and something more decisive: the procedure that turns these verbal elements into poetic fuel is characteristic of Surrealist painting. With tremendous originality and mastery, Frida assimilated this lesson of Surrealist art.

Her visual images were almost always real explosions of the psychic subsoil, that is, they were simultaneously *paintings* and *revelations*. This can be said of very few artists. In Frida's visual metaphors there is an impressive authenticity; standing before her paintings we can almost always say: *this is true, this has been lived, suffered, and re-created.* Frida endured a great deal of pain. She was brave and she was narcissistic. And so she did not scruple to show in her paintings the wounds and ravages of her body, martyrized by disease and surgeons. At times, I must confess, this pathos wearies me: it moves me but it does not attract me. I feel that I am before a complaint, not before a work of art. This self-gratification in bathos sometimes impairs certain of Frida Kahlo's paintings. (I have a similar response to a fair amount of the "confessional poetry" that has been the rage for more than twenty years in the United States and in England.) Our painter is almost always saved, thanks to the intervention of her two great gifts as a visual poet, humor and imagination. Two faculties that, in the service of the lesser great artist that Frida was, are able to convert everyday reality into a lightning image in which the two poles of existence fuse.

One can understand the fascination that André Breton felt when, in 1938, he saw one of her paintings, *What Water Has Given Me,* for the first time. A blood-drenched realism but a realism with wings and flames. A transfigured realism: Surrealism. The best and

most succinct definition of Frida Kahlo's art also comes from André Breton: "her painting is a bomb with a silk ribbon around it." I shall add: yes, an embroidered ribbon, a pink or blue one, on which a perverse little girl has written, with a bird's calligraphy, a message of winged and piercing words.

1988

María Izquierdo,

Seen in Her

Surroundings and Set

in Her Proper Place

MIGUEL CERVANTES: When did you meet María Izquierdo?

OCTAVIO PAZ: On my return from Spain, around 1938, in the Café París. For more than fifteen years, from 1930 to 1945, it was one of the centers of literary and artistic life in Mexico City. It was

In the exhibition halls of the Center for Contemporary Art in Mexico City, a major retrospective of the works of María Izquierdo (1902–1955) was held in the autumn of 1988. The organizers asked me to write the preface to the catalogue. I told them that, despite my admiration for María Izquierdo's painting, it would not be possible for me to write anything in time for the exhibit. They then proposed that I take part in a colloquium. I agreed, and the conversation took place early in August, at my home. Those who participated in the talk were Robert Littman the director of the center, Miguel Cervantes the curator of the exhibit, Marie José Paz, and I. The published text is a revised version of what we said.

crowded with writers, painters, musicians, actors and actresses, journalists, and with a floating world of curiosity seekers, loafers, and layabouts. The main room was spacious, with lots of light, the walls were painted a pale green, the little tables and wicker chairs were also green, the waitresses were breezy and dealt with their customers on familiar terms, and at the bar, between two huge gleaming metal coffeemakers that made a deafening racket as they gave off clouds of steam, the blonde and *plantureuse* proprietress, Madame Hélène, ruled—a famous matron, the haven of novice bullfighters without contracts and the safe harbor of lads gone astray. She smelled of coffee and tobacco. Malicious gossips spoke of traffic in drugs. *Chi lo sa?* The buzz of conversations rose and fell in gentle waves, the opposite of what happened in the turbulent Café Tupinamba, favored by the Spanish refugees.

MIGUEL CERVANTES: Didn't that same Madame Hélène later run a restaurant?

OCTAVIO PAZ: Yes, Chez Hélène, in the Lerma district of Mexico City. But that was fifteen years later. One ate well at Chez Hélène. I used to go there sometimes with José Gorostiza, who had been a friend of Hélène's since the days of the Café París. Or with Carlos Fuentes, Fernando Benítez and José Iturriaga. . . . The Café París had a very different atmosphere. Its name belongs not to the history of gastronomy or even of manners and mores but to that of literature and art. Or better put, to that history, which has yet to be written, of the groups, the personalities, and the tendencies that make up the literary and artistic society of an era. A history not so much of ideas and works as of the ways in which we shared our lives, and above all, a history of *taste.* I believe that the years of the Café París were the only period in which we had what has been called a "café society," as in France, Spain and Italy. The café was a literary institution that replaced the salon. But in Mexico we did not have literary salons: writers met in certain

bookstores and modernist poets in bars. The Café París was a society within society. And a geography as well: each table was a literary coterie, each coterie an island and a fortified site. The relations between the islands were at once frequent and risky. There was always some dauntless type—or some ignoramus— going from table to table. Some of them were messengers and others deserters. Because there were also emigrations and exclusions. Our table split up two or three times. We even emigrated from the Café París for a short time when a group of us, headed by Barreda, founded *El hijo pródigo.* The Café París had become too overcrowded and chaotic—and we met regularly in a nearby café on the Calle de Bolívar.

MIGUEL CERVANTES: How did you happen to go to the Café París for the first time?

OCTAVIO PAZ: I don't recall whether I was invited by Octavio Barreda or by Xavier Villaurrutia. The review *Letras de México* was practically edited and readied for the printer in the Café París. I began to collaborate on it, and little by little, I became one of those who turned up faithfully at every gathering, although I was much younger than the others. Barreda, Villaurrutia, Celestino Gorostiza, Samuel Ramos, Antonio Magaña Esquivel, Carlos Luquín, and Orozco Romero attended these meetings regularly. Jorge Cuesta, Elías Nandino, José Gorostiza, Ortiz de Montellano, Rodolfo Usigli showed up less often. When the Spaniards arrived, Moreno Villa and León Felipe joined the group. Occasionally a few of the younger generation came by: José Luis Martínez, Alberto Quintero Álvarez, Antonio Sánchez Barbudo. The mainstays of the table were Villaurrutia and Barreda. We talked about literature and art, commented on books and exhibitions, gossiped a bit, composed epigrams, laughed at others and at ourselves. Across from our table there was another one, also frequented by writers and artists. Almost all of them were from LEAR (the League of Revolutionary

Writers and Artists) and from the review *Ruta*, whose editor-in-chief was the writer José Mancisidor. Among his companions were the critic Ermilo Abreu Gómez and the musician Silvestre Revueltas. The latter—without a tie, his chest bared, fat and serious, with a head that resembled Balzac's carved with a knife—never failed to turn up. The relations between the two tables were polite, tense in the case of Abreu Gómez, ironic in that of Villaurrutia. We arrived at about four in the afternoon and left around five-thirty. At about six a tumultuous and colorful group appeared, made up of a number of women and a few young oddballs. The ringleader was a skinny, nervous, witty young fellow: Juan Soriano. Among the women I remember María Izquierdo, Lupe Marín, Lola Álvarez Bravo, and Lya Kosta, who later married Luis Cardoza. Because of their bearing and their dress, Lupe Marín and María Izquierdo were the centers of attraction.

MARIE JOSÉ PAZ: What about Lola Olmedo?

OCTAVIO PAZ: Lola frequented other worlds. Lupe Marín was the elegant one of the little group. She was a dressmaker and had been to Paris; if her life was tempestuous and her language daring, her dress was irreproachable and in sober good taste. María Izquierdo was just the opposite. She looked like a pre-Hispanic goddess. A face of sun-dried mud perfumed with copal incense. Highly made up, with cosmetics not at all up to date but age-old, ritual: lips like red-hot coals, cannibal teeth, wide nostrils to breathe in the delicious smoke of supplications and sacrifices, violently ocher cheeks, crow's brows and enormous dark circles surrounding deep-set eyes. Her dress was equally fantastic: jet black and magenta fabrics, laces, buttons, amulets, ostentatious earrings, sumptuous necklaces.

MIGUEL CERVANTES: Indian ones?

OCTAVIO PAZ: Sometimes. At other times, costume jewelry.

MARIE JOSÉ PAZ: With skulls, isn't that right?

OCTAVIO PAZ: With jaguar teeth. When I saw her, I thought: the only thing missing is for her to suddenly bare fangs or take an obsidian knife from her brassiere and cut out Juan Soriano's heart. But that woman with the terrifying look of a pre-Hispanic goddess was gentleness herself. Shy; a private person. In those days I saw very little of her. Sometimes we would happen to meet, on Saturday nights, in a little cabaret called . . .

MIGUEL CERVANTES: All the women were night owls?

OCTAVIO PAZ: Leda. Many people went to the Leda. Not only Juan Soriano's coterie—María Izquierdo, Lupe Marín, and Lola Álvarez Bravo—but Renato Leduc, Edmundo O'Gorman, and, oddly enough, Justino Fernández could also be seen there. Other habitués: José Luis Martínez, Pita Amor, Diego de Mesa, Neftalí Baltrán, José Revueltas. With Revueltas, I used to talk, amid all the hurly-burly, about Lenin and Dostoevsky. Or rather, about Revolution and Sin. This was my first period of contact with María. A superficial contact yet warm and cordial. . . . I liked her painting. Although she was already past her peak, she was still doing admirable things. In precisely those years we put out a review, *Taller*. It was founded by four of us who belonged to the younger generation: Rafael Solana, Efraín Huerta, Alberto Quintero Álvarez, and myself. The first issue of *Taller* (in December 1938) was illustrated with color reproductions of paintings by María Izquierdo. It was an act of homage paid by us young writers to a more or less heterodox painter, whose art was very far removed from the ideological painting of the Muralists. The introductory text was signed by Rafael Solana. An intelligent, well-written text. I have reread it and I still like it. It is strange—no, it is not strange; it is the norm in the milieu of those who are envious and forgetful by profession—that feature writers and art critics have not noted the significance of this homage by a group of young poets. Including the date: 1938.

ROBERT LITTMAN: Where was her work known? In art galleries?

MIGUEL CERVANTES: In art galleries and in private houses.

ROBERT LITTMAN: In private houses?

MIGUEL CERVANTES: Yes, There were those who owned works by María. Rafael Solana and Juan Soriano, for example, and others.

OCTAVIO PAZ: Moreover, we were able to see her works in Inés Amor's gallery and at exhibitions sponsored by the Ministry of Public Education.

ROBERT LITTMAN: Were collectors interested in Tamayo's work in that era?

OCTAVIO PAZ: I don't know. . . . Jacques Guelman, no doubt. . . . I met Tamayo, briefly, in 1938 at the headquarters of the Spanish Popular Front. He was on very friendly terms, as I was, with the Spanish Republicans. He was married at the time to Olga. Shortly thereafter, they left Mexico and went to New York. I saw him again several years later in that city. We became good friends after that. I have spoken of this meeting in "Review in the Form of a Preamble," an essay that opens my book on Mexican art. But I saw very little of him at the time we're speaking about, though I admired him for his independent attitude toward Muralism.

MIGUEL CERVANTES: I wanted to ask you if you knew about the friendship between Antonin Artaud and María. Was there much talk about it?

OCTAVIO PAZ: Yes, I knew about it, but nobody talked much about it. Artaud had left Mexico several years before. I must explain, moreover, that Artaud was known only by a few. There is nothing odd about that: in Paris, in those days, he was not a figure of the first magnitude either. Only later, after the war and his leaving the insane asylum, did he become a celebrity. His international fame was posthumous. And since we're speaking of Artaud, the Café París had two periods, that of the Calle de Gante and that of the Calle Cinco de Mayo. Two mythical poets, the American

Hart Crane and the Frenchman Antonin Artaud belong to the first period—which I missed out on: I was just a youngster at the time. I was able to read several articles by Artaud in *El Nacional* but I didn't meet him until much later, in 1947, in Paris. He had left the asylum at Rodez and was living in a town nearby, Yvry. He had been discovered after years of oblivion and suffering, and a great public ceremony in tribute to him was held in a theater. A great many people attended it, a brilliant gathering: all the younger generation of writers, many actors and actresses and notables of the day, among them André Gide, who at the end rose from his seat, climbed up onto the stage, walked to the rear of it, and embraced Artaud. One of the speakers at the ceremony was André Breton, just back from the United States. As we talked, he did not conceal his emotion: twenty years before, Artaud had been one of the really inspired voices of the Surrealist movement, but at the same time they had had a number of stormy public disagreements. Despite his reputation for being unforgiving, Breton was a generous spirit, and when his brief speech was over, he said: "I know that Antonin Artaud has *seen*, in the sense in which Rimbaud, and Novalis and Arnim before him, have spoken of *seeing* . . . and it is of little moment that what they *saw* in this way does not correspond to what is objectively visible." These words moved everyone who heard them. Now, however, after so many years, I wonder whether it is proper to compare Artaud's case with Novalis's and Arnim's or with Rimbaud's. None of the three was ever shut up in an insane asylum. The lives of Novalis and Arnim were not exceptional, save for their gifts and their literary creations; Rimbaud's was eccentric, violent, and irregular, but not clinically insane like Artaud's. Even the comparison with Hölderlin and Nerval is untenable. They too were victims of terrible mental disturbances and had to endure being committed to asylums—Hölderlin for more than half his life—but their visions and their works are of a totally different

nature from Artaud's. Hölderlin's poems surprise us by their mysterious beauty: they are compositions, not ejaculatory utterances. In Nerval's texts we are attracted and shocked by the continual shift from madness to lucidity; *Aurelia* is a unique book because it is an expression of conscious awareness from within a state of delirium. . . . But this is a subject that is a bottomless pit and calls for reflection in another context.

MARIE JOSÉ PAZ: You were telling us of your impressions of that famous soiree in honor of Artaud.

OCTAVIO PAZ: Yes. I apologize for the digression. At the end it was Artaud's turn. It was unforgettable: he recited three poems, one of them with an Indian theme. After that he referred to certain episodes of his life: the trip to Dublin, his commitment to an asylum, the horrors of electric shock treatment, the witchcraft and the sorcery of which he had been the victim. This second part of his participation in the program was listened to with a certain respectful skepticism. Despite the audience's obvious bias in his favor, his revelations concerning the magic spells used against him were coldly received. They did not convince anyone.

MARIE JOSÉ PAZ: How do you explain that?

OCTAVIO PAZ: It was a modern, secular audience. People had gone to the ceremony to *protest*. They saw in Artaud a victim of the impersonal powers and institutions of modernity, but at heart they believed in the principles that had served as the basis and the justification of that detested modernity. This is the paradox of modern intellectuals and this is the secret, at once pathetic and laughable, of their rebellion. They are—or rather, we are—the rebellious offspring of modernity . . . but we are modern. Not Artaud: he was a true modern poet and he was also truly mentally disturbed. His disturbance withdrew him from modernity and turned him into a man from another time. He believed what he was saying. So it sent shivers up our spines to hear him recite his

broken, spasmodic poems in a voice that was equally broken and spasmodic, interrupted every so often by purely rhythmical verses, in a language of his own invention, like stones falling into a well:

> nuyon kadi
> nuyon kadan
> nuyon kada
> bara bama
> baraba

MARIE JOSEÉ PAZ: This reminds me of the speaking in tongues at the Pentecostal church in that little black community in a suburb of Boston in 1974. Do you remember?

OCTAVIO PAZ: Yes. It is a trance that appears in many religions and in every era, both among Gnostics and primitive Christians and in certain Russian communities or, at this very moment, in the United States and in Mexico. It is revealing that glossalalia, a phenomenon usually associated with religious ceremonies, should appear among poets in the modern age. The first cases I know of are the Dadaist Hugo Ball, in Zurich in 1917, and, a short time before, the last two cantos of *Altazar*, Huidobro's poem, although that was less spontaneous, more literary, a written text and not a spoken one. It is no less revealing that no one, or almost no one, among those who heard Artaud that night realized that they were witnesses to an experience that there is no other word for except religious. What shortsightedness!

MARIE JOSÉ PAZ: Or rather, what deafness! Not to hear . . .

OCTAVIO PAZ: . . . the voice of the Beginning. . . . To make a long story short, a few days after this literary event, I went out to dinner in Saint-Germain-des-Prés with a young Mexican friend. We decided to have a drink together first in a little bar that still exists, Le Bar Vert. We sat down at the counter and ordered a

drink. At a nearby table a group was talking together excitedly. All of them left the place soon after—all but one of them, that is. I recognized him immediately. Even though in the theater I had seen him from a distance, I had just seen a photo of him in Pierre Loeb's gallery. A terrifying sight: an emaciated little man, all bent over, with the brusque movements of a tree branch buffeted by the wind; without a tie, dirty, a few locks of straight hair falling over his collar, gaunt cheeks, thin lips, a toothless mouth, burning eyes gazing out of the bottom of I don't know what abyss, eloquent bony hands. . . . Nerval's poem came to mind, and I thought, "El Desdichado." Was this how Nerval's Prince of Aquitaine and his ruined tower had ended up? . . . On hearing us speak together in Spanish, he rose from his chair and asked us if we were Mexicans. We said we were. Then he said to us, "Do you know who I am?" "Of course!" I replied. "You're the poet Antonin Artaud." He was delighted by my reply. He had immediately realized that he was face to face with people who knew his work. We spoke of his leaving the asylum, of his new activity as a poet, of Mexico and his memories of Mexico. He said to us, "There must be nothing left of your country now. Progress and industrialization will have spoiled everything. Not even Tibet has been able to resist progress. The *Rot* is universal." He looked at us and added, "The world is being eaten away by gangrene. That's why they kidnapped me and shut me up in the asylum. The Mexico that I knew was still alive though it was already evident that it would not last much longer. They have sealed up all the old wellsprings." . . . As he spoke, I remembered that someone had told me—or did he himself tell us that night?—that when he felt a wave of despair coming on, he would grab an ax and split an enormous tree trunk he had in the courtyard of his house. The blows with the ax calmed him down.

MARIE JOSÉ PAZ: Did he speak of María Izquierdo?

OCTAVIO PAZ: He first recalled a number of friends whom he

had known in Mexico, such as the poet Gorostieta (he was unable to pronounce his name correctly) and Luis Aragón (he forgot Cardoza). Then he spoke with devotion of María. The woman and the painter. He spoke of her as one would speak of a mountain that was also a person, a woman. "In her paintings the real Mexico, the ancient one, not Rivera's ideological one, appears with the heat of blood and of lava. María's reds!" And he went on: "When I left Mexico, she gave me four paintings for me to show to people here and arrange for an exhibition of her work in Paris. They stole them from me in the asylum, along with my manuscripts. Who? The envoys of. . . ." And he stood there staring at us. And then after a pause: "Well, you know who. They're everywhere. They're the same ones who put Van Gogh away in a madhouse and later *suicided* him. They were the ones who stole my manuscripts and María's paintings. Yes, the envoys. . . ."

MIGUEL CERVANTES: I've spent a great deal of time trying to track down the works that Artaud took with him.

OCTAVIO PAZ: He went on talking excitedly about Tibet, about the mountains of the Tarahumaras, about the spells and evil incantations that he had to ward off each day, about the envoys and the end of this period of human history. . . .

MARIE JOSÉ PAZ: Who could those "envoys" have been and who sent them?

OCTAVIO PAZ: He lived in a world of conspiracies and dark, shadowy forces. He was convinced, for instance, that many of the people he saw, and spoke with, were really dead. Sometimes these dead people didn't know that they were dead. He thought that Breton had tried to rescue him when they had committed him to the asylum, in 1937, and that Breton had died in a fight with the police and the psychiatrists.

MARIE JOSÉ PAZ: But how did he explain the presence of Breton at the ceremony in his honor?

OCTAVIO PAZ: Very easily. Breton *didn't know* that he was dead. He was a real *revenant*. Artaud's world was peopled with living persons who were dead and dead persons who were alive. His confusion, even though it may seem strange, is one we have all experienced. In our dreams we often speak with the dead. At times, those dead don't know that they're dead. I have even dreamed that I was dead; this didn't keep me from acting the way people who are alive do, although with a secret anxiety: I was afraid that the others would catch on. A feeling of shame having to do not with original sin but with the sin of nonbeing. . . . Anyway, at that point his friends returned, among them the actor and stage director Roger Blin and Paule Thenevin, who later very competently took charge of editing Artaud's complete works at Gallimard. Artaud said goodbye to us and went off with his friends. I never saw him again. He died a short time later.

MARIE JOSÉ PAZ: Let's get back to Mexico.

OCTAVIO PAZ: Despite the fact that María Izquierdo was not a literary figure and that she read little, her life was always linked to the literary world. She was a friend of Artaud's, at the Café París she was surrounded by the young poets, she was often seen in the company of Villaurrutia, and finally, she was a great friend of Pablo Neruda's. At Pablo's I saw a lot of her and her second husband, Raúl Uribe, like Pablo a Chilean. Before our falling out—which began at that sad dinner in his honor at the Asturian Center—I enjoyed a friendship with Neruda that I am not certain I could call a close one but that surely was a warm and affectionate one. We often visited each other's houses. I remember the Sunday lunches in the mansion in Mixcoac that for some reason Pablo insisted on telling people had once belonged to the poet López Velarde. He liked being surrounded by people constantly, and his parties were amusing and boisterous. There were always three or four "parasites," in the original, Roman sense of the word: those who amuse

the rich and share their table. His "parasites" were charming profes-
sionals, who helped Delia del Carril, "La Hormiguita"—"The
Little Ant"—take care of the many guests. There was also a most
picturesque and terrifying guest: a badger, who drank red wine and
tore the ladies' stockings. . . . Pablo was generous and at the same
time tyrannical. He was very faithful to his friends, but he did not
like them to be too independent. Perhaps María's serenity attracted
him. What is certain is that he always treated her with special
affection. When Pablo decreed my civil death—an order that a
number of friends of mine, both Mexicans and Spaniards, obeyed
without a word—María had the courage to disobey him and went
on seeing me. During those years she often visited my house with
Raúl Uribe. In October 1943, I left Mexico and did not return for
ten years. I was never able to see her again.

MIGUEL CERVANTES: It's curious: the years when Octavio knew
her coincide with María's best period, that of the "circuses" of
1938 to 1941.

OCTAVIO PAZ: In my opinion, her best period is the one just
shortly before that, during and a short time after the years of her
friendship with Rufino Tamayo. We need to correct an error con-
cerning María, very much like the one that has been bruited about
with regard to José Revueltas: she was not an unknown or a marginal
artist. She was recognized by José and Celestino Gorostiza, by
Villaurrutia, by Fernando Gamboa. Gamboa helped her. I have al-
ready mentioned the admiration that certain of us younger people
professed for her.

MIGUEL CERVANTES: Did the painting that all you younger
ones liked in the thirties have the same populist quality as María's?

OCTAVIO PAZ: Not populist—popular!

MIGUEL CERVANTES: Did you all admire what was popular?

OCTAVIO PAZ: Enormously. In those days we young people
didn't have much visual culture. We hadn't ever left Mexico and

there were few books, all of them expensive. I had had just a glimpse of the museums in Paris and New York during a brief trip—and that was all. But we knew that the popular art of Mexico was a living source and that the best of our painting bore a relationship to that popular and traditional source. Furthermore, we realized that modern European art had rediscovered the art of other civilizations, among them that of ancient Mexico. The visits of Breton and other great admirers of pre-Columbian and popular art reinforced these ideas of ours.

MIGUEL CERVANTES: And what about the Muralists?

OCTAVIO PAZ: We were tired of the grandiloquent plastic discourses of Orozco, Rivera, Siqueiros, and their acolytes. Painted oratory, we used to say. On the other hand, certain younger painters—Tamayo, María Izquierdo, Julio Castellanos—and one a bit older, Carlos Mérida, seemed to us livelier and more up to date. They didn't preach Mexicanism the way Rivera did: they were Mexicans because that was what they had been born. Their relationship to popular art was more authentic than the Muralists'. With talent and originality, some of them, such as Tamayo, had assimilated the great experience of modern European painting. Alongside these painters, for whom popular art was the great visual gift, there were others who were more European, such as Agustín Lazo. We respected him, but he did not excite us. Others, like El Corzo, interested us because of their mixture of humor and imagination. And now that I am recalling those years, I must speak of Manuel Rodríguez Lozano. He was a very intelligent man, a great rebel, and very much a loner. A narcissist with great talent. A more literary than plastic talent: the best thing about him was not his painting but his opinions. The most solid and highly gifted among them was Julio Castellanos. We owe to him four or five paintings that deserve to be called classics because of their sober harmony and their knowledgeable composition. Also many extraordinary

sketches. Others, who have been forgotten: Carlos Orozco Romero. Or who have yet to be discovered: Alfonso Michel. I could mention more names but I'm afraid of being unfair. Among all of them, the person and the work of María beam with a unique light, more lunar than solar. She seemed to me very modern and very ancient.

MIGUEL CERVANTES: It is a help in understanding her work to see her in her own time and among her contemporaries.

OCTAVIO PAZ: Moreover, this brief résumé shows that the rebellion against Muralism and its drum-and-bugle aesthetics was already widespread by the end of that decade. These things have to be repeated because, again and again, certain critics, who have halfway repented their prejudices and ideological deviations, are trying to *cosmeticize*—that is the proper word—the history of Mexican painting.

ROBERT LITTMAN: And what is Frida Kahlo's place in all this? Weren't she and María friends?

OCTAVIO PAZ: Frida and Diego's lifestyle was far removed from that of other Mexican writers and artists. Their world was international: critics and journalists from the U.S., celebrities, wealthy people. Carlos Pellicer saw them, and in all likelihood so did Salvador Novo, who dedicated one of his Surrealist poems to Frida. Frida and María resembled each other in their folkloric style of dress; as persons and as artists they had little or nothing in common. María's attire was more fantastic than Frida's; by that I mean that Frida's outfits were really regional garments whereas María's were versions of popular fashions that appealed to her vanity. María's clothes, despite their hieratic style, concealed a simple, popular personality; Frida's, a complex and not at all popular personality.

ROBERT LITTMAN: That's interesting. On the one hand you have María Izquierdo, and Frida Kahlo on the other: both of them go around dressed in those extraordinary costumes, both of them

paint their lives in small paintings, portraits, and self-portraits, but really . . .

MIGUEL CERVANTES: . . . there was a great difference between them. In the first place, like many Surrealist painters, Frida began as an academic painter. There is nothing naïve about either her draftsmanship or her composition. Just at the time that Frida ceases to be academic and begins to produce painting that it more interesting, she is clearly influenced by the Surrealists.

OCTAVIO PAZ: Precisely. It is absurd to deny the influence of Surrealism on Frida's painting, as certain nationalistic critics have tried to do. . . . One can go still farther than Miguel did. The differences between María and Frida are obvious, and they leap to the eye. Beginning with their names: Frida is a foreign name and, for us, an aristocratic one; María, on the other hand, is a name that comes straight from the people. Then their social background: Frida came from a cultivated, well-off family, María from a village in the provinces. One of them was half European (German) and the other of pronouncedly indigenous stock. Frida was familiar with academic studios and university classrooms; María briefly attended San Carlos—in all truth, she was a self-made woman, with a bit of help from her lovers, her fellow painters, and certain writers who were on friendly terms with her. Even their sexuality was different. Or rather, the opposite. Frida always had something of a young man about her: her slimness, her mischievousness, the pronounced mustachelike hair above her upper lip; when she was young, she was fond of dressing as a man. Frida's masculinity manifests itself not only in her physical traits but also in her bisexuality: her great passions were women. Her relationship with Diego—an obese, spongy figure—was that of a young boy to his immense, oceanic mother. A mother who was all bulging belly and huge breasts. María was the exact opposite, profoundly feminine, and her relationship with her lovers and her friends was maternal. She was an

embodiment of the powerful passivity of the Mexican-style tradi-
tional mother. She gave Artaud a helping hand, protected Raulito,
and even bore, with the stoicism of the "long-suffering woman,"
the verbal and physical violence of certain other men.

In Frida, it is narcissism that is central; in María, as in all
traditional feminine archetypes, the key word is *sacrifice*. Frida,
active; María, passive. Another difference: their careers. Frida at-
tained international renown; María was known by a mere handful
of people, and only in our own country. Her relationship with
Mexico was also different. Frida passionately wanted to be Mexi-
can, but her Mexicanism is a mask; what counts in her case is not
folklore (as is likewise true of Diego, another cultivated academic
painter) but poetic genius, imagination, humor. By contrast, María
did not want to be a Mexican, but there was no way not to be one.
In María, as a human being and as an artist, there is an element
both of fate and of spontaneity; in Frida there is a tragic will to
sublimate and transform her terrible sufferings into art. Frida had
more imagination and was more intelligent; nonetheless, amid the
poverty of her resources, María possessed greater visual power. She
had less mastery of her craft than Frida did—her draftsmanship
was simple, her composition naïve—but her instinct was surer, and
her sense of color and of chromatic relationships more profound.
There is more free flight in Frida, more earthiness in María. In
Frida there is a dramatic quality and a humor that do not appear
in María. When I say this, I am also saying that María's painting
is more painterly than Frida's. I am comparing them not in order
to denigrate the one and extol the other; I am trying to distinguish
them. I admire the two of them for different reasons.

MIGUEL CERVANTES: María's subjects are traditional ones.
They come from popular painting, they are still lifes, land-
scapes. . . .

OCTAVIO PAZ: Yes, Miguel, that's true, but it's also true that

there are European echoes in her. Her paintings with a circus motif come from European painting.

ROBERT LITTMAN: Yes, from Picasso.

OCTAVIO PAZ: Picasso had a decisive influence on many painters of that period. First and foremost, on Diego Rivera. I am referring, of course, to the Picasso who carried on with the lesson taught by Ingres. In other words, to the Neoclassical Picasso. That Picasso —for there are many—also influenced Rodríguez Lozano, and that influence is likewise noticeable in the best works of Julio Castellanos and Guerrero Galván. In María the influences of modern European painting were filtered through Tamayo's example.

MIGUEL CERVANTES: Yes, that's true. And how about Chirico?

OCTAVIO PAZ: Chirico was very much on our minds in those years. The one closest to him was Agustín Lazo. Through Lazo, most likely Villaurrutia. The atmosphere of certain of Xavier's poems is that of Chirico's paintings.

MIGUEL CERVANTES: The nocturne dedicated to Lazo, the "Nocturne of the Statue," is a Chirico.

OCTAVIO PAZ: In a short, precious critical text in prose, "Fichas sin sobre para Lazo" ["Index Cards without an Envelope for Lazo"], there are also constant allusions to Chirico. The traces of the Italian painter are very blurred in María. María's imagination is not literary, nor does she drink from Chirico's classical sources. Her inspiration lay in her provincial childhood: the columns and arcades that appear in her painting are not those of ruins in Italy but the ones that can still be seen in many small towns in Mexico. But I hasten to explain: María's realism is not realistic but *legendary*; by that I mean, it is an evocation, filtered through her sensibility, of her childhood and of the rustic poetry of the little towns and villages of Central and Western Mexico. A living antiquity. Hence her closeness to a painter like Chagall, as has been astutely pointed out by José Pierre. As always, influences are really confluences for

her. There is another traditional element in María's painting: her sense of kinship with animals. Not Frida's exotic animals but, rather, those of her childhood: cows, bulls, dogs, birds, burros, and studhorses.

MIGUEL CERVANTES: Chirico?

OCTAVIO PAZ: Perhaps. But we would be neglecting something very important were we to forget that the horses are those of her childhood and her adolescence. Mexican popular mythology is full of horses, or to use the people's word for them, *"los cuacos"*— "nags." Since the Conquest, the horse has been present in our combats and in our fiestas and ceremonies. One of the best of Reyes's poems has as its subject the horses of his childhood. And López Velarde: "I want to abduct you in Lenten darkness: on a stallion and with a wooden noisemaker." María Izquierdo's horses are suffused with symbolic sexuality and the violence of passion. The mythical and popular unconscious was decisive in her art. Nor is the presence of sirens in her painting accidental: they stem from popular art but also from traditional images. This is equally true of circuses. They are a universal motif, which, in modern art, harks back to Picasso as a precedent and, in poetry, to Apollinaire and Rilke. But the circus is engraved on popular memory; it appears once again in López Velarde—there is an unforgettable line in *Memorias del circo*: "the widower swinging on the trapeze"—and, of course, in many of Posada's woodcuts. María saw, read, and lived all of that.

MIGUEL CERVANTES: How would you define María Izquierdo's art?

OCTAVIO PAZ: I don't know. I mistrust definitions. But I know that on the day when the real history of the Mexican painting of this century is written, the name and the work of María Izquierdo will be a small but powerful center of magnetic radiation. A succinct work, accomplished more by instinct than by intellect, as pure,

spontaneous, and fascinating as a fiesta in the main square of some little town. A secret fiesta, which takes place neither here nor now but in some I-don't-know-where-or-when. Interiors and still lifes in which things are associated in accordance not with the laws of geometry but with those of affinity, in other words, by sympathetic magic. Portraits that show us not so much a person as an intimate relation. Mirrors, dressing tables, shelves, tables with vases of flowers or pieces of fruit, beds: ritual objects of an intimate, feminine religion. Pretty everyday things, simple or highly decorated, windows with curtains of violent or hot colors, forms and volumes linked to this world by an obscure desire to be and to last. A triumph of gravitation: to exist, merely to exist. Landscapes, houses, emblematic figures who give the appearance of being hypnotized—an expert horseman, a clown and a hoop, a little girl and three spheres, a young girl combing her hair in an empty room—mythical creatures, innocent, drowsy beasts, plants, clouds, stars, the whole submerged in an atmosphere that has slowed to a stop: time that passes without going by, the arrested time of little towns that know nothing of the hustle and bustle of history. The time of circuses outside of time and of public squares with a church and a circle of ash trees, the time of horses and plains surrounded by hills, the time of the voices of women bathing in the rivers and of the young girl who, on the night when witches cast their spell, goes down to the well, guided by the moon. María Izquierdo or the realest reality: not that of history but that of legend.

The Instant
and Revelation

Today nobody, save for an occasional eccentric, questions that photography is an art. This was not always so. In its early days many saw it as a simple medium permitting the mechanical reproduction of visible reality, useful as an instrument of scientific information and that was all. Although its powers were already greater than those of the eye—it penetrated stellar space and the microscopic world, it pierced fog, it perceived with equal precision the twistings and turnings of the snowflake as it fell and the flutter of the fly's wings against a pane of glass—it was thought that the photographic camera lacked sensitivity and imagination. In his article on the Salon of 1859 Baudelaire writes:

Introduction to the book *Instante y Revelación*. Thirty poems by Octavio Paz and sixty photographs by Manuel Álvarez Bravo. Mexico City, 1982.

Photography must be the servant of the arts and sciences, but the humble servant, like printing and stereography, which do not take the place of literature. . . . We are grateful to it for being the secretary and the archive of all those who, because of their professions, have need of an absolute material exactitude . . . but woe unto us if we allow it to meddle in the realms of the impalpable and the imaginary.

Surprised by the new instrument and irritated by its powers of immediate reproduction, the poet forgot that behind the camera lens there is a man: a sensitivity and a power of imagination. A point of view. In almost those exact same years, Emerson was enthusiastic about the very phenomenon that scandalized Baudelaire. "Photography is the true Republican style of painting. The artist stands aside and allows one to paint himself." A curious blindness: though the Frenchman deplored it and the American applauded it, both saw in the still camera the substitute of painting.

Baudelaire's and Emerson's confusion has recurred frequently. For instance, ever since the dawn of modern art it has been said that photography, by occupying many territories of visible reality that up until then had been the exclusive province of painting, had forced painting to retreat within itself. Painting ceased to see the world and explored essences, archetypes, and ideas; it was the painting of painting: Cubism and Abstractionism. Or else it spread into the realms of what Baudelaire called "the impalpable and the imaginary": it was the painting of what we see with our eyes closed. Reality soon disproved this theory, and in almost no time, photographers, by means of photomontage and other techniques, explored on their own the worlds of abstraction and of dreams. Need I remind the reader of Man Ray and Moholy Nagy? It is not surprising, therefore, that in recent years the idea of photography as a rival of painting has given way to another, which is perhaps more accurate: painting and photography are independent but related

visual arts. As always happens, certain critics have gone even farther. Today some of them see photography not as a mechanical invention that represented a break with pictorial tradition but, on the contrary, as the natural consequence of the evolution of Western painting.

The history of European painting from the sixteenth century on is the history of perspective, that is to say, of the art and the science of visual perception; hence photography, which instantaneously reproduces perspective, must be regarded not as an interruption but as a culmination of tradition. In 1981, the Museum of Modern Art in New York sponsored an exhibit of painting and photographs aimed at illustrating this idea. "Photography," Peter Galassi says, "is not a baby girl born out of wedlock and abandoned by science at the doors of painting but the legitimate daughter of the Western pictorial tradition."[1]

After more than a century of wavering, criticism has gone back to the starting point, not in order to condemn photography, as Baudelaire did, seeing in it a poor substitute for painting, but in order to extol it as an art born of the same tradition. It is hardly necessary to expatiate on the pertinence of this criterion: unlike the history of the pictorial art of other civilizations, the history of European painting from the Renaissance to Impressionism is impossible to understand as a process apart, separate from the evolution of perspective. By inventing photography, optics completed and perfected a process begun by Renaissance painters. We run the risk, however, of falling victim yet again to confusing painting and photography if we fail to note that photography, even though it came into being to satisfy the long-standing obsession of painting with reproducing the illusion of perspective, soon parted from pic-

[1] *Painting and the Invention of Photography* (catalogue of the exhibit *Before Photography*), New York: Museum of Modern Art, 1981.

torial art to create its own, altogether different realm, governed by laws and conventions peculiar to itself. Like perspective in earlier centuries, it is born of the union between science and painting, but it is neither the one nor the other: it is a different art. The phenomenon is repeated with cinema: it is born of photography, and yet one cannot possibly confuse the two. Moving pictures are the thawing of the fixed image, its immersion in the stream of time. On the screen the image moves, changes, turns into another and then yet another; the succession of images unfolds like a story. The photograph stops time, imprisons it; cinema frees it and sets it in motion. Hence, it moves away from photography and draws closer to those literary genres ruled by succession: the story, the novel, the theater, the writing of history, reportage.

The discovery of perspective coincided with the vision of an ideal order of nature, based on reason and science. The point of view of the Renaissance painter was not really his own: it was that of geometry. It was an ideal point of view toward an equally ideal reality. I am using the adjective *ideal* in its Platonic meaning: proportion, *ratio*, ideal. But the different pictorial movements that followed one upon the other in the West, from Mannerism to Fauvism, have been characterized by an increasingly violent role of subjectivity in the art of painting. The ideal objectivity of Renaissance perspective was shattered, or more precisely, was fragmented: on the one hand, movement of the angle of vision and, on the other, multiplicity of points of view. The continuity based on geometry was broken; perspective ceased to be an ideal medium and was used to serve the artist's imagination, sensibility, or caprice.

Photography was a culmination of this evolution. Through its ability to reproduce perspective mechanically, without the intervention of the artist, it facilitated the mobility of points of view and made them multiple. What was most surprising was that the triumph of subjectivity was achieved thanks to a mechanical

procedure that reproduces the visible world with maximum fidelity. In a photograph, subjectivity and objectivity are conjoined: the world as we see it but, at the same time, as seen from an unexpected angle and at an unexpected moment. The subjectivity of the point of view is intimately related to instantaneity: the photographic image is that fragment of reality which we see in a quick glance, without stopping to look; it is also objectivity in its purest form: the fixity of the instant. The camera lens is a powerful extension of the eye, but nonetheless, what the photograph shows us, once the film is developed, is something that the eye failed to see or that it was unable to retain the memory of. The camera is, at one and the same time, the eye that takes a look, the memory that preserves, and the imagination that composes. To imagine, to compose, and to create are contiguous verbs. Through *composition*, photography is an art.

I owe one of my first artistic experiences to photography. The experience is associated with my discovery of modern poetry as an adolescent. I was a university undergraduate, and one of the things I most enjoyed reading was the review *Contemporáneos*. I was sixteen or seventeen years old and didn't always manage to understand everything that appeared in its pages. The same was true of my friends, though neither they nor I owned up to the fact. Confronted with texts by Valéry, and Perse, Borges, and Neruda, Cuesta and Villaurrutia, we proceeded from curiosity to stupefaction, from instantaneous enlightenment to bafflement. Far from discouraging me, such mysteries—often of the most trivial sort, as I realize today—spurred me on. One afternoon, leafing through issue number 33 (February 1931), I discovered, following a translation of Eliot's "The Hollow Men," reproductions of three photographs by Manuel Álvarez Bravo. Ordinary, everyday themes and objects: a few leaves, the scar of a tree trunk, the folds of a curtain. I felt a strange discomposure, followed by that joy which accompanies understand-

ing, however incomplete. It was not hard to recognize, in one of those images, the leaves—dark green and veined—of a plant in the patio of my house or, in the other two, the trunk of the ash tree in our garden and the curtain of the study of one of my teachers. At the same time, those photographs were enigmas in black and white, silent but eloquent: without saying so, they alluded to other realities, and without showing them, they evoked other images. Each image called forth, and even *produced*, another image. Thus Álvarez Bravo's photographs were a sort of illustration or visual confirmation of the verbal experience with which my reading of modern poets confronted me each day: the poetic image is always double or triple. Each phrase, as it says what it says, says something else. Photography is a poetic art because, by showing us *this* it alludes to or presents *that*. A continuous communication between the explicit and the implicit, the seen and the unseen. The domain of photography, or of art, is no different from that of poetry: the impalpable and the imaginary. But *revealed* and, so to speak, *filtered*, through what is seen.

Manuel Álvarez Bravo's art, essentially poetic in its bare, spare realism, abounds in apparently simple images, which contain other images or produce other realities. At times the photographic image is sufficient unto itself; at other times it uses the title as a bridge that helps us proceed from one reality to another. Álvarez Bravo's titles function as a mental trigger: the phrase sets off a discharge, releasing the explicit image so as to make the other image, the implicit one, invisible up until then, appear. In other cases, the image of one photo alludes to another, which, in turn, leads us to a third and a fourth. Thus a network of visual, mental, and even tactile relationships is established that is reminiscent of the lines of a poem made into a whole by rhyme or the configurations that stars form on maps of the heavens. The first photograph in this book [*Instante y Revelación*] is entitled *First Act*: some children in

front of a backdrop as blank as the page of a composition book or as the future before one begins to live one's life. There is another photo that can be seen as—or, rather, that *is*—the visual response to the unformulated question of the first one: on a white wall we see the traces of a hand. A wall already defaced by shadows, human beings, time. The simplicity of the title (*Wall with Hand*) emphasizes the complexity of the relationships between humans and things: hands that are acts that are traces that are days.

The play of visual and verbal rhymes—I am choosing my examples more or less at random—is repeated in *Cold Sun and Box on the Grass*: the same silvery light illuminates the grass on which the box and the face of the worker lying stretched out are resting. But what unites these two images is merely the high plateau and the invisible breeze that stirs the blades of grass, unless it be that state of grace designated by the word *pause*: a moment of immobility in the rotation of the day. The moment when our eyes are half closed: we perceive the blink of time, its invisible footsteps.

Among the photographs in this book there is a justly famous one, which shows a murdered worker. On seeing it, André Breton wrote that Álvarez Bravo "had reached that height Baudelaire called the eternal style." The realism of this image is awesome, and it could be said, in the literal sense of these words and without the slightest religious faith, that it comes into contact with that electric realm of myth and the sacred. The man lying dead is drenched in his own blood, and that blood is silent: he has fallen silent, into silence itself. *Bell and Grave* is a dramatic reply. Silence turns into a loud outcry: a high valley, devastated hills, a grave, and a bell hung from a crosspiece between two poles, a silent bell, yet able to awaken the dead. A bell that arouses other images: those *Hands of the House of Díaz*, which appear to spring up out of a cave of shadows and which could be accusing or pleading—it is impossible to tell. Victims' hands.

At the other extreme, three photographs that together make up a veritable epiphany of feminine presence. In *Black Mountain, White Cloud* we see a rounded hill covered at intervals by the chiaroscuro of a fine vegetation stirred by a sunny afternoon wind; on high, above the dark earth, like a white garment flying in the air, a cloud. The presence just barely evoked by the folds of the hill, the play of light and shadow in the blades of grass, the whiteness of the cloud, is made manifest in two other photos. One of them, also famous, *The Implied Washerwomen*, a great visual and verbal success, shows several maguey cacti from which bed sheets as big as stage backdrops are hanging; up above, in the background, rhyme once again: the snow-white clouds of the high plateau. Clouds for sculpting images that a breath of air causes to vanish. What games or what rites are being held by the washerwomen, hidden behind the whiteness? A simple, everyday enigma: the curtain opens and a young girl suddenly appears, without our being able to see her face, between the blankets hung up to dry. A play of oppositions and symmetries: her face covered, her privates uncovered. Each explicit element—blankets, clouds, grass, hills—interlocks with the others until it forms the implicit image and makes it visible: an earthly presence.

The Mouths is another photo freighted with secret powers. A seascape: a marsh or a river branch? On top of the still water float blackish objects: logs? There is a beach covered with little stones and black spots, like mineral ashes; opposite, on the other edge of the water, a gently rounded hill. A sky with fleecy clouds; an uncertain light: is it five o'clock in the morning or five at night? The place is called Las bocas: The Mouths. A perfect correspondence: as it is reflected on the still water, the hill forms the outline of a pair of enormous lips. What are they saying? They are not speaking words; they are drawing a sign: the correspondence between natural forms and human ones. The photo is a most suc-

cessful variation on an old metaphor: nature is a body, and the body a universe.

The same system of equivalences and transformations governs another series. The central element is not water, the earth, or the cloud on high but fire, once again in relation to humankind. In *The Spark* it appears in its primordial and Promethean form: the fire of industry, which drills through iron, melts it, or molds it. This image of creative destruction is followed by another: *Portrait of the Eternal.* What is "the eternal" here? The woman sitting combing her hair and raising sparks from her dark hair or the look in her eyes as she gazes at herself in her little mirror? The woman looks at herself and we look at her looking at herself. Perhaps that is what "the eternal" is: looking at oneself, being looked at, looking. The spark, the flash, the brightness, the light in the eyes that ask, desire, contemplate, understand. To see: to shed light, to shed light on oneself. In another photograph, *Absent Portrait*, the fire has consumed itself and consumed the image of the woman: there is nothing left but an empty dress lying on an armchair and a ray of sunlight on the bare wall. Álvarez Bravo has not, of course, told us a story: he has shown us realities in rotation, momentary fixities. Everything links together and unlinks. Revelations of the instant but also instants of revelation.

MEXICO CITY, *February 8, 1982*

Sombras de obras

Contemporary Art

Price and Meaning

Every so often certain art critics denounce me as "an enemy of the Mexican school of painting." I will respond once again, although it strikes me as anachronistic to argue over the effectiveness of the Muralist movement at this late date; at issue is an aesthetic that is over and done with, viewed with horror today by the entire generation of young artists. I shall repeat, though, that I do not share the scorn of the young and of foreign criticism for the mural painting of Mexico. This scorn is understandable but unjust. Understandable because the art of the Muralists, precisely because of their lack of moderation, seems inept to us today: Rivera's interminable and boring historical dissertations, Orozco's perpetual convulsive grin, Siqueiros's bombast and striving for theatrical effect. . . . Unjust because, in the name of an aesthetic of businessmen, they

do their best to deny something that had a life of its own, which most contemporary painting on a world scale does not have.

If in art, as in everything else, the primary condition is *to be*, the mural painting of Mexico *was*; it had a tone, an existence, an unquestionable and even aggressive character. That cannot be said of the paintings that galleries in New York, Amsterdam, Bombay, or Buenos Aires show in our day. At the same time, the attitude of a certain variety of Mexican criticism that attributes the discrediting of mural painting to an international conspiracy of Yankee imperialism is simply grotesque. Instead of resorting to paranoid explanations, such critics ought to bear in mind that collectors and museums in the United States were the first, and almost the only ones, to purchase a substantial number of Mexican works and that it was the critics of that country who contributed, in large measure, to the international reputation of our painters. Criticism in the United States today ignores Mexican painting. It also rejects French painting, to which American art owes an even greater and profounder debt. What is surprising about that? The same is true everywhere else, and no one, it would appear, is safe from the contagion of nationalism.

In 1950 I published an article, "Tamayo en la pintura mexicana" ("Tamayo in Mexican Painting"), in which I intended to show the place occupied by this painter within the Mexican movement. The text, despite the natural limitation of its subject, was an attempt to consider our painting as a whole, that is to say, as a tradition. In the first part I endeavored to situate Tamayo's predecessors— Rivera, Orozco, and Siqueiros in particular.[1] I tried to shed light on the meaning of their works, paying more attention to their

[1] This text served as an introduction to an essay entitled "Los muralistas a primera vista" in the series *México en la obra de Octavio Paz*, Mexico City: Fondo de Cultura Económica, 1987, vol. III, part 1. Hence its brief and schematic presentation.

paintings than to their intentions. I tried to see their creations not as ideas but as visions of the world. In those years I believed that to *see* this painting we must cast aside the hard outer shell of ideology (not only from the painting but from our minds). I still believe this: a work is something more than the concepts and the precepts of a system. And this—seeing it with pure, uncorrupted eyes—is what neither the friends nor the enemies of mural painting have done. But is it necessary to defend my point of view? Isn't that what we do every day when we contemplate the works of the past? The movement of our Muralists—a movement and not a school—is something more than the ideology of those painters and of their Maecenas (the Mexican government). Moreover, that ideology is contradictory: there is nothing more contrary to Orozco's thought than the doctrines of Rivera and Siqueiros.

Mexican mural painting was a consequence not of the revolutionary ideas of Marxism—despite the fact that Rivera and Siqueiros professed their faith in that philosophy—but rather of the series of historical and personal circumstances that we call the Mexican Revolution. Without the Revolution those artists would not have expressed themselves, or their creations would have taken different forms; in like manner, without the work of the Muralists, the Revolution would not have been what it was. The Muralist movement was above all a discovery of Mexico's past and present, which the revolutionary upheaval had made evident: the true reality of our country was not what the liberals and the supporters of the dictator Porfirio Díaz of the last century saw but something quite different, buried but nonetheless alive. The discovery of Mexico was brought about by way of modern Western art. Without the lesson of Paris, the painter Diego Rivera would not have been able to see indigenous art. But it did not suffice to see with eyes wide open or to possess a sensibility trained to profit from the great transformation of modern Western art: it was necessary for reality

to stand on its own two feet and start walking. The world that Rivera's eyes saw was not a collection of museum objects but a living presence. And what gave life to that presence was the Mexican Revolution. All of us Mexicans feel nostalgia toward and an envy of a marvelous moment that we were not able to experience for ourselves. One of its memorable incidents was the one when, having just arrived from Europe, Diego Rivera sees Mexican reality once again, as though he had never before seen it.

In my article on Tamayo, despite its polemical tone (in those days this painter was cruelly denied recognition), I tried to be fair to the Muralists. Why wouldn't I have been some fifteen years later, when that trend had ceased to be a living movement? It is no secret to anyone that Mexican mural painting lacks in Mexico a single descendant of stature, although its pitiful successors continue to cover the walls of universities, museums, and public offices. What is marvelous is not inherited: it is seized by conquest. The true successors of the Muralists were not the disciples of the original movement, who were a docile and intolerant herd, but those who dared make their way into new territory.

Outside of Mexican circles something more was taking place. It is revealing that nationalist and "progressive-minded" critics never noticed the significant influence of Rivera, Orozco, and Siqueiros on modern painting in the United States at the beginning of the thirties. Many of these American artists not only were influenced by the art and the doctrines of the Mexicans but also directly collaborated with them, as their assistants. Jackson Pollock is the best known but not the only one; Philip Guston too was an assistant, to Siqueiros, in Los Angeles, around 1932; Isamo Noguchi, the great sculptor, collaborated with Rivera, lived in Mexico for a time, and left a mural here (an almost unknown work, in the Abelardo Rodríguez market); another outstanding sculptor, Louise Nevelson, was an aide to Diego Rivera in New York in 1930.

The period of the Mexican influence on the new American painting north of the border can be situated between 1929 and 1939. Those were the crucial years when several great artists were learning their craft. The trace of Orozco is visible in Mark Tobey's first works and is more or less visible too in Franz Kline, Mark Rothko, Arshile Gorky, and even Milton Avery, who for a short time saw Matisse *through* Rivera. Mexican painting acted not only as a model but also as a stimulus. The lesson that Pollock learned from Siqueiros, for instance, showed him the immense resources of spontaneity and the possibilities of using sheer happenstance— the accidental splotch of paint—as a point of departure. The American critic Hilton Kramer maintains that the example of Rivera opened for Louise Nevelson the doors to understanding pre-Columbian sculpture and architecture. In both cases, the Americans north of the border went farther than their masters. Why has our criticism had nothing to say about this? Naturally, to critics whose principal concern is the artist's nationality or political affiliation and not what the artist's forms actually say, whose attention is drawn to reading rather than to contemplating a painting, it is scandalous to associate the names of Rivera, Orozco, and Siqueiros with those of painters who explicitly rejected the summons of social art. The scandal ceases to be one if we keep in mind the fact that the stateside artists did not intend to repeat a lesson (as their Mexican followers did) but aimed, rather, at carrying on an experiment and seeing its ultimate consequences. Initiation is one thing and influence another.

The influence of the movement of the Mexican Muralists on the artists of the United States was exercised in the decade just prior to World War II. Those were the years of the international reputation of Rivera, Orozco, and Siqueiros. They never managed to make an altogether outstanding reputation for themselves in Europe, but their names and their works were an overwhelming

success in the United States. Many painters from north of the border visited our country then with the same fervor with which, in the century just past, the English went to Italy, and some of these painters, as I have said, worked in Mexico or in the United States as assistants to the Muralists. Naturally, those influences were not the only ones, nor, in the end, did they turn out to be the most important ones. But it is impossible to conceal them, as certain critics in the United States are now attempting to do. In this article, it is not my intention to discuss the subject in detail. I shall confine myself to mentioning certain circumstances that explain this Mexican influence.

The first concerted undertaking of the avant-garde in the United States goes back to the famous exhibition called the Armory Show, in 1913. Even though many American painters took part in it, the show was primarily an expression of the European art of the time. Apart from well-known figures such as Picasso, Matisse, and Braque, two names were the focus of the irritation and amazement of the critics and the public: Francis Picabia and Marcel Duchamp. Both of them influenced the precursors of the new painting in the United States; and the second, fifty years later, is the unquestionable master of young artists in the United States, among them two of great talent: Jasper Johns and Robert Rauschenberg. The experiences of the European avant-garde, however, were not immediately assimilated by American painters, and fifty years would go by before it bore full fruit. Dore Ashton observes that in those years the artists of her country were obsessed with the search for an art that would be, simultaneously, *new* and *American*. It was quite natural that they should turn their eyes toward Mexico, a country in which artists had similar ambitions and produced work praised by many critics in the United States. To this it should be added that those were the years of the great debate between pure and social art. Many writers and artists were *converted* (that is the

correct word) to Marxism; others professed a somewhat vague though no less militant "humanism." Hence it is not surprising that artists in the United States should rely on the example of the Mexicans, who had been cultivating those tendencies for years. Furthermore, instead of taking refuge in the academicism of the Russians—this was the period in which Stalinism triumphed in art—the Mexicans adopted certain of the innovations of the European avant-garde, and even Orozco and Siqueiros explored new forms and techniques. (It is curious that Diego Rivera, the only one to feel the influence of Cubism, was the most conservative.) Finally, in that same decade President Roosevelt's administration commissioned painters to decorate public buildings as Mexico had done, although on a lesser scale (the WPA). Among those painters were several who would later become the creators of the new painting in the United States: Gorky, de Kooning, Pollock, Davis. Around 1939 all of them, together with Mark Rothko, Adolph Gottlieb, and several others, founded the Federation of Modern Painters and Sculptors.

If the decade from 1929 to 1939 saw the influence of Mexican art, the one that followed saw the break with it. In its first public declaration, around 1940, the Federation of Modern Painters and Sculptors proclaimed itself against social art and, above all, against nationalism, "which denies universal tradition, the basis of modern artistic movements." There are numerous reasons for this brusque change, some of them social and others aesthetic. World War II, as we can now see, was the beginning of the end of ideologies (a temporary end: like the Hydra, ideologies are continually reborn). Social art became so debased in Russia that enlisting beneath its banner was now a symptom more of servility than of rebellion. All over the world, artists began to grow weary of propaganda and its simplistic versions of reality. Artists in the United States gave evidence of a laudable freedom of spirit when they rebelled against

nationalism, in the very middle of a war and at a time when the pressure to choose sides was most stifling. Finally, any challenge to state paternalism is salutary, and the Yankee painters' action was carried out within the best tradition of the individualism of that country. But the crucial factor was the inner change: not only did the painters realize the limitations of pseudohumanistic art and of the sophism inherent in all didacticism, they discovered that in our time true artistic creation is an exploration of realities stubbornly denied by the nineteenth century. By turning their eyes toward the European example, they were able to delve deeply within themselves.

The break with the tendencies of Mexican art, which had nourished them up until that point, was abrupt and total. Not so much so, however, that it keeps us from noting, beneath the change of inspiration and of aesthetics, certain traces of the Mexicans: the predilection for broad, brutal brush strokes; the love of broken forms, violent colors, somber contrasts, ferocity. All this, which is Mexican, is also very American. But its origin is European: Expressionism, one of the sources of both movements. The best examples, in the two respective countries, are Clemente Orozco and Willem de Kooning. Moreover, there is another similarity: the enthusiasm common to both countries for monumental art. Both north and south of the border, we owe extraordinary works to the temptation of the grandiose, and I need scarcely remind my reader of Teotihuacán and the architecture of Chicago and New York. In the case of painting, Hilton Kramer says that "it has long been recognized that the Mexican mural movement was one of the sources of the change in scale of the works that characterize Abstract Expressionism." This change was a salutary rebellion against the European format, whose proportions almost invariably correspond to the interior of bourgeois apartments. Without the example of the Muralists (the *gouaches decoupées* of Matisse appear later), painters in

the United States would perhaps not have dared to change the dimensions of their works; at the same time, the adoption of the new scale revealed an authentic and spontaneous affinity between Mexican and American artists. The vastness of our continent, with its immense spaces, has an impressive reality all its own, above and beyond the historical and cultural differences of our peoples. But the grandiose can sometimes degenerate into giantism. Our continent is torn between two extremes, what is too large and what is too small: it is a continent of skyscrapers and dwarfs, of pyramids and costumed fleas. Hence it is a good idea to remind our artists who lack a sense of moderation of the existence of works that, though less extreme, possess a radiation that, because it is secret, is all the more powerful: Uxmal and the Sagrario of Mexico City. When Louise Nevelson adopted the pre-Columbian scale, she humanized it.

The new painting in the United States is born around 1940, with so-called action painting, or Abstract Expressionism. The movement began as a break with the tendencies that up until then had prevailed in that country. Did it thereby break with the idea of finding an expression that was new and American? On the contrary. Read the declarations of the introducers of the movement in New York and in San Francisco: at one time or another they insist, with a certain confusion, on propounding a universal and American art, an art that is primitive and of our time. The idea, never completely formulated, that inspires all these declarations is this: America (by which they mean the United States) has reached the point of universality, and it is up to its artists to express the new universal vision. Like all other new or revolutionary visions, that of these painters also has its source in a nonhistorical antiquity: this new vision is the original or primordial one. Thus their art is the culmination of modernity and, simultaneously, the expression of that which is before history. A twofold rebellion: against Europe, the

symbol of history, and against the simplistic nationalism of their forebears. Their attitude is reminiscent of that of Whitman and, closer to us, that of William Carlos Williams. Something similar happens with Pop artists. Duchamp, Picabia, and Schwitters are the masters of these young painters, but Pop Art repeats the gesture of Abstract Expressionism and it too claims to be an "Americanism." Whether the proponents of Abstract Expressionism were conscious of the fact or not, its primary aspiration was not so much to be a continental American cosmopolitanism as to convert modern cosmopolitanism into a Yankee Americanism.

Abstract Expressionism would have been impossible without the lesson provided by Europe. (It is scarcely necessary to emphasize that a number of the proponents of the new painting were born in Europe: Gorky, de Kooning, Yunkers. . . .) Apart from the influence of those whom we would call the "classics" of contemporary art (Picasso, Kandinsky, Klee, Mondrian), that of the Surrealists was crucial: Miró, Max Ernst, Lam, Roberto Matta, André Masson. I believe that the example of the last two, above all Matta's, was decisive. Masson and Ernst were the very first to explore pictorial automatism—since that is what dripping and other techniques of action painting are—precisely at the time they were living in New York, during World War II. The impression made in New York artistic circles by the work and the person of Matta, moreover, is well known. His example was more than a stimulus for Gorky and Robert Motherwell. The impression made by Lam, another Latin American Surrealist, was no less profound. It seems unnecessary, finally, to mention the presence of André Breton and his relations with Gorky, one of the great artists whose work was produced in the United States. Even in an artist as far removed (to all appearances) from the "Surrealist image" as Barnett Newman, the influence of automatism and of the *attitude* of Surrealism toward art, life, and politics goes very deep. Yet the experiments of the

Surrealists were meant to benefit an aesthetic different from the one that the New York artists were to claim a little later on. For the Europeans, the search consisted of provoking, by means of automatism, the revelation of the image: an aesthetics of sudden appearance; for the New York school, what counted was the act of painting itself: that act was already the image sought.

Alongside these influences, which are the ones most often mentioned, two others, both Hispano-American and both decisive, should be mentioned as well: that of the Uruguayan Joaquín Torres García, one of the few universal artists that our Americas have produced, and that of David Alfaro Siqueiros. I will not expatiate on the influence of the former: see what Dore Ashton says in *The Unknown Shore* about the resemblance between Torres García's paintings and Adolph Gottlieb's (the work of the Uruguayan was painted some fifteen years before Gottlieb's). The influence of Siqueiros on Pollock was a matter as much of a sensibility as of an aesthetic. In the first place, his conception of space: Siqueiros breaks through the limits of the painting, which ceases to be a static dimension and becomes a dynamic surface. Space is movement: it is not what one paints on; rather, it is what gives rise, so to speak, to its own configurations. It is matter in motion. Hence the importance of the theory of the blotch of paint, a principle that Pollock learned from Siqueiros and that opened to him the doors of a physical universe that at the same time is a psychic world. The difference from other painters (Max Ernst serving as the most notable example) lies in the fact that it is not the painter's imagination that discovers these or those surprising figures in the blotch of paint: it is matter itself, flung at the canvas or the wall, that guides the painter. Nor is it a question of chance, as with the Surrealists. For Siqueiros matter is movement, energy fighting with itself, the dynamic principle of a dialectic. Pollock approved of this intuition and carried it to its ultimate consequences, without allowing it to

be contaminated or led astray by any ideological "orientation." In Pollock, Siqueiros's intellectual manipulation becomes an affective weight. The limitation of Siqueiros is the ideological schema, that of Pollock the fall into mere sensibility, the domain of the formless. But the work of Pollock, a great painter at his peak, is a vision of matter expanding and distending until it denies itself, until it ceases to be matter and is transformed into a cry. A cry and not a word: a total affirmation of energy and, at the same time, a no less total negation of meaning. Standing before certain paintings of Pollock's, I wonder: what is the place of man, the meaningful being by definition, in the whirlwind of movement endlessly expanding and contracting? I don't know if this question has an answer. I know that it is a question that the new poets and painters will be obliged to confront.

The interest of Siqueiros's ideas and experiments is not exhausted by the foregoing. For example, his use of the air gun and his insistence on trying new materials surely impressed painters of the prewar decade in the United States. Modern artists, on the whole, have used utensils and objects of modern life in their painting (almost always in collages), but very seldom have they decided to paint with the new equipment available. Siqueiros's preoccupations prolonged those of the Futurists and other schools of the early years of the century, as they focused on the attempt not only to express modern life but also to make art be modern, that is to say, to use the tools and materials of industrial society. On the other hand, their search for a dynamic perspective, conceived within the aesthetics of realism, strikes me as far removed from the concerns of contemporary art. In any event, all these experiments appear to be systematic efforts inseparable from a history and a society. For Siqueiros, technique is meaningful in and of itself. In other words, it is something more than a medium; it is a vision of reality as movement and energy and reveals itself only

through contact with the transforming action of human beings. Siqueiros's ideas were a brilliant rejoinder to Rivera's "archaism." They were soon imbedded in a simplistic Marxism—to put it gently—which holds, among other things, that the arts "progress" and that the end result of their progress is "Socialist realism." The official ideology of Stalinism, shortly thereafter, eventually dried up all these seeds of life.

Between 1930 and 1940 tendencies in opposition to Muralism made their appearance. Around 1950 the break became final through the decisive intervention of a group of young artists, a circumstance that favored the break. Another circumstance favorable to the break with the academicism of the so-called Mexican school of painting was the presence of a remarkable group of European artists, who settled in Mexico around 1939 and who have lived among us ever since. Only through a blind nationalism can they be called foreigners. Some of them belonged to the Surrealist group (Leonora Carrington, Wolfgang Paalen, Remedios Varo, Alice Raho); others, such as Matías Goeritz, represented a current different from the avant-garde, more or less close to Dada. The influence of the first group made itself felt primarily by way of example; Matías Goeritz, on the other hand, played an active part in the artistic life of Mexico, and his daring, inventive temperament soon made itself visible in painting and, above all, in sculpture and architecture.

The Austrian painter Wolfgang Paalen settled in Mexico during the war and died here in 1959. He was interested in the ancient art of Mexico and published a review, *Dyn*, in which scientific thought and the artistic theories of the avant-garde came into contact with each other. Beset by opposites within himself and finally torn apart by them, Paalen lived a life that was a succession of spiritual battles. He approached the ancient art of Mexico with passion and shed much light on it thanks to his exquisite aesthetic

understanding; at the same time, that art gave rise to strange re-
verberations in his painting. When one calls Paalen to mind it is
impossible not to think of the German Romantics. He was one of
them, and a century later, he disappeared among the tangled jungle
of reflections of the Mexican tropics.

The Spanish painter Remedios Varo, also a Surrealist, has left
us a not very abundant body of work but one of rare poetry. Re-
medios built a world of symmetries, analogies, and transparencies;
at a central point there pours forth a wellspring of secret music that
we hear with our eyes.

A painter and a writer, Leonora Carrington has close ties to
several mythologies: Celtic and Mexican, that of Surrealism at one
of its most madcap moments, and that of Alice in the land beyond
the looking glass. She is not a poet: she is a poem that walks,
smiles, opens an umbrella that turns into a bird, a bird that becomes
a fish and disappears at the bottom of a lake. Leonora's paintings
are enigmas: we must hear her colors and dance with her forms
without ever trying to decipher them. Her paintings are not mys-
terious but wondrous.

Among the meteorites that fell on Mexico during World War
II, we find another English Surrealist, Edward James. In the man-
ner of Gaudí or of the unknown sculptor-architects of the gardens
of Bomarzo, he turned his tropical estate into a park of fabulous
fancies. Architecture and sculpture carved in stone by delirium.
The initial period, the most difficult one, has as protagonists two
isolated figures, Pedro Coronel and Juan Soriano. (I point out, in
passing, that the influence of Soriano has been decisive not only
among painters and sculptors but also on theater and poetry.) At
the end of this period, José Luis Cuevas makes his appearance,
violent and completely sure of himself. An extraordinary temper-
ament and a born master of his craft. He is classified as an Expres-
sionist painter. He is indeed one, although in a different sense from

that of the other Mexican Expressionists. His work is not a judgment on outward reality. It is a world of representations that is also a revelation of hidden realities. It is not the world that the artist sees through the window of his "good" sentiments and condemns in the name of morality or of revolution. The evil that Cuevas paints is not visible evil. The monsters he shows exist not only in the hospitals, brothels, and suburbs of our cities: they inhabit our intimate selves, they are a part of us. Another exceptional artist: the sculptor and painter Manuel Felguérez, who, around 1955, on his return from Europe, begins a pointed and aggressive body of work, full of invention, lyricism, and strength, that lies midway between the dramatic Expressionist gesture and the Abstractionist flight of fabrication. More austere and rigorous but no less the master of his gifts, and at times possessed of a broader vision than the other young painters, Vicente Rojo: precision and invention, somnambulistic engineering. Close to them, Lilia Carrillo, not feminine painting but painting, period. Among so many young artists, a man going on fifty, one to whom our critics have paid scant attention: Gunther Gerzso. Rumor has it that he is our best abstract painter. That is quite true, but it is not the whole story: he is one of the great Latin American painters. At the other extreme, the passion, the humor, and the imagination of Gironella, who, at his very first showing in Paris, received André Breton's immediate and warm support. I shall not mention any more names. My being outside the country kept me from being familiar with the work of various young artists such as Fernando García Ponce, Arnaldo Coen, and others. But we know that things have changed, even though there are certain people who do not realize that fact. For the first time in the history of Mexico there are a literature and an art that are situated on the margin of, and at times against, official culture. Is it worth the trouble, at this point, to do battle with the old windmills that we once upon a time took to be giants? Whether

windmills or giants, the threat still persists. Its form has changed, but not its identity: its name is uniformity. Yesterday it was passionate and nationalistic, ideological and Manichaean; today it is technical.

Modern art began as a criticism of our society and as a subversion of values. In less than fifty years, society has assimilated and digested those poisons. The works that scandalized our parents are on exhibit today in museums, and young women attending universities are writing dissertations on Joyce and D. H. Lawrence. What is most serious is not this suspect consecration: if it is true, as Baudelaire maintained, that "nations hold their great artists in respect despite them," it is also true that, once those artists are dead, nations hasten to erect monuments of dubious taste to them. What worries me is that today it is no longer necessary for the artists to die: they are embalmed while they are still alive. This danger goes by the name of success. The work must be "novel" and "rebellious." It is a matter of a novelty that is mass-produced and of a rebellion that doesn't scare anyone. Artists have become sideshow monsters, scarecrows. And the works: plastic monsters neatly cut out, packaged, labeled, and provided with all sorts of stamped documents to get them through moral and aesthetic customs. Harmless monsters. Although I am not of the opinion that rebellion is the central value of art, I admit to a sense of shame when I contemplate those objects whose manufacture is ruled by a servile conception of the idea of rebellion. What is saddest is the fact that these artifacts bear such a close resemblance to one another: uniformity reigns from Paris to Delhi and from New York to Bogotá. Originality, the heart of the work of art, has been removed like a tumor.

The uniformity of styles could be attributed to contagion: what is the height of fashion is what is transmitted, and imitation is the commonest form of the spread of culture. At least that is what I

believed a few years ago. I was forgetting that the distinctive trait
of the current situation is not imitation—a phenomenon that char-
acterizes every period—but rather the mutilation of works and
artists. This process, simpler than ideological alienation and na-
tionalist self-deception, is anonymous: it is not the state or the
party, but a headless being, without a name or a sex, that cuts,
shreds to pieces, sews back together, packages, and distributes
artistic objects. The process is circular, as is, according to Ramón
Lull, "suffering in hell": a meaningless movement doomed to be
repeated indefinitely. Painting, from the Renaissance on, at least,
has always been a product that sells. The difference between yes-
terday's process of production and today's can be summed up in
the following phrase: from the workshop to the factory. In the past
a master, unable to satisfy all of his clientele, frequently entrusted
part of the execution of his works to his disciples and assistants,
five, ten, or more painters devoting all their efforts to painting like
a *single painter*. Today the process has become precisely the reverse:
commissioned by a gallery, an artist produces a countless number
of paintings and changes his style every three or four years: a painter
who devotes all his efforts to painting like *a hundred painters*. I don't
know whether the artist earns more money that way; I do know
that painting becomes poorer. This is not the only damage done.
The notion of value is transformed into that of price. In the opinion
of the experts, which was never fair yet, at the same time, was
human, has now been replaced by the label "it's a success." The
client and the Maecenas of bygone days have disappeared: the
buyer is the anonymous public, this or that millionaire from Texas
or from Singapore, the museum in Dallas or in Irapuato. The real
master goes by the name of "the market." It is faceless, and its
brand or tattoo is price.

Nationalism and Socialist didactic art are diseases of the imag-
ination and forms of mental derangement. The market suppresses

imagination: it is the death of the spirit. The obtuse or intelligent Maecenas, the sensitive or crude bourgeois, the State, the Party and the Church were, and are, difficult patrons who haven't always shown good taste. The market doesn't even have bad taste. It is impersonal; it is a mechanism that transforms creative works into objects and objects into exchange values: paintings are shares of stock, cashiers' checks. Governments and churches demanded that the artist serve their cause and legislated their morality, their aesthetics, and their intentions. They knew that human works, because they have a meaning, are capable of poking holes in any and every orthodoxy. For the market, works have nothing but a price, and therefore it imposes no aesthetic, no morality. The market does not have principles, nor does it have preferences: it accepts all works, all styles. It is not a question of imposing its will. The market does not have a will: it is a blind process, whose essence is the circulation of objects that price makes homogeneous. As a function of the concept behind it, the market automatically suppresses all meaning: what defines creative works is not what they say but how much they cost. By being circulated—this word has never been more expressive—works, which are the signs of humankind (its questions, its assertions, its doubts and negations), are transformed into nonsignifying objects. The canceling out of the will to be meaningful makes the artist a meaningless being.[1]

As time goes by, I am more and more convinced that artistic creation requires a moral temper. The expression is ambiguous, but I do not have another one at hand. When I write *moral,* I am not thinking of good causes or of public or private conduct. I am

[1] I recently read in *Le Monde* an article about a show of works by César, a sculptor of unquestioned talent. The critic says: "This artist represents one of the most amazing moments in modern art: the moment when the Mercedes, transformed by César into a cubic meter of scrap iron, brought the same price as a Mercedes fresh from the factory." The price *is* the meaning.

referring to that fidelity of the creator to what he wants to say, to the dialogue between the artist and his work. Creation demands a certain insensibility toward the outside world, an indifference, neither resigned nor haughtily disdainful, toward the rewards and punishments of this world. The artist is the absentminded person par excellence: he pays no attention to what the world has to say or to its morality, because his mind is entirely focused on the thread of that solitary conversation which he is engaged in—not with himself but with another. With someone—or, rather, with something—which does not, and never will, belong to him but belongs to others: his images, his representations. And there is a moment in which the poem questions the poet, in which the painting contemplates the painter. That moment is a test: although we may betray our creations, they never betray us and will always tell us what we are or what we were. The artist's morality is the temper that he has acquired so as to withstand the gaze of his best creations. In Mexico there are two admirable artists, two casters of spells who are themselves under a spell: they have never heard the words of praise or reproof of schools and political parties and have very often laughed at the master without a face. Indifferent to social morality, to aesthetics, and to price, Leonora Carrington and Remedios Varo go about our city with an air of supreme and indescribable distraction. Where are they headed? To the place where imagination and passion are summoning them. They are not an example, and they would be scandalized if someone were to propose them as a model. True artists are not exemplary beings: they are beings faithful to their visions. Their distraction is a detachment: when they create, they detach themselves from themselves. Their act rejects the marketplace and its arithmetic morality.

In the recent past a number of great artists, faced with a civilization that had made values and words ambiguous, tried their best to create an art that would dispel all meanings that were mere

specters and reveal that they literally mean *nothing*. Their decision confronted them with the powers of this world. Today the artist must confront himself. Faced with a society that has lost the very idea of meaning—the market is the perfect expression of nihilism—the artist must ask himself *to what purpose* he writes or paints. I do not claim to know the answer. I simply assert that it is the one question that counts.

<div align="right">

Delhi, *January 10, 1963*

</div>

Puertas al campo

Contemporary

Mexican Painting

There are misleading expressions. *Modern painting*, for example, is as old as the century. Another ambiguous term: *School of Paris*. It was not really a school but a succession of tendencies and styles, a series of movements in which a decisive role was played by great painters from various countries: Spaniards, Italians, Hollanders, Germans, Russians. The cosmopolitan character of the School of Paris, in fact, aptly underscores its modernity. In other words, it emphasizes its Pan-European nature: modern painting was born, almost simultaneously, in Paris and in Munich, in Milan and in St.

Presentation essay for the exhibit *Pintado en México* (*Painted in Mexico*), Madrid, 1983. The artists represented were Gunther Gerzso, Juan Soriano, Manuel Felguérez, Alberto Gironella, Vicente Rojo, Roger von Gunten, José Luis Cuevas, and Francisco Toledo.

Petersburg, to cite only the best-known centers of radiation. It was one of the last expressions of that Europe which was born in the eighteenth century and which, not without factional splits, survived until 1914, only to be destroyed by imperialist nationalisms. After World War I, the focal points of modern art were extinguished one by one, except for that in Paris. Although this is a phenomenon that has not yet been studied, it is reasonable to attribute the dying out of those movements to a combination of two adverse circumstances. The first: among all the cities wherein important artistic movements sprang up, only Paris was truly international; the second: the revolutions and counterrevolutions that triumphed in Russia, Italy, and Germany were inherent enemies of modern art and, above all, of two of its cardinal principles: internationalism and freedom of creation. It is not surprising, then, that the various contradictory tendencies that had made of modern art a living whole should emigrate to Paris and be concentrated there. It was the sole great free European city, which since the beginning of the century, unlike London, had been open to the winds of art from every direction. World War II marked the end of Paris as a world center and the end of the purely European period of the art of the twentieth century.

The modern artistic movement came into being in Europe, but it soon won the other continents over. The expansion began in America: at the Armory Show in New York in 1913, the avant-garde artists of Europe exhibited their works for the first time outside of the Old World. Nonetheless, it took more than thirty years for art in the United States to break away from that of Europe and cease to be a mere provincial reflection. The same thing happened elsewhere. The exception was Mexico: in that country, around 1920, a modern art sprang up with unmistakable traits all its own. Between 1920 and 1940, Mexican art combined, quite often successfully, two seemingly incompatible elements: an in-

ternational aesthetic vocabulary and an indigenous inspiration. Mexican artists adopted and re-created certain tendencies of the art of that era, above all Expressionism. The reelaboration of those tendencies was frequently powerful and original: rather than a transplant it was a metamorphosis. The fusion was a fertile one because the natural element, the soil and the sky in which those styles grew, was not so much a natural environment as a history. By that I mean, a nature—people, things, forms, colors, landscapes, atmosphere—seen and experienced through a unique history irreducible to European history. A conjunction of two discoveries: Mexican artists discovered modern art at the same time that, as a result of the Mexican Revolution, they discovered the hidden but living reality of their own country. Without that twofold discovery the Mexican pictorial movement would not have existed. The revolution revealed to Mexicans the reality of their land and its history; modern art taught its artists to see that reality with new eyes.

In its best period Mexican painting gave an original slant to the art of the first half of the century. It reached its zenith around 1930; after that, like all movements, it began to decline, although not without having first influenced a number of well-known American painters who were later to embrace Abstract Expressionism. Mexican painting was the victim of a twofold infection, two superstitions that were two prisons: ideology and nationalism. The first blocked the source of inner renovation, freedom and criticism; the second slammed shut the doors of communication with the outside world. Stagnation and repetition: the painters began to imitate themselves. Around 1940, a group of outstanding artists broke through the isolation, rejected ideological rhetoric, and decided to explore two worlds: that of universal painting and their own. Not only did these artists change and renew Mexican art, but we also owe several of its best works to them.

At the same time, in New York, art in the United States, rep-

resented by powerful personalities, gave the appearance of being the direct heir of the European avant-garde. Continuity, and a break as well: Abstract Expressionism claimed to be a synthesis and a transcending of the Surrealist automatism of the passions and of the Neoplatonic geometries of abstract painting. Abstract Expressionism was followed by a less vigorous tendency, Pop Art, which in its cocksureness was reminiscent of Dada, though unburdened of Dada's metaphysical passion and devoid of a fascination with death.

During these years New York occupied the central place that Paris had had before World War II. The differences, however, were (and are) enormous. In point of fact, for some time now, New York has been, above all else, the theater—or, more precisely, the circus—of the breakdown of the avant-garde. In less than thirty years—after turning into an academy, that is to say, into a method and a manner—the avant-garde has become a vogue. Art as an object both of high fashion and of financial speculation. New York continues to be a center, but one must not confuse the hegemony of the marketplace with fruitfulness, imagination, and the power to create.

The truth is that we must give up the superstition of centers: in every era, artistic creation has rebelled against both uniformity and centralization. The best artistic periods have been those in which several focal points of creation coexisted; local styles are always lively, whereas in imperial ones the mask vanquishes the living face. For more than twenty years we have been witnesses to the rebirth of schools, movements, tendencies, and personalities that belong to a nation or to a city, not to a world center. It is a phenomenon that develops in the opposite direction from the process of centralization, which has ended up making artists sterile and their creations uniform. The simultaneous existence of different national focal points—genuine axes in relation to one another

yet autonomous—is analogous to movements that are noticeable in other fields, in politics, religion, culture. Rather than a return, it is a resurrection. These movements, in all likelihood, will restore the health of modern art. Health: diversity, spontaneity, true originality, which is something quite different from fake novelty. It is encouraging that one of the first places in which this salutary reaction has manifested itself has been none other than Spain.

The situation in Mexico is in no way essentially different from the one that I have briefly described. Like all other artists, ours have experienced the fascination and the vertigo of the world center, but in general they have been wise enough to remain faithful to themselves. Their very own traditions, which give Mexico a sort of spiritual gravity, have been a factor favoring a proper balance. Equidistant from the attraction of the world market, which brings money and fame but dries up the soul, and from the easygoing complacency of provincials who take themselves to be the navel of the world, our painters are obliged, at one and the same time and without contradiction, to preserve their heritage and change it, to bare it to every wind that blows and yet not cease to be themselves. It is a challenge that every generation faces up to and that each one responds to in a different way.

The eight artists whose works are on exhibit today in Madrid, in a closed-off area of the Banco Exterior de España, doubtless represent the middle ground of our contemporary painting. Thanks to them, the Mexican art of this decade possesses character and diversity, boldness and maturity. As I see it, two or three names are missing, but not a one of those on exhibit is de trop: the show brings together a group of artists whose works reveal to us not only what Mexican painting is today but also, in certain instances, what it will be tomorrow. Although the aesthetic alternatives have been and are the same for all, the works of each of these artists express an individual vision of the world and of reality. Despite my heartfelt

wishes, I am unable to refer to any of them specifically: the object of these pages is, rather, to *situate them* in their historical context and within today's overall perspective. I have written elsewhere, however, a number of studies and poems about almost all of them. Hence, I need only repeat what I have said several times: if those who want to know what the living painting of Mexico is like, they must see the works of these painters. Let me add that among these works are certain ones that are central to contemporary art in Latin America.

The Mexican artists who are presenting their works in Spain today were obliged, first of all, to acquire the language of contemporary painting and then, after that, to make it their own. Moreover, they have had to face up to an unusual circumstance: they are men of the second half of the twentieth century but they are painting in a country in which the distant past is still a living present (I need scarcely call attention, for example, to the persistence and the vitality of Mexico's popular arts). Can one be an artist of his time and of his country when that country is Mexico? The answer to that question is not a matter of common agreement. Each of the works of these eight artists is an answer; each answer is different and each is valid. The variety and even the contradictory nature of those answers do not detract from their validity. Nor do these phenomena invalidate the question. Each answer changes it and, without doing away with it, transfigures it. The question is ever the same, yet in each case it is different. In all truth, the question is not only a starting point: to answer it is to enter the unknown, to discover a buried reality or to discover ourselves.

However different and dissimilar the works in which these painters answer the unformulated question that Mexican reality puts to them, there is an element that unites them and that, in a certain way, is a reply that includes them all: art is not a nationality, but neither is it an uprooting. Art is irreducible to the land, the

people, and the moment that produce it; nonetheless, it is insep-
arable from them. Art escapes history, but it is marked by it. The
work is a form that detaches itself from the soil and takes up no
room in space: it is an image. Except that the image takes on
concreteness because it is related to a soil and a moment: four
poplars that rise up from the sky of a pond, a naked wave that
emerges from a mirror, a little water or light that trickles between
the fingers of a hand, the reconciliation of a green triangle and an
orange circle. The work of art allows us to glimpse, for an instant,
the there in the here, the always in the now.

MEXICO CITY, *September 27, 1983*

Pintado en México